AN ARTIST ON ART

UNIVERSITY
PRESS
OF HAWAII

HONOLULU
1972

AN ARTIST ON ART
Collected Essays of
JEAN CHARLOT

Library of Congress Catalog Card Number 77-120323
ISBN 0-87022-118-3
Copyright © 1972 by The University Press of Hawaii
Printed in the United States of America

Designed by James Wageman
Title page photograph by Edward Weston: Jean
 Charlot, Mexico 1926

VOLUME II

Mexican Art

Contents

GENERAL

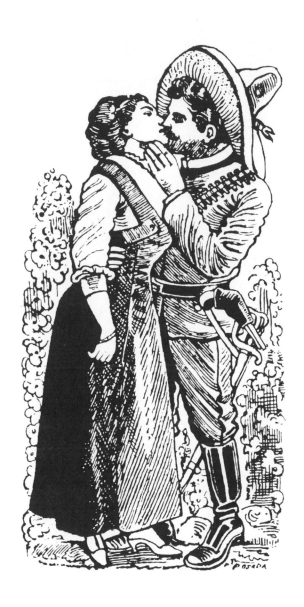

Painting and Revolution

Mexican art is, as a whole, characterized by a quality of *mexicanidad*, a term that could be translated as Mexicanness. This assertion would constitute a frightful commonplace if the forms that Mexican art has taken through the centuries were not so varied and at first contact so disparate that the search for, and detection of, their common spiritual and aesthetic denominator needs a flair and knowledge above the average. In the early twenties, it became the serious sport of the group of early muralists in search of a racial aesthetic tradition. At times, the search proved rewarding, as when a painter-turned-archeologist would unearth fragments of murals buried for centuries and find between them and his own still-fresh frescoes reassuring similarities. From colonial times, when art was produced in a near theocracy, churches offered as models the sculptured, gessoed, gilded, and polychromed statues that, besides being expressions of an active faith, remain masterpieces of plastic propaganda. An artist aiming at a clear and forceful expression should be humble enough to renounce

Posada: Relief etching, circa 1912

the more esoteric nuances of *l'art pour l'art*, a lesson that was not lost on us.

Three periods in the long history of Mexican art evoke clear, if over-simplified images: the Mexico of pre-Hispanic antiquity, its art-forms geared to the gesture of the priest wrenching the throbbing human heart from inside the cage of living ribs; colonial Mexico, when a sea of converts worshipped before a sea of images as tortured and bloody as any idols, or else as gilded and hieratical as a viceroy's retinue appearing to his subjects from atop a balcony. Thirdly, there are today's murals, always scaled to bigness and often to greatness, frescoed brown giants, their fists shaken into geometry, their mouths forever filled with inaudible shrieks.

Besides these well-defined periods, Mexico is further enriched by the arts of two times of transition, both keyed to crucial upheavals; lacking these less known periods, the three well-known styles, antique, colonial, and modern, would be hard put to prove their inner oneness. In the sixteenth century, the Conquest threw open to overseas influences the closed world of forms and colors informed with sacred meanings that the Aztec artist evolved and mastered; it was as if an Egyptian decorator of the third millennium B.C. had been placed in the presence of works by Titian or Tintoretto, and bid to copy them. That a regional flavor survived at all after this *grand écart* is proof of the sturdiness of Mexico's esthetic instinct. Shedding their pagan skin, the idols were renewed into Christian holy intercessors. For a short time, the art of conquered Mexico adopted a Byzantine stiffness, as the

novelty of the subject matter piled new terrors on top of the old esoteric dogma. Soon, familiarity with heaven bred a mood of loving appreciation and, from then on, Christian grace informs even the more roughly hewn stone, the most childishly scribbled ex-voto.

The second period of transition is much closer to us in time, but even less known today than are the shifting forms of art at the time of the Conquest. Politically, the nineteenth century was filled as much with disasters and revolutions as had been the sixteenth century; but everything now was geared in reverse. As it seceded from Spain, the young Republic wished obscurely for an art of its own. This time, the problem was how to break away from European art and to trace one's way back to primitiveness, though none of the patriotic artists of that time would have cared to express it that bluntly. A formidable task confronted the generation born early in the century, nurtured to masterhood at the Regal Academy of San Carlos under the coldly shining star of Mengs' neo-classical teachings. At heart, they knew well that Spanish art, even official Spanish art, was great in its achievements. Yet it was their higher duty to turn their back on the Greek masterpieces cast in plaster that were a gift to the school from the Crown of Spain, so splendid as to enthuse no less a connoisseur than Baron de Humboldt. The young men of the 1840's gleaned what revolt they could from shreds of the work of Goya, impolite, cynical, brutally frank at times, a work mysteriously tuned to their own as yet unexpressed quality of *mexicanidad*, that needed another century to mature. It was the time when the Indian sculptor, Patiño Ixtolinque,

carved local stones with due regard for their natural grain and shape. Though his subject matter remained academic —women symbolizing virtues—the brown hand managed the chisel with all the discretion of a stone age sculptor, and the cheese cloth ceased to hide the monolith. A rich residue of Mexican aesthetics awaits the patience of the modern appreciator of the work of a master muralist of mid-nineteenth century, Juan Cordero. He covered thousands of square feet of walls and cupolas with heroic compositions. His gift for chromatic dissonances that his well-meaning friends denied or minimized is what endears him to us today.

At the turn of our century, these gropings matured into an annunciation of the present period. *Ca.* 1900, men of the generation of Rivera lived their youth in a Mexico that was provincial perhaps, but also self-sufficient. As the gifted child walked to art school—the same Royal Academy of San Carlos, now become the National Academy—he could ease his walk to a stop alongside the open shop of Guadalupe Posada, popular engraver of penny dreadfuls, who carved with burin his metal plates in plain sight of the passers-by. Before Rivera was even born, Posada had lived through an aesthetic crisis of his own and solved it the heroic way, that of *mexicanidad*: the Indian master renounced his delicate lithographic craft that leaned on the works of French lithographers—Cham or Gavarni—to adopt instead the brusk black-and-white of metal blocks suited to his native temper. As he watched the engraver at work, the youthful student of the Academy realized at least that what he saw was unlike anything he

was taught at art school, unpolished, impolite, unrefined, lacking in Roman dignity. So many negative qualifications came to sum up to one big positive assertion, a lesson in independence. When time came to make their own crucial decisions, the masters of the generation of Rivera would in turn patriotically steel themselves against the pleasures and pomps of their beloved School of Paris.

Modern Mexican art is said to have been born of a revolution, or rather the Revolution, started in 1910 and still "in the air" today. Perhaps, however, in the aesthetic sense, it was no more than a return to the past, a reassessment of an honorable patrimony. The Revolution proved useful mostly as a cog, the piece of machinery needed to join together ancient walls and young muralists. To make frescoes possible, it was imperative that there be men in power unafraid of public opinion. As it turned out, *ca.* 1920, these upper-dog politicos were in fact desirous to ram down the throat of the bourgeois the consciousness of defeat and a squirming sense of their social predicament. Bohemians in their twenties, or at most their thirties, were given public walls to paint as other men had been given palaces to sack, but the resentment at such a breach of etiquette, being of a cultural nature, simmers up to this day. The champions of genteel taste, who were also the opponents of the upstart regime, patiently waited for the public revulsion that would get rid of these mural monstrosities and herald the political humiliation of their enemies. These frescoes, once condemned so roundly, have meanwhile become a national pride and even an international asset. Not even the aging men who commissioned

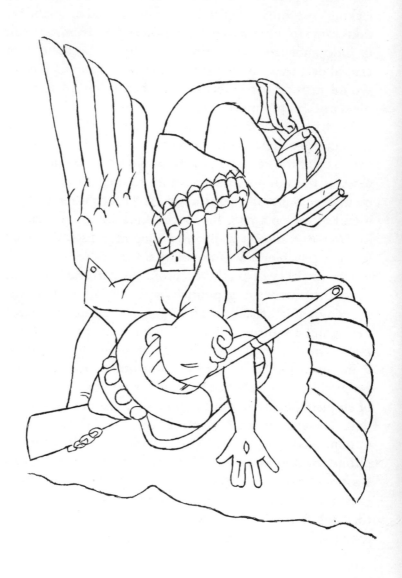

the works when they were young, as a lusty *beau geste*, understand how it all came to pass, but they breathe the more easily.

What happened is that the artists commissioned to paint walls felt how these noble seasoned buildings dictated a task vaster than a display of personality: if their work was to be successful, it should prove to be more, a mouthpiece for collective feelings that, at the time, ran their gamut from the passionate mayhem of active revolution to the stilled depths of meditation that precede and follow action wherever Indian blood is concerned. Perhaps the best proof that the painters acted not unlike mediums is the fact that, regardless of their leftist mouthings, they produced such masterpieces of religious art as Orozco's series on the life of Saint Francis, or Revueltas' *Devotion to the Virgin of Guadalupe*, fit expressions of their people.

At the time that the first murals were being painted on government walls, the young artists could, in conscience, hardly feel the elation of true pioneers, for the City of Mexico, or rather its streets, exhibited as usual numberless murals, painted on the inner and outer walls of *pulquerias*, or wine-shops. Even when they were content merely to enlarge to mural scale Swiss postcards or Spanish chromos, the folk artists never failed to let drip from the blunt tip of their *brocha gorda*, or house painter's brush, excesses of *mexicanidad*. Nowadays, this perpetual free show is nowhere to be seen, prohibited by a sanitary law patterned after those of the Northern Neighbor.

Charlot: Pen and ink drawing, 1924

Each school of art may be summed up in a single aesthetic canon. For example, the Greek ideal type, be it a bronze athlete or a marble Venus, flexes his muscles or exhibits her curves as a king set within a vacuum. The Mexican Indian prefers to take his stand in nature with a kind of artless camouflage, flesh color melting into the color of earth; the Greek theatrical gesture gives way here to less exposed ones, bending and squatting. In consequence, sometime throughout the years 1920–1925, an ideal Mexican type was evolved that has already become a classical art form, as shorn of paraphernalia as was the Greek nude man. Intent on duplicating Indian ways, the muralist found to his delight that, to better paint this brown man clad in white, all that was needed was a severely limited palette of lime-resistant pigments, all earth colors that are the very nuances of earth, and dust, and straw, and dark flesh. Aesthetic considerations blending with technical ones led to the rebirth on a large scale of true fresco.

Once they had asserted themselves, the muralists could not hold long the allegiance of a slightly younger generation, come to artistic maturity in a milieu that took murals for granted and thus looked for excitement to a different fare. If we list the antithesis of mural work, we also define this very natural reaction. The very big gave way to the very small, the quick coverage of vast areas to a miniature technique, and decorative simplifications to a patient rendering of accumulated detail. Perhaps Julio Castellanos, now dead, remains the star of the anti-mural trend.

In the Paris of the 1920s, cubism proved a natural ally of our brand of muralism, imbued as both were with an

architectural spirit and, at least, a groping towards collective expression. When cubism gave way to surrealism, these secret affinities were severed, and a few Mexicans attempted to forge another link, this time on a new basis. It remains the specialized role of masters like Merida and Tamayo to help international critics bridge over what, in their work, is orthodox modernism, towards the mysterious lands of Amerindian thought and culture.

This article first appeared in slightly different form in *Saturday Review*, September 15, 1951.

Twenty Centuries
of Mexican Art

On my way to the Mexican exhibition at the Museum of
Modern Art the words of an elderly Indian came back to
me. Speaking of the Spanish conquest, he said: "It was
fated. If it had not been the Spaniards it would have been
some other tribe." He was thinking, perhaps, of the U.S.
tribe. I also remembered an experience in a museum library
where I was looking in vain for slides of the magnificent
stelae of Copan. At last, approaching the librarian I was
told to look for them "under P, for Primitive."

The exhibition now in New York may help in smoothing
over some similar misconceptions in other quarters. It is
well nigh all-inclusive but leans heavily on both "prim-
itive" and "folk" art. To enjoy it to the full, the Yankee
spectator need not stoop to what he may assume to be the
level of the Indian and the peasant, for those dead Indians,
Aztecs, Mayans, Olmecs, were good Indians; indeed they
were great. And the Mexican peasant is heir to an un-
broken tradition dating back a few millenniums. Nor
should a desire for a short cut to better understanding

Tresguerras: Nuestra Señora de la Merced. Engraving on
copper, 1817

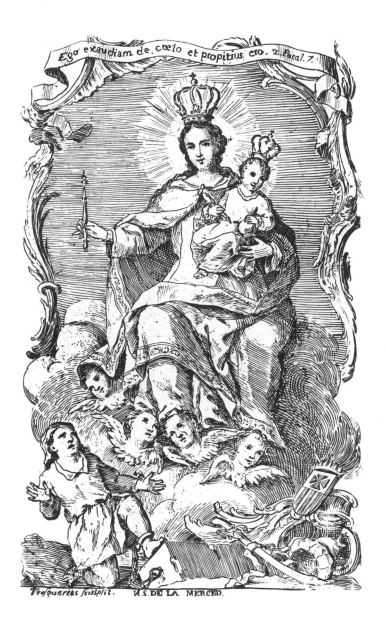

Ego exaudiam de cœlo et propitius ero. 2 Paral. 7.

Trespuertas sculpsit. N.S. DE LA MERCED.

result in shaping a roly-poly image of Mexican art closer perhaps to the optimism of our Elmers than to the more important truth.

Through the course of Mexican aesthetics, a subjective *leitmotiv* recurs, linking together the three great epochs, pre-Spanish, Colonial, and Modern, in spite of outward differences. Totally unrelated to the cult of physical beauty which is the mainspring of our own tradition in art, it deals with physical pain and with death. The skull *motiv* is equally dear to Aztec theogony, to the Christian hermit who fondles it lovingly in his cell, and it still runs riot today in those bitter pennysheets sold in the streets of Mexico on the Day of the Dead. It is, however, but the outward sign of a mood of deeper significance.

Lips drawn in an unanesthetized rictus, eyes glazed, teeth clamped in torture, her body spent and strained, a woman gives birth. The sculptor carves the hard stone with furious precision into a symmetry that makes the basin arch and open with the dignity of a church portal. To the Aztec, birth-giving was the privilege of woman. The same goddess who hallowed soldiers killed in battle threw her heroic influence over women who died in childbirth. Pain as a positive asset in the building and cementing of the world is one of the Aztec dogmas, consistent with their belief that the universe has come to maturity through the Four Destructions.

To our deodorized minds, such bold facing of the biological is distasteful. Yet the Church of colonial times insisted, as did the pagans, on this carrying of a cross. We see here the saints, lips drawn and teeth clamped in

anguish, ejecting through bloody martyrdom their own soul to be born into eternity.

Again today the great Mexican murals depict undainty subjects—the flagellation of a stripped agrarian tied to a pole, the opening of wounds with pistol and knife, women again weeping, this time over the dead. Those pictures deal with the birth, through revolution, of a new social order, with the tortured parents wishing it godspeed.

The section of pre-Spanish art is especially strong in Aztec sculpture which more than any illustrates the loving intercourse that should exist between the sculptor and the material he chooses, a problem of peculiar actuality to the modern partisans of direct carving. The Aztec standard for good sculpture is identical with that of Michelangelo: to be proclaimed beautiful, the statue should roll intact from the top of a mountain to the valley below.

Most admirable are those egg-shaped stones that lack a base and refuse a pedestal as if the sculptor had carved them not for any static display, but to nestle in the palm of a giant hand. In the same degree that the russet "locust" and the green "gourd" mimic a bug and a fruit, they emphasize their quality of being stone, as if the tools of the artist, however successful in their description of the subject, were as naturally attuned to the material as is weather erosion. The same respect for organic laws accounts for the beauty of the Teponaztle carvings, the ocelot as ready to spring as a stalking feline, yet so truly wood that the roughened grain and split trunk do not subtract from but add to the sculptor's achievement.

In the representation of gods and humans, fingers and

toes, plumes and fringes cling close to the core of the stone as if sucked in by centripetal forces. Elbows and hands push into the torso, the knees and soles of the squatting females telescope into the main bulk as do the wings and wing-shells of a beetle after flight.

Aztec sculpture is self-sufficient, not intended to convince or to please. It acquires the natural quality of boulders long under water, as if the metaphysical stream that shaped it used a working logic akin to hydraulic forces. Its emotional power remains crammed within an outer shell as cool and smooth as an engineer's maquette; this sculpture does not require a spectator. To handle its textures with eyes closed is to gain a knowledge keener than what comes through the eye. It seems that, overlooked in a jungle, it would still breathe a kind of hibernated life like a cocoon, that buried underground it would continue to exude a silent existence like a bulb.

The Mayans are well represented by small objects and temple models but—especially after the strong showing they were given at the San Francisco Fair—one misses the grandeur of their bas-reliefs, the elevation of their stelae. To round out his knowledge of them the New Yorker would do well to go to the Museum of Natural History and walk among these towering monoliths that added to the forests that were their habitat an army of trunks carved in stone.

Those who consider the Colonial section of the show Spanish have probably never been to Spain. A Spaniard is most puzzled when confronted by this "provincial"

development and Mexicans are likely to find Spanish architecture dull.

If Aztec sculpture is self-contained, Colonial art is, on the contrary, a theatre. Its sculpture preaches to the congregation; its force is centrifugal, radiating from the dummy heart and soul of the effigy through extensions of contorted limbs, up to the very tips of the extended fingers, into space.

To know such sculpture through tactile tests would be no more of an aesthetic experience than to frisk a window dummy, for the baroque taste of the Colonial masters favored a choice of mixed materials. Wooden statues are gessoed, lacquered, and painted, with eyelashes and wigs made of human hair, teeth, and ribs of true bone, often beribboned and dressed in damasks and velvets, their wooden feet shod in silver. Some of the sculptors, still unsatisfied by the static limitations of their materials, dabbled in cinematography: the skull of the saint was emptied, the orbits gouged out, and eyes on ball-bearings, as impressive as doll's eyes, bulged and rolled in mystic agonies, moved from behind the scenes by a discreet tug at hidden strings. The man who is a purist as concerns technique can only feel indignation at such license, but one should rather admire the strength of an impulse that did not shy at using such bastard means, this art that broke all the rules of good art in its desire to stir, to expostulate, and to convert.

Colonial sculpture may look weak when compared with the Aztec, but one could hardly call it squeamish.

Souls sizzling in purgatory, with a pope or cardinal thrown in, windlasses unrolling the guts of martyrs, eyes served on a plate and breasts ditto, Christ after flagellation, skinned to the ribs, bleeding on all fours in his cell like a wounded animal in its lair—such are the favorite subjects of their art. It is strong stuff compared to the sugar-saints sculptured today, sporting their sanctity as a kind of social accomplishment.

The section reserved to folk arts is especially complete. In its quaintness and color it is also the one that needs less training to approach. It may be viewed as decorative art if one forgets the soulless, fashionable connotations of the word. Out of humble materials, clay, straw, gourds, thousands of objects are made, exquisite alike in their shapes and colors. Such objects are rather bartered than sold and in any case will bring only a few centavos. The ingenuity in planning and pleasure in executing them is matched only by the indifference of the artist to the problems of distribution and of gain; they belie the theory that man works spurred only by the profit motive. Rather do those Mexican crafts illustrate Verlaine's opinion that the last vestige of divine freedom left to man, driven from Paradise, exists in his creative capacity for work.

To know what folk art really means to the folk who make it needs as much objective research as to scan the puzzle of Aztec relics. Those bright masks with comical beards and horns which connote for us a gay mardi-gras are to the man who wears them more akin to a priest's surplice. The impetus of muscular exertion that seizes the faithful on the day of the feast of Guadalupe uses the

peacock's splendor of the bouquet of feathers implanted in a grinning mask as if it were an optical prayer. The rattles held and shaken rhythmically through the dance acquire a propitiatory meaning, as does a Tibetan prayer-mill. The "Arab" masqueraders, topped with huge horns, should be seen in action when the danced pilgrimage of Chalma proceeds—hundreds of devils spring in ordered bedlam in front of the main altar, as if exorcized into sight by the powers of its life-size crucifix.

Even the pottery, to us charming or quizzical, may be heavy with feeling for its Indian owner. A little girl was passing through the streets of Acapanzingo holding a jug of water, a plain jug, egg-shaped with the gullet sideways. Suggested a tourist, "It looks like a duck." She answered indignantly, "It is a duck," hugged it tighter and ran. They have no dolls to love in Acapanzingo.

Folk painting is painting done by people that some well-to-do critics would not enjoy meeting socially. Out of this anonymous limbo of folk art have emerged already such artists as Posada, Manila, and Estrada, that will rank as old masters in the eyes of the twenty-first century. Thus the distinction made in this show between both species of painting—the popular and the professional—should be taken with some grains of salt. There is a lovely portrait in white, done by one of the folk, that the artists in the next rooms have good grounds to study and envy. There are, among the *milagros* or ex-votos, pictures of consummate art and great depth.

Among us, people give thanks for graces received: health, money, ambitions satiated. But the Mexican devout

pray for less obvious gifts. There exists a *milagro* representing a lonely room and a bed, and in it a woman very dead and green, dedicated as follows: "Mrs. . . . having left her village and come to town wished to die. Her family erects this picture to give thanks in her name that her wish has been happily granted."

After Murger wrote his *Vie de Bohème* and it had become a bestseller, a number of elderly bums, once his friends, nourished a lively controversy as to which one of them was the original bohemian he had been writing about, and made a few pennies lecturing on how picturesquely they had once sowed their wild oats. Whenever I talk or write about Mexican modern art I am reminded of this incident. What was once alive, strong, and seething has now faded into club talk. What we created that was without precedent has established, only too well, its precedent.

There was a heroic scope to the gesture of those men who, turning their backs on both art dealers and patrons, and their minds away from the Parisian novelty shop, planted their works indelibly on the walls of Mexico's buildings, with no incentive to do so but that of an inner urge synchronized with the social unrest, with no assurance that they would ever be noticed by the "cultured," but with the positive belief that they had ceased being artistic and were now artisans, companions to the carpenters and plasterers who were collaborating in the work. At this stage, Rivera would smash the camera of a press photog-

Rivera: Tehuantepec Marketplace. Detail from a lithograph

rapher that had sneaked up on him, with orders to expose the spending of government money for things people considered ugly. Siqueiros, receiving the news that a friend had just been assassinated, painted in tribute his *Burial of a Worker,* secreting in the wall behind the painted coffin a bottle with a message of adieu. Orozco, his works stoned and maimed, would with superb indifference ask his mason not only to patch, but also to repaint the work. Such intensity of collective creation could not last long; as an attempt at erecting a painted monument in the anonymous mood with which the ancients had built cathedrals, the Mexican experiment comes to a close before the end of the 'twenties.

Another group was in the meantime indulging in a more restrained painting, with the accent on pure plastic values. Let us say that while the full orchestra of Mexican muralists was blaring, for those who had keen ears some chamber music was still to be heard. The best of those easel painters have been able to ply to their ends the influx of modernisms, and yet retain genuine style and scope. The impetus they gave gathers force with the 'thirties, spreads the reaction against monumentality. A new emphasis is laid upon the qualities that mural work lacked perforce: the full rainbow range of chemical pigments, a variety of textures, a lighter mood. Steady eyes and hands perform on a miniature scale pictures as astonishing as the *Our Father* inscribed on a grain of wheat.

The discreet portion of the Museum of Modern Art allotted to the modern art of Mexico does not tell this story in full: for unexplained reasons, the decade 1930–40

is featured, thus glossing over the important period before. Even though murals cannot be transported for exhibition purposes, there exists a body of works closely related to them: geometric diagrams, studies of details from nature, full-scale tracings used on the wall. Much of this material is now lost, thrown from a scaffold and trampled at the end of a work day; much that remains could have been reassembled and shown. Even the painters that opposed in style the school of muralists would have increased in significance against this historic background. The oversight of a bare five years (1921–26) punches a gigantic hole into the close-knit trend of those two thousand years of Mexican art.

Releases given by the Museum to the press suggest that the arts of Mexico are characterized by "gentleness and a love of fun and play." The emphasis put by the display on the tender innocence of Mexican toys, the colorfulness of peasant costumes, the amused exercises of sophisticated artists, comes dangerously close to proving this point. It is as if the vast Mexican panorama had been surveyed through a rose lorgnette. Considering the world today, so cruelly different from the optimistic world of yesteryear, the art of Mexico at its most severe scores a prophetic point; it would have been a more responsible performance if the present show had had courage enough to underscore it.

A review of a show held at the Museum of Modern Art, New York City, 1940, this article first appeared in slightly different form in *Magazine of Art*, July 1940. Reprinted by permission of The American Federation of Arts.

PRE-HISPANIC

Who Discovered America?

Contrary to the current prideful cliché, primitive art was not wholly unappreciated in the past. From the sixteenth to the eighteenth centuries many a non-classical masterpiece has been lovingly preserved for us in the *cabinets de curiosités* of the amateur. Though mingled as a rule with other curios—stuffed crocodiles or giant clams—its magic nevertheless may well have worked on its cultured collector, too shy to publicize an appreciation that ran against the taste of his day.

More recently and openly, the apport of so-called primitive cultures has enriched immeasurably the form and manner of our contemporary arts. Insomuch as the dictatorship of taste imposed by Greco-Roman forms waned, advanced artists and critics, as eager as were their Victorian predecessors to lean on precedent, filled the void with a new or renewed appreciation of African, Oceanic and Amerindian arts. In this indirect form of specialized pleading, once the finger is put on comparable

Seal impression, Vera Cruz. A deer

facets in primitive and modern art, the need is filled, and interest lags.

I wish to review here the shifting standards that Occidental taste successively used in its appreciation of pre-Hispanic art. Such a review may expose the relative shallowness of our convictions when faced with Aztec, Mayan or Tarascan works, and underline the fact that, notwithstanding their present aesthetic canonization, these forms and their original meaning remain largely for us *terra incognita.*

In the case of Mexico, we possess critical texts dating from the earliest days of the Conquest. Hernan Cortez was a lawyer at heart and a *conquistador de facto;* yet who could miss his awe at the beauty of the Aztec royal treasure as he took time out of the very act of plunder to report the news to his Emperor: "What could be more astonishing than that a barbarous monarch such as he [Montezuma] should have reproductions made of gold and silver, precious stones and feathers, of all things to be found in his land, and so perfectly reproduced that there is no goldsmith or silversmith in the world who could better them, nor can one understand what instrument could have been used for fashioning the jewels. As for the featherwork, its like is not to be seen in either wax or embroidery, it is so marvelously delicate."

And again, writing just after the siege and sack of Tenochtitlan: "Among the other booty taken from the city were many golden shields, crests and plumes, and other such marvelous things that they could not be described in writing nor comprehended unless they were

actually seen; so that it seemed fitting to me that they should not be divided, but rather that they should be presented as a whole to your Majesty."

When the Aztec loot reached Spain at last, the Crown Treasurer had it measured and weighed with calculating intent; the value of precious metals and rare stones took precedence over the even more precious imponderables that neither scales nor calipers could detect:

"*Firstly:* a large wheel of solid gold with a monster's face upon it, worked all over with ornaments in bas-relief and weighing 3,800 pesos of gold.

"*Item:* two collars of gold and precious stones. In another square box a huge head of an alligator in gold. . . . Also two large eyes of beaten metal and blue stones to put in the head of the alligator.

"*Item:* eighteen shields ornamented with precious stones with colored feathers hanging from them.

"*Also:* two books such as the Indians use.

"*In addition:* a huge silver wheel; also bracelets and beaten silver ornaments."

Ominously suggestive was the estimate of the raw metal's weight. Before being melted and cast into more acceptable currency, Cortez' gift to the Crown was paraded before courtiers, rather than as an art exhibition as a reminder of the far-reaching might of the sovereign. When Charles V made his triumphal entry into Antwerp in 1521, the American loot was part of the many carnival exhibits. Albrecht Dürer saw it there and then on his tour of the Netherlands, and jotted in his diary the earliest estimate by an artist of the strange objects: "Further,

I have seen the things brought to the King from the new golden land: a sun, wholly of gold, wide a whole fathom; also a moon, wholly of silver and just as big; also two chambers full of their implements, and two others full of their weapons, armor, shooting engines, marvelous shields, strange garments, bedspreads and all sorts of wondrous things for many uses, much more beautiful to behold than miracles. These things are so costly that they have been estimated at a hundred thousand florins; and in all my life I have seen nothing which has gladdened my heart so much as these things. For I have seen therein wonders of art and have marveled at the subtle *ingenia* of people in far-off lands. And I know not how to express what I have experienced thereby."

If it tells us something about Aztec art, this text is equally eloquent as concerns Dürer himself. The Italianate veneer of the mature master washed off when confronted with this American revelation. To the fore came his Gothic training as a German goldsmith and a taste for Apocalyptic intricacies that could well rejoice in the fullness of craft linked with nightmarish visions of his Indian counterparts.

All through Colonial times in Mexico, cultural matters remained in the hands of missionaries, mostly Franciscans and Dominicans. Properly to convert the heathen, the missionary learned his tongue and assimilated his customs. Influences worked both ways, with the conqueror not always cast as the victor in this cultural bout. In the sixteenth century, the preacher orated in *nahuatl* to a squatting congregation, pointing with a stick to pictures painted,

or rather sign-written, by native converts. Their style, in its Indian-ness, belies the foreign subject matter. A Franciscan *mestizo*, Fray Diego Valadez, learned even to engrave didactic plates that stand halfway between Aztec hieroglyphs and the symbolical theological tableaux that were then the fashion in Europe. Though not in words, his works constitute a sixteenth-century critical appreciation of Amerindian aesthetics, appreciation to the point of mimicry.

However, the business of the missionaries was to convert natives to Christianity; and it was passionate business, carried on with passion, and replete with incidents that appear brutal when looked at with a hindsight colored by modern liberalism: the willful toppling over high cliffs of monolithic idols that would smash on the rocks below; the staged bonfires of manuscripts; the melting of pagan jewels to be remodeled into vessels for use at the altar. A simple enumeration of wreckings and burnings may be misleading, for this mayhem was unconcerned with art; it never was the form, line or color that was then under judgment as was to be the case in Victorian times. The theologian at bay was convinced that behind the daemonic force of the forms lurked an actively demoniac power. It was not unappreciatively that the monk hacked at and put to the torch such works, but, as it was, fully conscious of their worth. Thus, when the great stone *Coatlicue* was unearthed on the main plaza in the eighteenth century, it was speedily and fearfully buried again. In 1803, Baron von Humboldt stepped over the awesome idol, "stretched out in one of the galleries of the edifice of the University

. . . covered with three or four inches of earth."

Touched, as was his class and his generation, by the spirit of the free-thinking French *philosophes*, Baron von Humboldt could look at pre-Hispanic art factually, merely as carved stone or as painted agave paper. His is the first modern dispassionate appraisal of Aztec art for art's sake. Unlike Albrecht Dürer, Humboldt, nurtured on the classical theories of beauty of Raphael Mengs, could not wash away from his consciousness the Greeks and the Romans, but handled the resulting conflict with great equanimity. After having described the extensive collection of casts—Apollo Belvedere, Laocoön, etc.—given by the King of Spain to the Mexican Academy of Art, he mused: "The remains of the Mexican sculpture, those colossal statues of basaltes and porphyry, which are covered with Aztec hieroglyphs, and bear some relation to the Egyptian and Hindu style, ought to be collected together in the edifice of the Academy, or rather in one of the courts which belong to it. It would be curious to see these monuments of the first cultivation of our species, the work of a semibarbarian people inhabiting the Mexican Andes, placed beside the beautiful forms produced under the sky of Greece and Italy."

So in advance of the times was this proposition to exhibit pre-Hispanic sculpture in a museum of art that it had to wait until our days to come true.

Soon after Humboldt spoke, the Victorian spirit closed in upon most cultivated men's understanding of art. The Mexicans themselves were far from immune to this narrowed attitude, even though it denied value to their

racial tradition. Typical of a correct gentleman's opinion in the mid-nineteenth century is that of José Bernardo Couto, great appreciator of Colonial art, but blinded by fashionable prejudices to what had come before. In his *Dialogue of the History of Painting in Mexico*, 1860, he has only this to say of Aztec paintings: "One should not look in them for a knowledge of chiaroscuro or of perspective, or for a taste for beauty and grace They failed to express moral qualities and the moods of the soul . . . and showed a certain propensity to observe and to copy the less genteel aspects of Nature, such as animals of disagreeable aspect."

It can be said that a new broadening of understanding, already on its way when Couto spoke so flatly in the negative, was a fruit of Romanticism. The accepted love of ruins, especially if bathed in moonlight, could not but influence explorers. Men nurtured on graveyard elegies and troubadour clocks were naturally awed by the Gothic silhouettes of Mayan ruins seen against a Yucatecan full-moon. Exoticism, a love of the far-flung in space and in time, was another factor. It had thrived early on news of Napoleon's Egyptian campaign, with Mamelukes artfully vignetted between sphinxes and pyramids. Travelers such as Catherwood could hardly miss the parallel between the American pyramids and the African ones, and Indians could do for Arabs. Waldeck, fearless explorer, doctored subconsciously his reports to fit the fashion: he saw and sketched a Mayan mural relief of an owl in flight as if it were a winged scarab, then a popular Egyptian motif.

Last of the romantics, Dr. Le Plongeon, in the 1870s,

was to go Waldeck one better with his theory concerning Queen Moo. Born eight thousand years ago, this Mayan princess, of whom the good doctor spoke with familiarity, fell in love with a pre-Dynastic Egyptian prince and followed him to his native country with, for her dowry, the Mayan culture that gave rise to the Egyptian one.

Despite such romanticized appraisals, there remained throughout the nineteenth century the stark stumbling block of style. The few norms used to estimate art remained all too close to nature: the classic norm upheld a well-proportioned, healthy human body as its ideal; the Renaissance norm, somewhat hesitantly, stuck a smile by Leonardo on a Virgin by Raphael; at the end of the century, most current was the photographic norm, patterned after the styleless style of the painter then considered as the greatest living master, Ernest Meissonier. What small pickings there were in pre-Hispanic art when looked at from these points of view were tested by Dr. Gamio, the Mexican archaeologist. He gave to cultured laymen a heap of archaeological specimens to sort, asking them to single out what they considered to be artistic objects. Though the test was taken individually, no man knowing what the next one would do, the results pretty much agreed. Gamio noticed how the objects rejected as non-artistic were unfamiliar to his friends, that is had no parallels in European culture. The favorite among art objects was a realist head of a knight, its martial profile seen between the open prongs of a beaked helmet. It looked a twin to the head of Alexander in the guise of Hercules, its profile seen inside the jaws of a lion pelt—a

Greek medal that is a standard illustration in college textbooks.

I myself experienced the impact of what I have called the Renaissance norm when at work with Dr. Sylvanus G. Morley in the ruins of the Temple of the Warriors in Chichen-Itza. At the back of the inner chamber on top of the pyramid were found seventeen stone atlantean columns that once supported the slab of the main altar. Out of these seventeen pieces, all related in craft and style, we at once picked one as a masterpiece, neglecting the other sixteen. We called the elect the "Mona Lisa of Chichen-Itza"; it was photographed and published, and became mildly famous. Years after, reflecting on the choice, I realized that our "Mona Lisa" was the only one of these statuettes whose lips curled upwards!

A slackening of naturalistic taboos coincides with the advent of Cubism, that took as its slogan Cézanne's dictum: "Treat nature by the cylinder, the sphere, the cone." The new ideal widened immeasurably the scope of appreciation of pre-Hispanic specimens. Minus its romantic moonlight, the pyramid could still thrill as Cézanne's cone. The lack of naturalism in pre-Hispanic objects, that had proved a block to the devotee of Meissonier, had positive value for the lover of Braque and Picasso. In Mexico City, the Museum of Archaeology became, without transition, both a Louvre and a Museum of Modern Art. Aztec theogonic sculptures, great serpent heads, blood basins, sacrificial and calendar stones, seemed suddenly the imposing pre-forms of the purist trend that had just swept from pictures all the boot-blacks shooting

crap, the cardinals eating lobster, the naked women, that had passed for art only a generation before.

However, so completely were the tables turned that there now was an uneasy feeling that the pre-Hispanic artist still stood ahead of those of the School of Paris in the uncompromisingness of his means. The flat colors of the illuminated Aztec manuscripts, with raw hues paired in refined discords, could pass as the goal towards which the Matisse of *Music* and *Dance* took his first hesitant steps. The anatomies that Léger put together as if with ruler and compass were doubtless veering away from Bouguereau, but still had far to go on their semi-mechanical legs to equal the frightfully abstract countenance of a *Tlaloc* or of a *Tzontemoc*. Just emerged out of Paris and of Cubism, Diego Rivera could say in 1921: "The search that European artists further with such intensity ends here in Mexico, in the abundant realization of our national art. I could tell you much concerning the progress to be made by a painter, a sculptor, an artist, if he observes, analyzes, studies, Mayan, Aztec or Toltec art, none of which falls short of any other art, in my opinion."

The Cubists, better to appreciate what they called the pure plastic forms of Amerindian sculpture, concentrated on its physical aspect only, an artful conglomeration of cubes, cylinders, cones and spheres, wholly disdainful of make-believe. It was in a way disingenuous to deal thus in terms of style with the fruits of a culture that had no name in its tongue for the "fine art" artist and no concept of art for art's sake. The next step—to take into consideration this essential truth—came again as the backwash of strong

currents unleashed from a far-off milieu: reacting against a period in which subject matter in art was slighted as literary, and emotion skirted around as old-fashioned, surrealism readmitted factors that the cubists had shunned as obsolete: symbols of life, love and death, inspiration, magic. Surrealism helped the informed critic to investigate in turn the passions, sadism or ecstasy, intimately woven in the "cubist" body of pre-Hispanic masterpieces. Successive interpretations of a single object can illustrate the change. To the cubist, the head of Xipe was beautiful for purely plastic reasons: the ovalized spherical segment of the mask, a positive form, was answered by the negative space of the O of the open mouth; it was truly as pure a sculpture as the best Brancusi. Surrealism helped one remember also how these lovely circular rhythms were mysteriously built around a less delicate event: the flaying alive of a God-impersonating victim, and the priest clothing himself in the warm and dripping hide.

Out of old folios came facts trustfully collected by the missionaries concerning the incests and bestiality, the massacres, mutilations, and planetary suicides related of the Indian theogonies. Thus, in 1945, Leo Katz could give us a renewed estimate of *Coatlicue*: "Vitzilopuchtli's first act after birth is the destruction of his many older brothers, the stars, and of his plotting sister, Coyolxauhqui, the moon, all blotted out by the rising sun. From the point of view of the subconscious, we have a very interesting analysis of Vitzilopuchtli's Oedipus complex in protecting his mother, and the Electra complex of the daughter

Coyolxauhqui against her. It is a perfect Freudian background for the surrealist power of this symbolic image with its skulls, its serpents, its cut-off hands and cut-out hearts, so strongly reminiscent of early surrealist films."

Thus we come back today to our point of departure in time, with a passable understanding of both the form and content of pre-Hispanic art. A familiarity with modern art has truly increased our potential familiarity with Amerindian art. Perhaps, after all, when the missionaries of Colonial times took fright at sensing the energy dormant in Aztec sculptures, and retaliated by physically maiming them, they paid the fullest homage possible to this art, never intended by its makers for Platonic appreciation.

A review of the Arensberg Collection of Pre-Columbian objects, the Philadelphia Museum, this article first appeared in slightly different form in *Art News*, November 1953.

Mayan Art

The study of Mayan art and the appreciation of its monuments have been left wholly to the taste of scientists, and those precise gentlemen, being mostly interested in chronology, too often overlook its beauty to indulge in technical discussions which make the layman yawn. This may account for the fact that Mayan art, although one of the few fully ripe racial expressions the world has known, is still waiting to become a part of our common aesthetic heritage.

Mayan art appears more and more as a purely autochthonous growth. The much heralded Chinese or Siamese resemblances fade away as our knowledge of its style increases and its purely American characteristics are made clear. Even the die-hard fairy tale of the Mayans' being a survival of the lost Atlantis tribes is less in clash with the facts, the close connection between the art, the race, and its geographical environment, than the more commonplace theory of an Asiatic importation.

The layman tends to regard this art as just another of our many American tribal expressions. He does so with the paternal condescension with which the civilized appreciates any savage culture, since Parisian aesthetes

started the Negro art fad. But on the contrary, if one possesses an aesthetic flair and a sense of the fitness of respect, one will approach Mayan art much in the same way that a learned Occidental studies Chinese ink paintings or Japanese poetry, considering it as something more subtle than the similar products of our own present-day era.

Its stylistic cycle follows the universal scheme. It started from archaic forms to culminate in a genuine classical purity, then, through the overripe excesses of baroquism, vanished together with the civilization that had given it growth. Just before the end, a reaction of purism or neo-archaism gave birth to some of its most exquisite monuments.

A choice between the diversified wealth of its remains is mostly a question of taste, and taste is a very personal affair. Here again the archaeologist, innocent of aesthetic training, looms as dictator, and the public, taking his word for granted, knows and admires most the monuments typical of later rococo times. Lovers of virtuosity for its own sake can well take pride in the decadent "dentelles de pierre" of Quirigua and in the late works of other sites, all of them unsurpassed in the history of monumental sculpture for their confusing amount of carefully worked details. Through decorative spirals, volutes, and curves, men, animals, monsters, and gods intertwine their bodies in competition with the surrounding tropical exuberance. By a sort of artificial mimetism, chunks of stone are made to look like corners of a jungle. Let the imagination surround them again with hordes of chieftains and priests in heavily embroidered gowns, with their god-masks, weapons, and ceremonial staffs, and you

will not fail to enthuse both theatrical managers and "nouveaux riches." Here indeed were splendors that put to shame even a Roxy.

But Mayan life and Mayan thought were not only this gorgeous pageantry. Their classical manifestations are less luxurious but wealthier in human values. A sober taste guided the authors of the "Beau Relief" of Palenque, and some eight hundred years later the fresco painters of Chaćmultun and Chichen-Itza. On plain backgrounds, personages clad in peplum-like garments move with elegant, over-refined gestures, their slim bodies elongated to the utmost. The artist, as the Greeks had done before him, attempts to summarize his philosophy in the choice proportions of the male form, and stakes all on the human body. But in these works palpitates a spirituality that clashes with the Greek athletic ideal that gave such a rustic health to both men and gods. The quasi-morbid attitude that those reliefs immortalize is still the appanage of modern Mayans. How such languid-looking adolescents were able to build and to keep in working order the complex machinery of their civilization is more understandable for those who have seen Mayan masons lift with lazy gesture, and carry on their heads, weights under which one of our strong men would stagger. In the whole field of Mayan monuments, this group of art works stands the closest to us, being endowed with a psychological flavor that links it closely to our own anthropomorphic habits of thought.

But in the Mayan scheme of things, man was far from playing the dominant role. He was a well-nigh useless addition to a universe in which planets, stars, and an in-

numerable and complex host of gods moved in orderly fashion. To live his life without crossing the way of those mysterious beings was man's main concern. Hence the priest controlled all. The metaphysical subjects proposed by the priesthood to the hired artist were, by a happy accident or a racial affinity, exactly those that befitted his gift. The Mayan artist was most interested in abstractions. The use of line, volume, and color for non-descriptive, highly intellectualized purpose, was as natural with him as an objective fidelity is to the camera. As a result, this art stands as one of the wealthiest mines of theological motives and plastic abstractions the world has known.

The simplest and presumably oldest forms of human representation (stela 8, Naranjo) are realistic, with a trend to caricature. The conception, however, soon widens with the growing ability and ambition of the stone worker. The representation loses its naturalistic appearance, anatomical proportions become distorted, and the wealth of complicated garments and ceremonial ornaments climbs, vine-like, over the human figure, humbling it to the role of a mere peg for symbols. The features remain visible for a time, as the last objective spot amidst this wealth of abstractions, then disappear in turn under a fantastic mask, thus depriving us, the modern onlookers, of even this last refuge for our too strictly emotional appreciation of art. Thus the typical Mayan monolith was an encyclopedia of dogmatic knowledge. Once an accumulator for religious energies, it is now, with its meaning mainly lost, still a foyer of plastic ardor.

Deer ceremonial. Detail from Camara Vase. Tracing by Jean Charlot

That a process of purification modified natural forms into a highly divergent pattern is in many cases evident, the link being as brittle as that between a Picasso picture and a guitar. But another group of art forms must have been born directly from the mind of their makers. Theirs is a more radically abstract language than any of those used by modern artists, and baffling indeed for the scientist who attempts to pin down some objective model from which such symbols could evolve. One of two groups of equally serious explorers saw a parrot in a detail of stela B, at Copan, the other group an elephant!

An individual may create a new pot shape or decorate a vase for his own egotistic satisfaction. But the impulse that gave birth to the temples and major sculptures of the Mayas was the collective urge that seizes whole crowds and makes them build as one, be they Athenian Greeks or Gothic Frenchmen. This social art, now that its society has vanished, remains in enforced idleness amidst its jungle surroundings. As a modern recognition of its utilitarian origin, Indian hunters still make sacrifices of deer and burn copal in wooden spoons at the feet of the carved stelae. Even the white man recognizes dimly that no purely aesthetic appreciation will do it full justice. He tries to complete the picture by scanning the other remains of this civilization, tries to read its written texts and discover the spring that caused those monuments to surge as an answer to the need of the people. About a fifth of their hieroglyphs have by now been deciphered, but most of these texts happen to be merely arithmetic, dealing with astronomical computations, the movements of the sun,

the moon, and the planets. This very lack of sought-for sentimental corollaries is illuminating. The backbone of the art, the mental scaffolding the priests offered to the artist so that he could clothe it with his own aesthetic passion, is mathematical. Numbers, being measure and rhythm, are poetry in a sense, but poetry accessible only to a few. In order to attract crowds it must be clad in less metaphysical garments. This was the role incumbent upon the Mayan artists, sculptors, modelers, and painters. They made this dry, if noble, dogma partake of the richness of the landscape, yet not following it in its disorder, but creating a human tropic of new shapes and meanings. Stela 11, in Yaxchilan, perhaps the most impressive conception ever attempted in sculpture, shows that the artist fully understands his role; here trembling worshippers kneel before a shrine. A miracle happens and the god appears, a frightful god indeed. Behind the divine mask magnificently carved, the artist reveals to us, and to us only, the profile of the priest who impersonates the god. He is a dry, shrewd, scientific person, wholly disdainful of the tremendous sensation that his disguise creates.

The more plebeian art objects are teeming with a wealth of grinning gods, old gods, black gods, and even among them the ambiguous beauty of the Maize God. Thus did the artist grind food for popular sentimentality, something to cling to when one ignores mathematics and yet needs a faith and a morale.

This article first appeared in slightly different form in *Magazine of Art*, July 1935. Reprinted by permission of The American Federation of Arts.

A Twelfth-Century
Mayan Mural

Mexican murals have been much discussed. Both in their physical make-up, the true fresco technique, and in their sociological implications, they have sown seeds that fructify even unto the humblest post offices of the U.S.A. Though this movement has helped American art to a distinct and different status from the art of the school of Paris, people, most incurious as to why it should have started in Mexico, vaguely imagine that Mexican modern art is a mushroom growth, unrelated to the traditions and monuments of its past. Mexican murals have come to mean those that have been painted in the last fifteen years and few suspect that there is in Mexico a mural tradition centuries old. Though this truly indigenous tradition had been despised through the nineteenth century and humbled to the walls of village chapels and of wine-shops, it can be traced directly to the mural decorations of Aztec and Mayan temples.

We gain an indirect knowledge of Mayan murals, those of the Southern school, only through the potteries painted

Mayan mural. Warrior sprinting. Tracing by Jean Charlot

in monumental style and the low bas-reliefs carved or stuccoed in temples, which, in their heyday were thoroughly polychromed and thus more paintings than sculptures. Frescoes proper could hardly resist the jungle dampness. But from the so-called New Empire of the North we still possess some important remains.

The Temple of the Tigers is a small edifice which dominates the ball court in Chichen-Itza, Yucatan. There players and judges probably went to pray for victory or there the victorious team received its prize. Though the national game combined some features of football and basketball, this chapel served a purpose similar to those chapels in Spain, annexed to the arenas, where bull fighters kneel before they kill. Its age has been computed as dating from 20,000 B.C. by the enthusiastic and unreliable Le Plongeon who saw in its paintings the source of all Egyptian art. Hard-headed German scientists claim it to have been built but little before the Spanish conquest. It is more probably of the twelfth century, being one of the oldest monuments in this New Empire metropolis. Whatever its date, it contains most perfect specimens of Mayan painting in its inner chamber, depictions of peace and war, religious ceremonies, apparitions of the gods. Their line and color were still brilliant enough in 1842, when Stephens and Catherwood rediscovered Chichen, to make them exclaim that here was the Sistine Chapel of the Mayas.

Of the seven panels which constitute the decoration, the best preserved today is at the right of the inner door. The painting has suffered to some extent. Much of the last

coat of paint has flaked off, uncovering a preliminary tracing in light pink, only faintly visible against the creamy ground. Souvenir seekers have done their work of destruction, travelers have inscribed their names or scribblings since pre-Hispanic times. On account of this, a patient study through careful tracing does more justice to the work than does direct photography. A copy of the whole wall traced directly from the original by Mrs. E. H. Morris and myself in 1926, and unpublished up to now, is the basis for the illustrations of this article. Its line matches stroke for stroke the one that the artist traced on the wall before covering it with an opaque pigment now gone. It does not show the picture as it was when finished but as the first draft which was to be amended and illuminated later. As is the case with most sketches, although it has not the perfection of the completed work it shows more spontaneity, makes us commune more intimately with the mind of the artist.

The technique employed is complex: the wall itself was of carefully squared and joined stones on which a first coat of rather rough-surfaced lime was spread. On a second coat, as smooth as paper, the preliminary sketching was done in true fresco. The brushes must have been long, pointed and fat as are the Japanese brushes, which alone can explain the flexibility of line and the quick variations of thickness. In this first phase of the work, the artist sought rather the balance of masses than a detailed story-telling. It must have been to him something of a daub, as great chunks of wall were covered at one sitting. The brush, vigorously wielded, has left many spatters of the too

liquid tone, most visible on the lower areas. The line is of a very pale madder red, of transparent quality, and includes corrections of posture, anatomical indications under the garments, changes of mind concerning accessories. When the line had been traced, the background was filled in with terre verte, also in fresco, and the local colors of people and objects were lightly sampled in a water color effect. When this part of the work was dry, another technique was put into use. The painter instead of using a liquid color changed to a pigment of much body, a kind of thick tempera which admitted of more depth and variety of tone; over the fresco proper was spread this new set of colors of a density and intensity of enamel, the most conspicuous being a cerulean blue, a mauve and a Veronese green. Those and also a thick gouache whiter-than-lime mixture were spread over the frescoed wall in absolutely opaque coats a sixteenth of an inch thick. The adhesion to the wall was not as perfect as that of the different coats of lime to the stone, so that much of it has now peeled off, uncovering the preparatory sketch. The last step in painting consisted of filling in the details on those colored silhouettes, inventing new lines where the first one had been lost and, where it was still to be seen, interpreting it freely with black. The result is most original: the pigments play not only through color but also through texture, transparent or opaque, albeit some of the frescoed part remained uncovered, especially on the backgrounds. The painter, having massed in his compositions in the first sketch, could in the last rendering go to the extreme detail without losing the balance of masses.

Between the floor and the level of the painting proper a decorative dado was painted, representing Atlas-like figures up-holding the lower edge of the picture, amidst water lilies and fishes silhouetted against a dark blue ground. The painting proper is square in shape, covering an area of a hundred square feet. It stops at the left in the northeastern corner of the room; at the right it butts against the stone jamb of the door, on which is sculptured and polychromed a standing warrior. The lintel of this door, a beam of hard wood, cuts deeply into the square itself. The subject matter is that of a battle being fought on a field which spreads between the raised tents of an army and the thatched-roof houses of their foes. The composition divides itself naturally into three bands, the upper one being the village, drawn as a background to the fight. The men have gone to the battle, the women busy themselves with provisions for the warriors, a few old men and women squat on the ground or on roofs unmoved by the goings-on around them. One warrior is seen in an interior, the *atl-atl* or spear thrower held in hand, either coming from or going to the battle. An important looking elder person, in which one would·be tempted to recognize an in-law, seems to criticize his action strongly. This creature sits between the soldier and a young woman, probably his wife, who offers him a drink from a cylindrical jar. The eternal triangle is suggested by a good looking girl, a neighbor, who signals to the young man from behind the back of the other two, with an offer of food in her lap. To the left a woman with a load on her back, going towards the front lines, turns toward the group and waves an adieu.

The artist has strongly emphasized the architectural quality of the houses so that at a distance the human incidents become plastically negligible. The verticals and horizontals of the buildings mark this whole upper part of the picture as static. This painted area stops at the lower line of the door lintel, a proof that the artist made his story-telling subservient to its architectural surroundings.

We come now to the battle proper which covers two-thirds of the whole picture. More than a hundred soldiers are engaged in individual combat or roam in small aggressive bands under the command of two chieftains, each being silhouetted against the coils of a plumed serpent, his own tribal god. The multi-colored implements, the bodies of burnt umber, carry well against the light terre verte of the field. The soldiers display round shields and long javelins. One of them is dead with a spear through his thigh. Though the scene is one of extreme agitation seen close to, the more one recedes from it, the more a kind of secret order emerges.

The artist has played a masterly game of geometry, using as units the circle which is the shield and the straight line which is the spear. Both elements dovetail into a series of pyramiding forms, the lower ones more obtuse, the higher ones sharper. All those diagonals surging upwards from the outside towards the center bring a compositional order the more admirable for using as its means the very excess of action depicted. Each individual drama cooperates into constructing this ideal pyramid which is the hidden goal of the artist. Only two men hold lances horizontally and those are placed at equal distances from the

horizontal middle, substantially at the place where the golden sections would be, a unique proof of the universal aesthetic appeal of this venerable proportion. Rows of trees on both sides of the battlefield chart its topographical area as being identical with the actual area of the picture.

This most dynamic battle scene is sandwiched between the architectural presentation of the village already described at the top, and a corresponding strip of static content which is both the lower part of the picture and its intended foreground. Among semi-spherical tents, martially adorned with feather and canvas standards, chieftains are quietly seated, engrossed in negotiations. It is again a calm composition, plastically speaking, the counterpart of the village, its immobile personages accentuating the extreme action of the fighters. Boldly rising from this lower part far into the very field of battle, two unusually high standards are topped by an apparition of the senior god. He presides at the negotiations from his abode, a solar disk fringed with resplendent rays. Because of its religious import, this vision is the spiritual climax of the picture, but also through the artist's choice of the long, straight banners tipped with the concentric circles of the sun motif, it proposes and amplifies the two plastic units which recur in opposition all through the picture, the straight line and the circle, the spear and the shield.

Though we possess many precious remnants of Mayan murals, this is the only composition which has come down to us whole. Its geometric scaffolding, the elasticity of the symmetric themes, and moreover the ease with which all calculations efface themselves to let us enjoy the vivacious-

ness of the story-telling make of it a model composition comparable to the best of whatever age or country.

Art historians would have a tough time trying to fit this mural within the iron corset of their classifications. In its absence of modeling, of cast shadows, of atmospheric perspective, it differs from our own realistic school, being closer to the conventions of the Near East. But the landscape suggested by the simplest means, a few trees, some waving lines to suggest a hilly ground, is a mere device, a pedestal to make more prominent the human body displayed in many attitudes. This lack of interest in natural spectacles, this focusing on man, shows a very different mental state from that of the Orient. It leans to the Greek, whose line drawings on vases are also stylistically very near to the drawing of our muralist. But we lack here the godly postures that man strikes in Greek art; here the keen observation of familiar details, the good humor and quick action remind one, in spite of a different plastic language, of a Flemish picture à la Brueghel. Mayan art defies any label.

The human figures heaped on top of each other no more suggest recession in space than do Egyptian bas-reliefs, but while the Egyptian would at least have had them all of the same size, here, the more they recede the more they increase in scale, a most unusual effect to an eye trained, as ours is, in the postulates of Italian perspective. The chieftains in the foreground, drawn directly over the dado, are less than half the size of the warriors that are to be seen

Mayan mural. Chieftain seated. Tracing by Jean Charlot

behind the houses of the village, perhaps a mile off in space. This puzzling feature is yet a proof of the scientific care that the artist took to fit his mural to the problems of architecture and point of view. The room is narrow enough so that one squatting, as one was intended to do, would find those lower personages on his horizon line and close to his eyes, but would get a more and more diagonal view as his eyes moved up the wall. The increase in size of the personages at the top is corrective of such a condition, and gives a squatting man the illusion that all people depicted are the same size. Similar optical correction to an intended shape has been found by Dr. Spinden in another temple, its principle being an elongation of the verticals. It was the same problem that confronted El Greco in some of the narrow chapels of Toledo and it called for a similar solution.

To the narrowness of the room is also due the choice of a minute scale, the figures averaging some ten inches high, which carries well at close range. The only exception in the chamber is on the opposite wall facing the door, a central panel which would be seen through the succession of rooms and even from the other side of the court. Only two figures are painted there, and those of a heroic size, again a logical solution of another problem in point of view. The painter was also interested in the illusion of movement: a file of warriors in action are in reality the same man seen through different phases of one gesture, as happens when we look at a cinematographic film unrolled flat. The time that the eye takes to move from one posture

to the next equals the actual time needed for the bodily shift.

The "canon" of human proportions is similar to the late Greek, being six or seven head-lengths to a body. However, the art fashions of the time must have been as quickly changing as ours, for this elongated appearance which we identify as "refined" gave way within a few generations to a different one which we see displayed in the neighboring Temple of the Warriors. There the painted people, as in much Negro sculpture, have a height of some four heads to the body, which to us seems "primitive" or "barbaric." Was it one of the adepts of the new school, incensed by what he thought was an absurd elongation in the older fresco, who went so far as to scratch into the beautiful painting the figure of a little fellow which exemplified the new art? If so, the layman of the time must have deplored the lack of respect that youth showed for the art of such a recent yesterday, and grumbled in front of this squatty graffito that painting was going to the dogs.

This gloomy talk came true. The "little people" painted in the Temple of the Warriors seem to have been a last show of vitality within Chichen-Itza. When the Spaniards entered Yucatan in the sixteenth century, not only Mayan art, but Mayan might had crumbled. The jungle had reclaimed the city.

This article first appeared in slightly different form in *Magazine of Art*, November 1938. Reprinted by permission of The American Federation of Arts.

The Ancient Maya

This fat book is beautifully illustrated with photographs and diagrams that confront the ancient Maya with the living Maya who lives today off the harsh Yucatan soil. It gives us a knowledge of and a respect for both. Dr. Morley is a great specialist, whose enthusiasm for his subject orchestrates into a unity of mood the many facts assessed. The volume manages to review most of the available evidence concerning a civilization as strangely complex as that of any lost Atlantis. It adds clues and parallels taken from the present folklore of the descendants of ancient kings, warriors and pagan priests, who, stripped of the paraphernalia of plumes, jewels and embroideries that clothed their ancestors, still retain a regal courtesy and sophisticated manner.

Dr. Morley's personal interest is primarily concerned with chronology, with the finding and refining of a correct correlation between the Mayan and Christian calendars; and yet this book rightfully comes within the scope of an art review because the maze of evidence through which the researcher wades before attributing

Charlot: Temple Builders, Chichen-Itza, Yucatan.
Woodcut, 1926

58

a date to a stela, interpreting a codex, or rebuilding a ruined temple, is mostly a conglomerate of art objects. Even though the codices be filled with mathematical and astronomical computations, each letter and each figure is a pictorial glyph pregnant with esthetic values. In the Mayan texts, painted or sculptured, reigns the unmistakable Mayan profile, with hanging lower lip, beak nose and receding forehead, retaining humanistic content despite the strange markings that identify each personage as a sound or a number.

This strongly characterized standard of human beauty is as far evolved from nature and as noble as the Greek, and bespeaks an ideal as rich. It is also to us more mysterious and more poignant, because while we still partake of Greek literature and philosophy and can appreciate hellenic marbles against this framework of thoughts, the only spokesmen left for the ancient Maya are their plastic remains. The physical bulk of building stones and the grooves chiseled out of hard jadeite are our only approach to the understanding of a people whose inclinations were mainly metaphysical.

When the *conquistadores* crossed through the Yucatan jungle in the sixteenth century Mayan ruins were already half-digested by the stone-eating flora. For a few more centuries Mayan cultural witnesses remained secretly stored in this giant deserted greenhouse, to emerge in our days as a timely esthetic revelation.

Mayan art is well appreciated from the peculiar vantage point of our modern art. It puzzled rather than excited enthusiasm in its Victorian discoverers, being an art form

totally disdainful of beauty as they understood it, innocent of the concept of Italian perspective and of the muscle parade known as anatomy. Such zealots were the Mayans in their belief in their own peculiar ideal of beauty that artists were called upon to produce it not only in stone but in living flesh. With a set of planks and a twist of rope they tampered with the new-born to force its growth along the lines of slanting forehead and elongated skull that alone seemed beautiful.

Mayan art passes through a complete stylistic cycle, from archaic to baroque. It is only in its last gasps of life that it approaches the anecdotal or the photographic. At its height it was wilfully abstract. As social arrangements increased in complexity, as the means of execution were enriched—an important consideration for men working in a Stone Age—the Mayan artists dealt increasingly in abstractions. Through sheer sophistication, the proportions of the human body became as unrealistic as those of an African fetich. Limbs and torso were hidden under a vine growth of symbols and ornaments. The face, modeled already after an unnatural ideal, hid itself under a mask even further removed from nature, perhaps beast-like, godlike perhaps, but notably lacking in those safe standbys of occidental art, the speaking mouth and soulful eyes. As Mayan art reached its peak of grandeur in the eighth century A.D., in a blaze of geometric forms blended with the writhing frozen flames of an acute baroque, not even a toehold was left for the two Victorian art standards, ideal beauty and photographic realism.

The great stelae still standing can no longer be read

according to the theogonical content woven into them by their builders. But with the fading out of the stiff theocracy that commissioned the works, the personal message of the artist is released from its official bondage in a purer form than before. Our epoch feels unusual kinship with the point of view of the Mayan sculptor. Modern art has also shed the fetichistic cult of the "form divine," and even though the artist does not attempt to impose his plastic ideal on living beings and by surgical means, deformations are again held in high esteem. Taking advantage of the present day's unfamiliarity with the gods and godlings that crowd the Mayan pantheon, surrealists too have made it a field day for interpreting the many striking symbols along most subjective if unorthodox lines.

Better than an art treatise confined to a single theme, this book illustrates how art becomes the common denominator of the many pursuits of man in any highly evolved culture. Having read the carefully factual relation and consulted the plates that clarify a custom or check a date, the sensitive reader would do well to wash his mind of all previous connotations and to look again at the plates to receive this time only the artist's message. Despite the diversity of mediums, periods and subjects he will thus familiarize himself with an undercurrent, the spirit of Maya, that vies in power and in depth with the best of Greece and of China.

A review of Sylvanus G. Morley, *The Ancient Maya* (Stanford University Press, 1946), this article first appeared in slightly different form in *Magazine of Art*, July 1947. Reprinted by permission of The American Federation of Arts.

The Indian
beneath the Skin

Two beautiful and authoritative books, newly published, suggest it is time to take stock of Pre-Columbian art in the light of today. Expectedly, they overlap copiously as regards their subject matter with Mexico as the center of the show in both. The Phaidon volume—a catalogue of the Bliss Collection—concerned with portable objects—includes items of Peruvian culture. Choosing his examples at will, as did Malraux in his "museum without walls," Covarrubias describes monumental pieces and great architectures that no museum or private collection could claim.

Points of view differ. Displayed in our National Gallery with proper pomp, and mostly an array of sumptuous materials—jade, jadeite, turquoise, crystal and gold—the Bliss Collection leans to the aristocratic. The foreword underlines the fact that only very few of its expensive specimens could be construed as folk-art: instead, these objects were made for the delight of a ruling class, their appeal was aimed at an elite. One is given to understand that such exclusiveness may well be an indispensable ingredient of aesthetic appeal.

In contrast Covarrubias, in his concern for the people at large, freely delights in the less elaborated and, as yet, less appreciated products of pre-classical art: humble pellets of clay showing the imprint of the fingers and fingernails of their naked makers. A few inches high, some doll-like bodies, swaddled in loincloths as if in diapers, are quite devoid of the paraphernalia of heraldic shields, turquoise pendants and plumed head-dresses that blinded generations of archeologists to more homely charms. The lusty little fellows, busy at their everyday chores, dance, cook, make love, make war and make music in such lively ways that museum officials still hesitate to take them seriously, despite their undoubted antiquity.

The Bliss book has truly sumptuous colorplates, with a superb choice of assorted backgrounds: the marble mask of a jaguar, brownish against marbleized blue streaks; a diorite palmate stone set on raw rocks; the Goddess of Birth, of a sickly green against clean opalescent blue; a fierce mosaic mask of green turquoise set against the pallid pink of a smear of finger painting.

Covarrubias favors "old-fashioned" hand-painted color-plates. These watercolors show obvious delight in spite of the patience required for the exacting task. They minimize, as photography may not, the meaningless erosion of time, bypass the artificial awe one feels before museum specimens. They make one forget too many learned commentaries concerning date and provenance. Cleansed of this dusty,

Charlot: Native Guide. Sketched on an expedition to Coba-Macanxoc, 1926

mossy growth, the object emerges as novel, fresh and polychrome as a new-born.

For millenniums before Columbus' fateful visit, Indians created and treasured pre-Columbian art. It is only since the time of Dürer, as art history goes, that non-Indians could contact this art, mostly to loathe it or to puzzle about it. In our day, propped up by new archeological finds, more scientific dating and a more articulate vocabulary, our well-meaning wide-eyed admiration of Pre-Columbian aesthetics still has far to go to become informed understanding. We can only surmise what this art meant to its makers and original consumers. But perhaps today there is a chance to gain at least a toe-hold into the mystery, thanks to the successive shifts of taste that mark our own restless art.

Our familiarity, become almost a surfeit with distortion and abstraction, has forever loosened our appreciation from the apron strings of realistic canons. In the 'twenties, cubism opened vistas, with its emphasis on primary volumes, on Aztec and Toltec monolithic beauty. Surrealism, in the 'thirties, bravely tackled the impalpable psyche behind the carved volumes. Fingers and toes on each frightful limb of the godly countenances may be three, five or thirty. Whatever the count, it will not be deemed an aesthetic blight any more, nor lauded as if it implied an aesthetic manifesto.

The present classification of styles in pre-classic, classic, and baroque borrows its terms from our own history of art. Clearer than obsolete nomenclatures, this one is

perhaps too clear. For Western man, the term "classic" may never shake off its European connotations nor the attendant awe, born in the classroom. The greatest of Amerindian art hardly reminds us of Apollo Belvedere or the Venus of Melos.

Yet, if we go to the springs of the classical rather than loiter on the outer form, the term is not much of a misnomer after all. Man, be he B.C. or A.D., his eyes closed and just feeling from inside what the world is about, finds himself reduced to the irrevocable denominator of his own naked body and its contact with what woven stuff swaddles it. The Greek aesthetic canon—the body naked or draped— marks the limits of this basic haptic world, permanently opposed to the passing visual one made, then as now, of variety, particularities and disorder.

The Amerindian artist, with eyes closed, also took stock of himself as the one basic subject matter of art. Linen was replaced by cotton, and peplum or chlamys by loincloth or kilt, but the body remained the norm. There are basic differences, however. The Greek cherished a sort of immortality, at least the passing immortality of good health. Fascinated by death, the Indian preferred to probe surgically into self, aware of the inner organs stacked within the cage of the ribs.

Greek athletic sports were unknown in a Mexico that thronged rather to a lethal kind of ecclesiastical sport. It made a show of the palpitating heart of the sacrificed, and turned piles of heads into triumphal pyramids. The inner cogs of man turned inside out thus became a part of every

man's visual awareness. Skulls and femurs and blood basins are to Indian aesthetics what soft skin and genitals are to the Greeks.

Man must be quite a spiritual animal after all to make beauty out of reeking carnage. The sculptor of masks never loses the consciousness of the bony scaffold that props up the face. Beauty for him resides in the sphere of the cranium, the ridge of the orbitae. These he tools and polishes out of the hard stone with a caressing skill that other cultures reserved for the curl and the dimple.

Marble into flesh is the Greek's barely credible tour-de-force. Hard stone into hard bone remains the Amerindian's achievement. It emphasizes the hardness and the perenniality of his outlook, in tune with the dense material he chose to carve it in.

A review of S. K. Lothrop, W. F. Foshag, and Joy Mahler, *Pre-Columbian Art* (Phaidon, 1957) and Miguel Covarrubias, *Indian Art of Mexico and Central America* (Knopf, 1957), this article first appeared in slightly different form in *Art News*, May 1958.

Mexican Heritage

Mainly an album of photographs, this book is beautifully put together. The halftones are especially successful in rendering the vast scale of grays that are the palette of Hoyningen Huene. Captions are printed at the end of the volume, so that the plates are free to tell their plastic story unhampered by written data, however pertinent.

The rambling, deceivingly casual text of Alfonso Reyes stresses nuances, takes for granted the main lines of the story, and thus may puzzle North American readers intent on factual estimates. Its virtue lies in its mood, based on the spiritual qualities and racial traits peculiar to the Mexican. This text gives an insider's account of a story that the photographs retell through the eyes of an experienced traveler.

In the pre-Hispanic section the plates of archeological specimens accomplish miracles of rescuscitation. They never show the chunk of clay or carved stone alone, against the neutral ground of a showcase and with a label reminiscent of the number in a rogues' gallery. Even when his subject is lifted out of a museum case, Hoyningen Huene suggests what climate, what landscape, and often what

spiritual mood concurred to produce it. Architectural fragments are caught in the process of being digested by green leaves that soon remake temple into hill and mock the meanders of gesso ornaments with webs of roots not a whit less baroque.

The dosage of mystery in these photographs deepens in the same ratio as the sunlight increases. Sunlight brings out, from the core of the carved stone, marks even more ancient than those left by the pre-Hispanic chisel, the mottled volcanic texture, the congealed geological fierceness that matches (and perhaps in the beginning inspired) the fierceness of the theogonical concept. The tropical zenithal rays that beat upon the ancient remains, by disclosing every trail of the tool as well as every chip of erosion, make all the more clear to our Greek-fed routine taste the uniqueness of an aesthetic that could just as well have evolved on another planet as on this continent that had not yet tasted of Europe.

Hoyningen Huene is at his best in a make-believe world where he may use the technique of the show window, with its pretended scale and elusive depth. When his model is really colossal, like the staircase at Teotihuacan, crawling with pagan gargoyles, the photograph lacks the conviction evoked by tinier spectacles. To his camera, truth is not quite as convincing as the white lies of ingenious fiction.

Of the landscapes, which show the configuration of the Mexican earth long before the most ancient civilization had intruded upon it, the best are the close-ups of leaves and rocks, modeled by the sun with the same precision with which it heightens the quality of pre-Hispanic

sculpture. When the lens takes in larger vistas, the tendency is to eschew substance for filigree, to cut out artful black silhouettes against a backdrop of clouds. Nothing is trite and postcardlike; there is instead a certain "Vogue" impeccability, and a curious suggestion of perpetual moonlight at variance with this arid earth which sows the spiked maguey over the sharp volcanic rock, and in the tropics engineers a *machine infernale* which none has yet conquered.

A third section, concerned with colonial remains, is the one in which Hoyningen Huene adjusts more easily to his subject. The Catholic architecture that fell upon Mexico as a spread arras of liturgical embroidery is now in tatters; it fits only loosely over a land churned deep by successive revolutions. It is this metamorphosis of one era into another, this tension between past theocracy and present laissez-faire that here informs the sensitive camera vision. The monastery steps smoothed concave by the long traffic of sandaled feet, the deserted refectories and fireless kitchens are as much ruins in these plates as the pagan temples that served forgotten cults; and the planners who had the faith and muscle to build these *machines à prier* are present as a mound of skulls piled in a niche of the splendid habitat which their brains once conceived and wrought.

Here again, Hoyningen Huene is at his best in close-ups. A single tortured face of a saint with enameled doll's eyes convulsed in ecstasy, its nose eaten by time's leprosy, revealing a core of gesso and wood, tells more about colonial *mores* than a battalion of saints drilled to stand in the beehive of a baroque altarpiece.

A view of a whole carved and painted ceiling ornate with angels, birds, and curlicues is no more rewarding as concerns human values than a patch of jungle vine. The camera must come closer, catch a unit of the artificial forest to release its stylistic and spiritual flavor. One naked *putti* with his suggestion of flesh pink, of blueberry magenta lined with gold for a flying scarf, fluttering in his childishly holy way among thick-stemmed buds as gaudily daubed as he, magically concentrates in a single plate the anachronistically medieval fervor with which churches were built in Mexico from the sixteenth to the eighteenth century, with the compact crudeness and sincerity that in Europe one associates with the twelfth century.

From colonial to folk art the borderline wavers, and Hoyningen Huene includes ex-votos and clothed sculptures that carry us straight into the nineteenth century. So intent are the sacred dolls, attired in velvets and damasks and moth-eaten linens, on performing convincingly their sacred mimicries that it is difficult to think of them in terms of *objets d'art*. Blood oozes lavishly from wounds in all-over patterns whose brutal and holy meaning is neutralized by the photographic refinements of an unusually selective eye. Beautiful as are some of these plates, one may feel that the deviation from the original exegetical meaning towards decorativeness has been only too successfully realized. As one appreciates the delicate tracings drawn in red on white by the martyr's blood, one remains callously unaware of the meaning of martyrdom.

Only a very few people are pictured in this book and these furtively. Live Indians are the heirs of this "Mexican

Heritage." But they would intrude in this world which is not so much their native land as it is a vision the artist has engendered from delicate balances of shapes and refined textural contrasts. The plates also stress a clash of two cultures, but fail to indicate how both cohabit in their common heir, the Mexican of today. The mixture is dynamic, as witness the many flourishes of social changes, and the few modern works of art that would rate nobly, placed alongside the best of pre-Hispanic and colonial works. A few such plates are needed to take us from past into current life, and to justify in plastic terms what use modern Mexico has made of its contrasting heritages. It would also correct the sense of lethal split, of frightful bilocation which—after the plates have yielded the kind of abstract delectation that Hoyningen Huene's trained shutter finger rarely fails to convey—emerges from a survey of the two Mexicos described.

A review of Hoyningen Huene, *Mexican Heritage,* text by Alfonso Reyes (J. J. Augustin Inc., 1946), this article first appeared in slightly different form in *Magazine of Art*, January 1947. Reprinted by permission of the American Federation of Arts.

COLONIAL

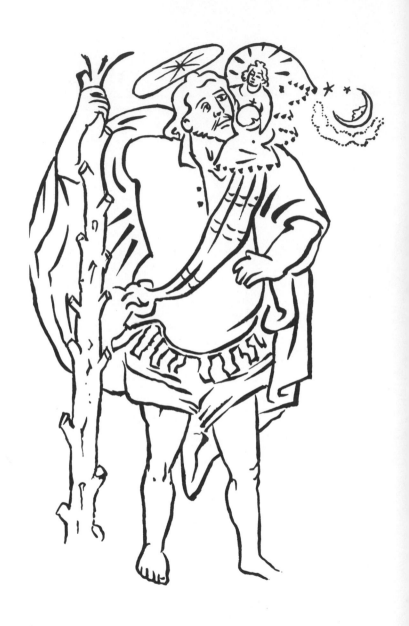

The Saint Christopher of
Santiago Tlatelolco

The Church of Santiago Tlatelolco was reopened for
worship in 1944 after a lapse of sixty years, and its for-
gotten mural paintings were rediscovered. These murals
are painted in a variety of styles, ranging from raw
primitivism to a very provincial variety of rococo. The
panel that dominates all others—if not for its beauty, at
least for its great size and stylistic strength—represents a
Saint Christopher. It is painted directly on the wall, over
the lateral exit from the temple.

The same subject in a similar location was painted in
many a church in the Middle Ages. According to a pious
tradition, one who looked upon Saint Christopher would
not die a sudden, unrepentant death that day: "*Christophori
faciem die quacumque tueris, illa nempe die non morte mala
morieris.*" As a corollary to this belief, both the size and
the place of the image were chosen in terms of function,
to insure for the faithful all the benefits mentioned, to be
received, consciously or unconsciously, as he walked out
of the church.

Saint Christopher. Mural in the Church of Santiago
Tlatelolco, Mexico, circa 1610. Approximately 44 feet in
height

New Spain adopted the belief at an early date. Don Manuel Toussaint mentions a Saint Christopher painted in the sixteenth century in the stairwell of the Dominican convent of Yanhuitlán, a painting that, in his opinion, shows a survival of Byzantine style. In Mexico City, Don Bernardo Couto mentions a giant Christopher frescoed by Baltazar de Echave over the main portal of the church of San Francisco, and yet another Christopher, painted by José Juarez, at the side entrance of the church of St. Augustin.

As happened in the case of many another custom transplanted from Europe, the cult of Saint Christopher acquired a distinctive flavor in the New World. A parallel came to be drawn between the Saint and his modern namesake, the discoverer of the Americas. Whereas the original Christopher forded a river carrying the Child Jesus, but found even his giant strength no match for the miraculous weight of his Burden, the modern Christopher crossed an ocean bearing on his shoulders the weight of the whole Catholic Church. He too succeeded, but became a martyr in the effort.

Another detail that struck American consciousness was the fact that, before discovering Christ, the Saint had been a servant of the devil. In the opening centuries of European Christianity, the moral of this had found ready application. In the sixteenth century, however, the episode had lost some of its aptness, at least in the Old World. It recovered its initial apologetic value in Mexico, a land barely emerging from paganism. The episode spoke forcefully

to crowds of brown converts such as those that Father Motolinia described in 1540: "Whenever the doors open in the early morning, there are the Indians already waiting. Having neither to put clothes on nor to shave, they start for church at the first sign of dawn."

Despite its primitiveness, the Saint Christopher of Tlatelolco is not a true contemporary of these, the earliest converts. The first chapel built on this site, circa 1530, was destroyed before the present church was built and opened for worship in the first decade of the seventeenth century. This constitutes the earliest time, and also the most probable one, for the date of this painting.

The gigantic figure, close to forty-five feet in height, is a true mural, painted directly on the lime mortar in a technique resembling that found in the sixteenth-century churches of Acolman and Actopan. These murals are usually spoken of as painted *al fresco*, though the Mexican walls lack the visible joints between day-by-day areas found in the orthodox *fresco buono* of Italy. In the case of Tlatelolco, the medium appears to be *fresco seco*, in which the whole wall is surfaced at once and left to dry. It is painted afterwards with pigments mixed with *leche de cal*, or water-thinned lime. The addition of lime to the pigment results in light values and a generally chalky effect. In Tlatelolco we meet a range of values wider than that obtainable in the *seco* medium, which suggests an all-over retouching in distemper, probably glue-tempera.

The iconography is mostly orthodox. Christopher walks through the shallow waters leaning on a makeshift

stick to match his giant size, a tree trunk cut whole. His torso is molded in the skin-tight armor of the Roman legion, of which he was once a soldier. He has rolled his trousers over the knee, as the Indians do to this day with their *calzoncillos* to keep them dry while fording a stream. To protect him against the cool of the night, the Saint is bundled in a huge windblown cape. Perched on his mountainous shoulder is the Divine Child, tiny as a humming bird. To clarify the spiritual meaning of the scene, a discus-halo levitates over Christopher's curly wig, and light shafts radiate from the blond curls of the Child. Rustic surroundings are suggested by the grotto from which emerges the hermit, the only human witness of the prodigious sight. The nocturnal hour is emphasized by the horn-lantern carried by the hermit. A moon and its attendant star, celestial witnesses, nestle in a hammock-shaped cloud.

Three distinct styles overlap and blend imperfectly in this plastic palimpsest. It appears probable that this seventeenth-century image is based on a still older one, either a mural that decorated the primitive chapel, or a folk *santo*, perhaps a crude woodcut from which the muralist derived his inspiration. Such an assumption is suggested by the fact that, in this image, a kind of military aggressiveness dwells together with the religious spirit, a fact that hints at the generation of the *conquistadores* rather than at the cultural clime of the following century. This puzzling throwback in style may be simply one of the stylistic anomalies often found in both colonial and provincial works.

Whatever the reason, there is a striking unbalance of body proportions. The legs are strong, and knots of muscles give them a resemblance to the rugged tree trunk by their side. The Saint is as solidly based and as pyramidal as is the neighboring Aztec temple, or *teocalli*. His bulk shrinks and tapers towards the top, with the tiny head of the Child as its apex. Perspective deformations add to the painted ones, since the unusually high wall is sighted diagonally from underneath, increasing the pyramidal illusion.

A second stylistic stratum consists of elements incongruously borrowed from the Italian Renaissance. The plastic counterpoint achieved by the contrasting circular folds of the two mantles is in its essence, if not in its realization, at the opposite pole from the primitive. The Roman armor reveals all the muscles of the strong torso in an exaggerated folk version of the pride of the age that discovered anatomy. We also taste the somewhat theatrical archeological knowledge of the Renaissance in the scalloped fringe of leather tongues that ornaments the belt.

Concerning the third, and more modern, stylistic stratum, we have concrete data. Nearby the Saint, a rococo shield is inscribed with this proud statement: "With money raised and dedicated to the task by our most Reverend Father Manuel de Najera, then provincial of the Order for New Spain, this image was retouched and the whole church cleaned and whitewashed both inside and outside. The main altarpiece was gilded anew, as well as the pilasters of the two side-altars. The year 1763."

A expensas solicita
das y aplicadas por
N. M. R. P. Fr. Manuel
de Naxera siendo Comp.
Gral de esta Nueva España
se retocó esta imagen: se Baseº
y blanqueó toda esta Iglesia
por dentro y fuera y se doraron
de Nuevo el Retablo. Ma=
yor y los dos laterales
de sus Pilastras
Año del 763

Though not specifically mentioned in the inscription, there are inside the church small decorative murals that can be safely dated as of the same year as the renovation. Painted inside niches and meant as backgrounds for statues now disappeared, they are mainly *semis* of floral motives in imitation of rich brocades. They are an index of the taste of the Tlatelolco burghers in the eighteenth century, a taste so different from that shown in the Christopher, painted a century and a half before. These later people were enamored of roses, ribbons, and garlands, and must have found the ancient image truly coarse and ugly. They may have been strongly tempted to include the mural in the thorough job of whitewashing then in progress. That they resisted the temptation and respected the old mural must have meant a compromise with their aesthetic principles for the sake of religious convenience. It is the deeply rooted cult of the image on the part of the more rustic parishioners that saved it from the wrath of the more cultured folk; saved it from being destroyed, but not from being retouched.

Not even in periods that aim at historical objectivity can ancient paintings be retouched in the spirit in which they were originally painted. Consciously or not, the brushwork of the restorer will be an expression of his own period. No such problems were even raised in an eighteenth century exclusively engrossed in its own exciting novelties. The painter of 1763 conscientiously gave the Saint a new skin, prettiness to the two heads and orderly curls to their windblown hair.

Inscription relating to the restoration of the mural in 1763

To the three centuries—sixteenth, seventeenth, eighteenth—to which this mural is related, we should add still another. Indeed, few periods of history could appreciate the merit of its colossal size, its brutal force, its obvious awkwardness and far from academic proportions. Yet our twentieth century feels a special gratitude towards the Saint Christopher of Tlatelolco, a precursor that unconsciously embodies some of the characteristics of modern Mexican murals.

This article was originally published in Spanish in *Memorias de la Academia de Historia,* Vol. IV (3 Sobretiro), in *Tlatelolco a traves de los tiempos,* No. 5, 1945.

Juan Cordero:
A Nineteenth-Century Mexican Muralist

In November 1874, Mexico City celebrated the Feasts of Peace with a civic fair, industrial and artistic, located in a temporary pavilion erected for the purpose. *El Ahuizote* of November 6th reports, "The building is a cluster of shacks precariously put together with wicker and canvas, surrounding a something called a brave rotunda, perhaps because of its cheek in staying put in the center of the Plaza de la Constitucion. . . . People go there to look at idols from the Museum, stuffed birds from the medical school, and products of foreign industries. There is a china pot with live fish in it: the pot is French, the fish Mexican, only the water drawn from a city pump typifies our National Industry."

One feature of this fair was of more lasting import however. Outcome of the Juarez reforms, an art renaissance was rampant.

"Allocution delivered by Don Gabino Barreda in the name of the National Preparatoria School, during the festivities in which said school crowned with laurels the eminent artist, Señor Juan Cordero, as public testimonial

of gratitude and admiration for the mural painting with which he adorned its walls."

Mentioning "the fine arts that near extinction in our country because of a lack of subject matter . . .," Don Gabino lifts his eyes to a rosier future: "It is the glorious lot of the Preparatoria School to blaze a new trail for Mexican aesthetics. It feels proud of having inspired to the genius of a true artist a composition meant to idealize the spirits of Science and of Industry that stand for the pacific activities of man. . . . The Preparatory School places today by my hand on the brow of this sublime artist the symbol of immortality."

At this juncture the artist was crowned with a wreath of solid gold, kept in his family to this day.

Cordero's reply, "With pleasure do I accept the laurels with which you garland our humble work. The best leaf in my artist's crown, this wreath will have a conspicuous place in my studio and seeing it there, Inspiration will swoop down on to my palette"

We may add that the ceremony in which the painter was crowned by the hand of Gabino Barreda assumed bizarre undertones for the two main participants. Besides being director of the Preparatoria School, Barreda was a medical doctor and family doctor to the Cordero family, and Juan Cordero made use of his professional services. Thus we witness the unusual spectacle of a doctor solemnly bestowing on his patient the gift of immortality.

1874 marks the apotheosis of Juan Cordero's career, fulfilled at a time usually considered a low ebb of Mexican painting. The splendid flowering of colonial religious

frescoes was a thing of the past, the modern renaissance a thing of the future. Mid-nineteenth century conventions imposed Europeans as directors for the National School of Fine Arts. Much of Cordero's life was an effort to give things Mexican their due, and to take the place of the Spaniard that was at the head of the Art Academy.

Born in the State of Puebla, in the village of Teziutlan, Cordero comes early to the Capital, combining his art studies with a peddler's job and long treks, selling thread, needles, ribbons to villagers, saving enough in the end to pay his fare to Italy.

The Mexican government, always ingenious where its artists are concerned, made Cordero secretary of its Legation to the Holy See, with a small pay and, better still, free time to soak in the wondrous sights of Rome and to paint on his own.

In 1853, Cordero made the slow and not so safe return trip to the patria, carting with him a mammoth easel picture, twenty palms wide by fourteen high, *The Redemptor and the Woman Taken in Adultery*. It was the fruit of much industry. The artist reserved "fourteen hours daily for studies distributed between Drawing, Perspective, Anatomy, Painting, the rules of Composition and of History." Exhibited at the Mexican Academy, the picture proved to most taxpayers that their money had not been wasted, that the young painter loomed as a rival to his Italian teacher, Natal de la Carta, whose work I know not. Prefigure of a pattern that is to haunt Cordero through life, the picture raised a controversy. Besides public admiration it attracted "the venomous darts of

envy" and "all classes of invectives" reports *La Illustracion Mexicana* for 1853.

On the strength of this discussed showing, the artist was offered the sub-directorship of the Academy, under the Catalan painter Pelegrin Clavé, imported years before as director. Cordero refused the post and one thousand pesos annually in a letter where Mexicanism runs high, "I must confess that I did not sacrifice the best years of my life in foreign countries . . . to come back to my own patria to serve under Señor Pelegrin Clavé."

In truth, Cordero coveted the directorship and was not too particular as far as means to that end were concerned. The big stick held by the Head of State, Dictator Antonio Lopez de Santa-Anna, meant much at the time. Cordero painted the Mexican general straddling impassively a fiery stallion, and his good wife, Señora Dolores Tosta de Santa-Anna, to match in her resplendent Sunday best, strewn with loops of pearls threaded among bouquets of laurel leaves, in allusion to beauty wedded to glory. Long suede gloves and retroussis of gold brocade round up her regal ensemble.

Those easel pictures announce already Cordero's mural style. Of a blunt mastery that matches that of a sign painter, of a gross taste that harmonizes with that of the gown displayed by the First Lady, the pictures propose a Mexican aesthetic poles apart from the Spanish one of Clavé. The latter's manner was called "papillonée" by contemporaries, a term meant to suggest swarms of butterflies in flight.

Santa-Anna's sturdy taste was one with that of his lady

and that of his painter as well. He commanded that Clavé be dismissed at once and that Cordero be seated in his place. Conscious of the ancient privileges of their institution, the trustees of the Academy refused to comply, a political *beau-geste*, but a blunder with regard to the future of Mexican art.

Cordero never did reach the directorship. Defeated in his bureaucratic ambitions as far as the world was aware, he turned perforce to mural painting to assert his supremacy. One of his first mural tasks was to decorate the Church of Jesus-Maria with a lunette in oil representing *The Child Jesus among the Doctors*. Once keyed to mural scale, he switched to the more exclusively mural medium of tempera that suited admirably the theatrical brilliancy assayed already in the Santa-Anna portraits. The Church of Santa Teresa had been rebuilt in 1845 after a disastrous earthquake and Cordero, then only twenty-one and still in Italy, had been commissioned to replace with his own the destroyed murals of Ximeno. The job he tackled so successfully ten years later must have been based on earlier sketches.

Santa Teresa is a masterpiece of tempera decoration. Raised on a ring of stones deeply honeycombed after the pattern of the Roman Pantheon, the painted dome acquires in illusion more robustness and weight than its huge frame. From its zenith, against the giant omelette of an egg-yellow dawn, God the Father swoops down, swaddled in Mars violet drapes, His Hand ready to bless, and equally ready to cushion the unavoidable fall that his bulk suggests. Seated around the ledge of the circumference, Cardinal and Theological Virtues are giantesses

transformed by the ceiling perspective and the epic strength of the brush into heaps of granite-hard draperies. Unflagging chromas and punch-dizzy contrasts make even an eye keyed to Matisse and Picasso wince. The pin-headed colossi cradle in their fleshy arms holy attributes, an anchor, a cross, a palm, accessories carpentered for just such a celestial opera.

Harsh to accept in our day, impossible for its period, this dome eternizes a unique moment of exaltation, when the young man defeated at politics felt himself more than a king alone on his high scaffold. Such a moment could not last. As soon as the dome was shown, jubilant foes and worried friends alike told the artist still at work that he should stop impersonating a color-mad Michelangelo.

The scaffold was lowered to proceed with the job of painting the pendentives, where the four Evangelists are cautiously brushed, though painted volumes still hold their own along clouds gessoed in relief. On the side walls triangular panels represent History, Poetry, Science, and Astronomy. Their scale is small, the mood pacified, the style Raphaelesque enough to sooth souls milder than that of Cordero. The artist had already sobered from his jag of genius.

Tempera is a heroic medium inasmuch as values and colors change in drying, as in fresco. Clavé's minions, eager to demolish his rival, seized on the fact that it lacked the polished appearance of oil, and on the strength of style and medium convicted the decor of coarseness. This

Church of Santa Teresa after the Earthquake.
Lithograph, 1845

91

loaded critical estimate found favor with a public whose adverse opinion cowed Cordero into accepting three thousand pesos less than the contracted price.

His urge to paint walls, his hope to defeat criticism, were such that Cordero started to decorate another church, that of San Fernando, though this time he was offered no pay whatsoever.

The dome of San Fernando is an attempted *mea culpa* for Santa Teresa; but not with as disarming a result as the artist had hoped for. The Immaculate Conception, oyster gray in a dark blue mantle, ascends a heaven changing from golden ochre to a kind of blueing-blue, passing by a shade of flesh. A ring-around-rosy of rose cherubs rings the shaft of the lantern, sporting green, red, and purple panties. Adolescent angelic musicians fill the dome, twanging harps, blowing trumpets, tickling cellos. Others raise banners and display mottoes. Their tunics are either painted all of a piece out of a single pot of paint, or have theatrical sheens: a leaf green warms up to salmon pink, a magenta turns baby blue.

The artist's resolve to reform bred a swarm of cottonwad clouds, but a temperamental bluntness still jars this atmospheric peace; among well-behaved drapes one vermilion scarf sticks a feeler of cast iron; if the jolly angels changed mood and threw harps and cellos at the faithful below, one would witness the crash of a hardware stock. Such strident notes in an otherwise chastised ensemble are what still endears the work to us today.

The attempted compromise bore fruits. *El Diario de Avisos* of July 13, 1860, records the sayings of onlookers.

"I find in it I know not what that is surprising and celestial."

"It seems to me that courage is needed to solve problems in this style for no place is left to doubt what one meant to express . . . This method must be connected with a type of nerve and energy that is both incisive and aggressive." The only dissenter is an old gentleman who shivers when he learns that the work is a true mural in tempera, "What will the foreigners say if they happen to note that it is not an oil" We heard similar arguments in the nineteen-twenties as our own murals were taking shape.

Cordero's accomplishments and near success proved too much for Director Clavé who had counted up to then on his priority rights as the best argument of supremacy. He rolled up his pedagogical sleeves and, with a phalanx of art students, started in 1861 to decorate in oil the dome of the Church of La Profesa.

His scheme divided the semi-sphere into seven segments, allotting each to one of the seven Sacraments. Soon after it was begun, the reform laws of Juarez disbanded monastic congregations, federal troops invaded the premises, and the work stopped. It was resumed under Maximilian and finished in the besieged capital of the tottering empire while Juarez-aimed bullets whizzed by the uprights of the scaffold. The dome was uncovered in 1867 to a distracted Republic. It was the turn of the critics friendly to Cordero to belittle the work: it destroys the unity of the architecture, lacks the autography of a master's hand, recurs to the medium of oil as being easier than tempera.

Time sided with Cordero. His Santa Teresa is intact.

The unflagging enthusiasm of the artist seems to have acted as the perfect chemical binder. It is hard to appraise Clavé's work today, seared as it is by the heat of a fire that wrecked the church in 1914. The oil film has so scaled off the walls that it is difficult to unravel what was once a classical drape from what is now an efflorescence of saltpeter.

Having fulfilled all the years of his successive contracts as director of the Art Academy, Clavé returned to Spain and Cordero put in the last brush stroke, to end their artistic battle, with his *Triumph of Science and Study over Ignorance and Sloth*, that led to his being crowned with laurels, the moral winner in this long drawn-out contest.

Such big mural jobs executed for little or for nothing do not explain how the artist lived. His business was portraits. Here again Clavé was his rival, having a practical monopoly of sitters in the capital. Still a peddler in his maturity, Cordero left seasonally for Yucatan, a state too remote to come under the commercial jurisdiction of Clavé. He came back with reams of photographs of would-be sitters to be returned the following season as portraits in oil. A biographer remarks ruefully that Cordero's procedure was semi-industrial; he painted *à la prima* and without further benefit of model one portrait per day.

As muralist, Cordero bridged the gap in time between colonial and modern and helped keep nineteenth-century Mexico mural-conscious. Significant of Cordero's role is what the art critic Lopez-Lopez, the artist's friend since childhood, wrote in 1874, "recommending to the good

taste and culture of the administration the convenient beautification of public buildings with mural paintings . . . The schools of medicine, law, mining, agriculture and commerce . . . the palaces of the government, palace of justice, city halls and others that house the administrative sovereignty, all need distinctive marks and wait for the brush and chisel of Mexican artists, dedicated to the study of the fine arts that such places be spared the trite appearance of private dwellings."

Today the prophecy has been fulfilled. Lopez–Lopez' future is our present.

Written in conjunction with a retrospective show of Cordero's painting held in 1946 at Palacio de Belles Artes, Mexico City. Two lectures were given during the course of the show, one by Diego Rivera, and the other by the author.

FOLK

Charlot: Luciana, 1924

Mexico of
the Poor, 1922

I had staged in my head a sham Mexico, fanned with feathers of blue, green and red, its trees feverish with tropical mimics. I somehow felt cheated after landing, in spite of the guided tours, the marble bulk of the National Theatre, the powdered maidens dressed in organdy, the gentlemen sunk within stiff collars. One of the latter, as wealthy as he was senile, said: "No equality is possible here; decent people and wild men." I was soon to find the truth of his assertion.

At six o'clock in the morning, I was in the streets. Automobiles and ladies were still asleep, and the true features of the town emerged, washed of this phony coat of paint which disfigures it in the daylight. Beautiful beings people the street like Ladies of Guadalupe innumerable. They move noiselessly, feet flat to the ground, antique beauty come to life. The wealthier quarters are as empty and soiled as a music hall at noon, but everywhere else, among those low-lying houses, cubic and freshly daubed, processions are staged. At a first glance the crowd is the color of dust. Flesh and cloth, both worn out with use, melt into this grey which is the very livery

of humbleness. Eye and mind soon learn to focus, and this race, its confidence won, attests its beauty through its fabrics, its straw, its flesh.

A shy taste has chosen for blouses and skirts designs not of contrasts but of neighbors: grey on grey, black on beige, pinks and wine reds. The rebozos are of all shades, so subtle that an impertinent eye cannot distinguish between them: blacks and greys, tans, blues, from the nocturnal blue to the tenderest water color wash, pigeon-breast, with fringes that master the theme with coarser contrast.

As a broken wing, so is an empty rebozo. It lacks the fluttering, the living folds that the enclosed head makes, even when unseen. From the back, twin braids often appear with a purple wool braided in, and the arc of the shoulders melts into one body and cloth. Front view, the oval or the sphere of a face, its ochre pigment an equivalent of the cloth, deepens by contrast to the white of teeth and eyes. There are many ways of wearing a rebozo, all noble. It will only yield the most essential folds, functional resultants of the body in action, as do not those imported stuffs that frizzle on one, poodle-like. The maidens of the Parthenon would accept as sister any one of those shoeless Indians. Same gait, same gesture, the print of the naked feet on the earth is antique, the sole clinging horizontally to the ground, tactile as a hand, and the trotting step of the peasant women, foreheads slit by their burden, inclines

Charlot: Street Vendor. Woodcut, 1923

Jean Charlot
23

their torso diagonally like those ancient Victories bestowing crowns. Or, the belly armoured in a robust sash, the shirt stretched by the young breast, there is an Egyptian narrowness of the hips, with the arms hanging at ease, unconcerned with the weight on their shoulders of a bundled baby asleep. The patting of the dough by "tortilleras" re-echoes in the hypogeas of the Nile. Wrists and ankles are small as those of a child.

Blessed be the cold spells when the man wraps himself into his sarape—a peplum! He would be a tribune on a pedestal, if the hand-woven cloth did not seem even more perennial than marble togas, and heavier. The colors of the sarape vary but could be summed up with a white, a beige and a black; most beautiful are those plain ones whose shade and texture imitate the scarce fur of over-burdened donkeys, some white threads mottling the grey as the hair grows on the scar of a wound. The sarape needs a body. When hung on a wall, tourist fashion, its slit yawns like a neck beheaded. As in Brittany, when the young widow draws from the chest a sweater still bulging from the pressure of dead shoulders. Those sarapes that the tourist treasures are loud with parroty designs to warm his barbarian heart, but the weaver will not wear them, and the wool soaks into such dyes gingerly.

The head closes the sarape, the hat crowns the head. Of many straws, from those thick as slim bulrushes, whose open basketry rains sun spots on the shoulders, to those

Charlot: Stroller with Sarape. Woodcut, 1923

which, ribbon-flat and green, still keep a suppleness of living leaf. Of all shapes: circular as haloes gathering the light as does the underbrush, light as wings to which the rhythm of the march communicates flight, some thick and embossed, reminiscent of breasts and of Babels, the hieratic ones like the tiaras of disused rites, the earthly ones whose handiwork of embroidered leather spells the prosperous cattleman. All, geometrically beautiful, isolate the head from the landscape, its psychological worth intensified within this vacuum.

This race has the wisdom of the philosophers who walked with naked feet in a stream while abstracting ideals. Its toys have the twist of Aesop's fables, its bodies the patina of those antique athletes of whom Lucian states that they are like sun-baked bricks. When the servants troop out of the earlier Mass, the repetitious beauty of their naked feet, the ample petticoats, the draped scarves, duplicate the rhythm of the Panatheneas. Greek vases parade into life. Here the women bringing water from the well, there the wrestlers of Euphronios, and at all street corners or in the shade of a statue, beggars and burden-bearers squat and loiter at ease, gorged guests of an invisible banquet.

Rebozo, sarape, flesh and hair partake of those shades which are the palette of Nature: yellows, reds and greys of earth colors, the blue-greys, the grey-blues, and as a climax those changing colors of the pigeon's throat. I

Charlot: Pilgrims. Woodcut, 1923

arrived with good chemical colors bought in France, ready to match monkeys and palms, as an explorer carries gaudy calicoes to do barter. How could they stand for these, the very colors of water, earth, wood and straw. Even my up-to-date theories of art must go over-board, as I face the features of this land truly secretive and classical, whose perennial mission seems to be the apotheosis of the poor and the scandal of the impertinent.

Charlot: Chicken Vendor. Woodcut, 1923

Originally written in French in 1922, this article contains some of my first impressions of Mexico. A Spanish translation was made by Diego Rivera. A slightly different English version was first published in *Mexican Life*, March 1926.

Aesthetics
of Indian Dances

The quality of the preserved relics of pre-Spanish civilizations—sculpture and architecture—suggests a similar beauty for the more ephemeral manifestations of their art: painting, music, the dance. Even after a few centuries of forced contact with European culture, we can still watch some mutilated reflections of what they were.

Our own "civilized" dance proceeds as a pantomime of sexual gymnastics. The Indian dance is the fruit of a taste based on a comparison of proportions, a quasi-mathematical precision that has very little to do with what we consider pretty.

The dance, at once an optical and a musical spectacle, participates of both arts. As in painting, its essence is in simultaneous relations of shapes and colors independent of the time factor. As in music, it proceeds by successive steps bound to a time element. In the Indian dance, the permanent elements constitute a kind of stage upon which the fugitive ones parade. The ephemeral and brittle essence of motion is emphasized by the use of wooden

Charlot: Dance of the Pastoras, Chalma. Lithograph, 1925

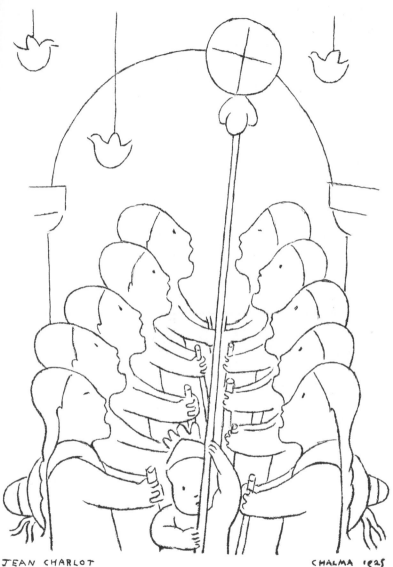

JEAN CHARLOT CHALMA 1925

masks and rigid armor-like costumes. A new kind of beauty is born out of this relation of contrasting neighbors.

The mood of the dance varies from the grossest slapstick comedy to the highest and most rarefied religious emotion. Its only hiatus is that it never treats the sexual theme, even indirectly, as if by common consent such a doubtful job had been delegated to the whites. The Indian possesses an instinct of style which, omitting the realistic mimicry inherent to a given emotion, transposes its essence upon a higher plane where it is digested and reborn into a series of plastic proportions. The white man, impotent to choose between a number of photographic attitudes that fit a theme, ends by omitting none. This results in a hodge-podge of bodily movements that tire physically both dancer and public, a sweating sport that precludes a more spiritual fruit. The Indian takes an agglomerate of movements, sums them in a composite so meaningful that the single gesture constitutes a whole dance. In the ballet of the Magi, in Michoacan, only one of the three kings does perform, only three slow steps does he take, yet they conjure the mystery of this legendary cortege and the prophetic belief that started it on its way. In Chalma, the vivacious tempo of the "Gachupines" (dance of the Spaniards), so unrelated to the squat, slow moving Indian body, is a plastic illustration of the mediocrity of certain white men who talk too much, act too much, believe too much in themselves, lack a central core of faith.

Other dances are reminiscent of mystery plays, include a libretto and complex stage directions. A pre-Spanish type

still in use is the hunting dance of the Yaqui. The dancer-prey mimics the despair of the animal at bay with a nervous pendulum movement of its antlered head, while the dancer-hunter fires a rasping noise by rubbing two notched sticks, a more telling menace than would be the actual popping of a blunderbuss.

Discreet mathematics rule pathetic moments. In mock battles, whose fury seems true enough to the eye, a clash of sabers rhymes with the musical phrase. In a dance of Santiagos, the Arab chieftain, alone fighting six Christians, falters into a spiral of steps that recedes to a center where, the geometric figure completed, he falls dead. The Indian will express emotion rather through numbers and figures, for he has a born repugnance to using the tool par excellence of the white actor, his features. A painter of classical antiquity was lauded for having veiled the face of a figure in a tragic moment for, remarks the Greek text, "it would not be possible to represent directly such situations without indecency." Thus, when the Arab chief enters in agony, far from contorting eyes and mouth, he covers his face with a kerchief and it is only the slowing-down pace, this melancholy of the spiral shrinking its ray, that testify to the drama at hand.

What makes the strength of such pantomimes is that they do not mistrust the natural gesture. They stylize it, amplify it so as to further its optical range, never debase it into gesticulation. Because of this conformation to truth, such dances may utilize one of the most moving but also most brittle of means, the innocence of children. Childish *quadrillas*, *pastoras*, *malinches*, keep intact those

deep infantile qualities from which the most able of our ballet masters could extract only cuteness. Those children-dancers do not ape grown-ups as do our juvenile actors; the gesture starts and ends with little accent and much hesitancy, a plastic cipher for those sheltered souls whose contact with the world is still amateurish.

Unlike our professionals, riveted to the level of a stage and its inverted lighting, the Indian dances inside churches by candle light, in the sunlight of outer plazas or amidst mountain scenery. He uses a variety of levels, mingles in the street with his public, is raised a few feet by improvised scaffoldings, perches in this hut on stilts, throne of the Tepozteco, flies to stratospheric peaks with the gymnasts of the Volador.

Our dance clothes the dancer to emphasize the human appearance. A woman, for example, gambols wrapped in veils which underline her femininity and exasperate the mechanics of desire. The Indian costume and mask have a contrary aim: they remove the dancer from bed level, place him in an abstract atmosphere suggestive of the entity which he symbolizes, even if to gain this end the man has to be annihilated, transformed into a kind of animated glyph. The face remains impassive, be it the features of flesh or a carved mask. With its dovetailing plates stiff and squared, its unnatural proportions, the clothing attains more vitality than the body buried in it, lives its own life. The dancer is no more than a cog in this complicated mechanism of the dance.

The ingenuity of the Indian in his handling of the human dummy is diverse. Not only will the face be

hidden behind a mask, but it loses its place as the apex of the human pyramid, is humbled under those elevated coiffures whose parasol of mirrors, tin and feathers suggest the palm tree as our high hats reminisce of the chimney. Toe-dancing elongates the leg, knee-dancing amputates it; the hugeness of belts and bracelets increases the hips, or destroys the symmetry of limbs. The masks are not the psychological masterpieces of the Japanese No; they abuse the head ruthlessly, shrink it smaller than nature as do the masks of the Yaqui, make it larger, or double-faced, armed with huge horns which give the dancer the barbaric aspect of a standing bull. To the Indian mind horror is also a form of beauty, which makes them partial to the carved semblance of white men. Pink cheeks, blue spectacles, red beards trimmed Spanish fashion produce on their brown public impressions of laughter and terror similar to those indulged in by our children when they see masks of black or green devils.

Modernism has reopened for us abstract sources of beauty, cleansed our aesthetic sense of a too pervading sexual content, made us prefer to dramatic mimicry gesture as conjurer of geometry. We own anew the keys to the aesthetic of Indian dances. Alvarado, to have massacred the participants of the Flower Dance in the Great Temple, must have been a soldier impervious to artistry, or the incensed addict of racy and photographic art.

This article first appeared in slightly different form in *Mexican Folk Ways,* September 1925.

The Indian Way

I

These cuts are details from a catechism in hieroglyphs of the sixteenth century, from the Von Humbolt collection. They illustrate articles of Faith:

1. Our Lord dies to save sinners.
2. He goes into Hell and delivers the souls of the Patriarchs.

The strength of pre-Hispanic art animates those scenes, in spite of the imported theme; which points to the casual role of typical subject matter in the creation of a national art. The keenness of proportion and ease in abstraction here shown still live in contemporary so-called popular arts.

——————

Anonymous: Pictographs for a Catechism, sixteenth century

Anonymous: Veronica's Veil. Engraving

II

In Oaxaca, one may buy for a few cents a child's game
played upon a paper checker-board emblazoned with
hand-painted designs: hearts, pineapples, suns, cacti,
umbrellas, skulls, roses, scorpions, straw hats.

One of them is the puzzling motif here reproduced,
which may be identified with Veronica's kerchief, a
devotion widely observed in this region. It is enlightening

Indian interpretation of Veronica's Veil

to follow the stylistic process by which the Face of Christ
becomes one with the napkin. The features are drained of
sentimentality, the folds of the linen become serpentines,
the rosettes at the top pennaches. We surprise here in its
creative motion the Indian's genius for plastic abstraction.
He willingly accepts our ways, if allowed to make his
own interpolations.

This article was originally published in Spanish in *Forma,* No. 2,
1926, and No. 4, 1927.

Pulqueria *Painting*

I know some cultured Mexicans who cruised to Egypt to see the Pyramids, but never took the bus to their own pyramids of Teotihuacan. Touring through Italy they go to Pompeii and rightly admire the murals which adorned the shops of bakers and wine merchants of the first century A.D. How supremely refined this Roman civilization to leave such remains, to create works of art out of commercial posters and graffiti scratched by drunken soldiers. The tourists sigh, thinking such an era well dead, such art a prize for museums only.

Little do they realize that their own country, this Mexico of today, has more than one trait parallel with the Roman resort. Much as in Pompeii, bad taste piles up dubious furniture, exasperating objets d'art in the palaces of the wealthy, while good taste goes into the ornamenting of the small shops, bakeries, wine shops of the poorer quarters. The rich thrive on alabaster statuettes, Louis XV pianos and telephones in the style of Louis XVI. Poor people, who can afford only what they make, enjoy

Charlot: The Potter Panduro at Work. Sketched in San
Pedro Tlaquepaque, 1923

creations of a sturdier health. The theory of art for art has not touched them. Pictures must have a definite reason to be: devotees bribe saints with ex-votos, lovers melt the heart of the beloved with a portrait, artisans, merchants, hire the painter to beautify their shop with murals and thus increase the business. Sculpture also exists for specialized aims: dark ones, idols of secret worship, semblances used for black magic; innocent ones: those marvelous toys worth a few cents, beautiful as Han tomb figures. This production is so varied as to be unclassifiable, so cheap as to be despised, so near us, so thrust under our very eyes, as to become invisible. Yet, when those who create such objects are dead, when the wear and tear of constant use has made them rare, those items will rest in show cases as do today the similar humble objects of Etruscan or Chaldean sources.

When "cultured" people paint or sculpt, their very lack of specific purpose is lauded by those who approve of mandarin nails which make the hand unfit to toil. But for the man in the street, those canvases and bronzes should be an example of what not to do, similar to the slave that the Roman master would make drunk to show his sons the repulsiveness of vice. Art for art is a bad enough slogan, but it is a front for even baser things, this love of money which concocts best sellers, this smugness of the man curled up within his originality, this pride of having learned so many incompatible things that we have lost faith in each.

We would like to believe that what walls we have painted, what pictures we have frescoed, constitute

what newspapers have dubbed a Mexican Renaissance, yet there is this disturbing fact that through the centuries, in unbroken and magnificent routine, popular artists have carried on a Mexican tradition which has been and is in the best of health. Such artists do not pride themselves on their doings, could not give interviews, yet Mexican art is alive enough to mar somewhat our assertion that in our works it is reborn.

The true show of art is in the streets, ennobled by the murals on the walls of grog-shops. Their themes are varied as are the very names of those *pulquerias*. What ingeniousness must a painter have to illustrate "The Memory of the Future," or "The Wise-men without Study." The muralist does original work if such be the wish of his patron, but unlike his cultured colleague, he is original in all humility. When his fancy turns to doing an extra good job, he copies some foreign work, Swiss landscapes, post cards of the World War or German chromos. Though partial to Aryan women of pink skin and flaxen hair, his work remains more Mexican than those brown Indians that I insist on painting.

In those works, descriptive subject matter exists side by side with abstractions; walls bulge or sink, peopled by make-believe solids and multi-color planes. A flat surface is camouflaged into receding niches or buttressed with illusive columns. This solution in depth of the decorative problem would annoy Puvis de Chavannes, whose painted walls make an effort to look as flat as if they were already whitewashed.

Such wine shops, butcher shops or bakeries with

façades and interiors excitingly frescoed are a practical answer to queries as to the whys of art. A writer proved the use of poetry by declaiming to his cook; moved by the verses, the coldhearted woman had to yield. In the same way does the picture invite its public. More patrons will get drunk in a wine shop well adorned, thus proving the reality of art. Nor is it by pleasant subject matter that the charm is woven, but by line and color. The story itself remains incidental, may even be of a disquieting nature, as in a butcher shop of la Piedad, on whose walls cows and pigs busy themselves with quartering, cooking and eating the customers of the establishment.

It is too bad that people of good taste will not take notice of the art show in the streets. More than museums and art galleries, the streets of Mexico are an index to its culture.

This article was originally published in Spanish in *Forma,* No. 1, October 1926.

Mexican Ex-Votos

Pre-Hispanic and colonial traditions meet and fuse on contemporary terms in Mexican folk painting. This humble overlapping, neither Spanish nor Indian, is an important source of Mexico's modern plastic language.

What usually passes for folk art is readily accessible on curio counters and in the open-air shops of Mexico City. Vivid colors, amusing shapes, and attractive prices alike appeal to the traveler, who returns to his hotel hugging a painted pig.

Only the tainted fringe of the folk arts, however, reaches the tourist market. The creators of true folk art are the people, who are its consumers as well. The quality of the popular arts as a pastime and a product of leisure is scarcely endorsed by the native artist; a quota of art means the anguish of creation for its maker in Mexico as it does the world over.

The purpose of folk art may be as serious as the making of it. Amusing by our standards, in the eye of the initiate a rag doll or clay puppet may be an awesome instrument of witchcraft. A Posada print, which a museum curator appreciates gingerly, has sharpened *machetes* and cocked

pistols for action. Comical in our estimate, a *retablo* may be intended by its creator to be the Jacob's ladder that will narrow the gap between the devout and God.

The output of folk artists is so varied as to be unclassifiable, so cheap as to be despised, so thrust under everyone's eyes as to become invisible. The aesthetic instinct is perhaps the prime motive for the Mexican who has but a weak economic instinct, and it excludes any thought of art as a luxury because, for him, it is in truth a necessity. Art as the Mexican understands it pervades all activities of daily life: lovers melt the hearts of their beloved with self-portraits, bartenders hire muralists to beautify their premises and thus increase business, devotees bribe saints with ex-votos. Indeed, the Mexican need not have contact with an object of luxury to experience aesthetic delight. Much folk art that may not pass the test of dealer or museum nevertheless generates delight.

Anonymity veils the origin of much folk art and allows the sophisticate to make much of the product and little of the producer. But folk artists are not a whit more alike, nor less complex, than their fine arts colleagues. I will tell of three among those I knew in Mexico, whose only common denominator was art—a *pulqueria* painter, a potter, and a *sarape* weaver.

In the 1920s, Siqueiros and I were journeying together through Puebla. We admired the freshly painted sign of an inn, and, after asking for the address of the artist, went to pay him our respects. We found ourselves in a quiet, clean, cubical house and were received by a modest, ascetic, nut-brown Indian shuffling silently in *huaraches*. Siqueiros

showed him a photograph of Masaccio's *St. Peter Curing the Sick*, without which he rarely stepped out at that time, and commissioned a free rendering of the masterpiece.

The painter gave the photograph an appreciative look and his face lighted, "You want a *capricho*," a caprice, his trade name for a picture free of the functional slant, architectural and commercial, which is the tavern-sign painter's usual lot. We left an advance and our treasured Alinari print with this muralist to the people, but neither Siqueiros nor I ever had occasion to return to fetch the panel that was ours, on which Italy and Mexico perhaps mingled more successfully than they do on the government walls we frescoed.

In Tonala, a group of us visited Amado Galvan, the master potter and decorator, humble, quiet, polite, but with the impatience of the inspired artist who wishes to be left alone with his work and his vision. He let Edward Weston photograph his clay-incrusted hand spanking a spherical pot, newborn out of slimy clay, and allowed Rivera to sketch him squatting and painting his own brand of Indian designs on a jar, all five fingers tightly wrapped around the brush held vertically, Chinese-like—but also Aztec-like as depicted in the codices.

Leon Venado, a *sarape* maker from Texcoco, came to the city to take advantage of the tourist market, rigged his primitive loom in the rented entrance of an apartment house, and started weaving. Soon he was friendly with the painters—swapped drawings, would sit evenings edgewise on a bed with his guitar on his knees and improvise *corridos* keyed to melancholy. Done in severe Indian taste,

his *sarapes* displayed a splendid range of grays sharpened by a ground of velvet black shot with the lightnings of thin white streaks. To Northern customers insisting on more "Mexican" color schemes, he allowed only a minimum quota of imported aniline dyes. Soon he returned to his village and the civilization he understood and vented his nostalgia by painting watercolors with picturesque subject matter as did his city friends, but in reverse perspective. I have a picture of his which shows a German botanist resting in the high grass after an exhausting pursuit of cacti: green sunglasses, green tweeds, green felt hat, and green tin box, emblems of his pursuit, are set off by a red beard and a red tie. Perhaps innocently, the artist mistook a knotted alpenstock for a monkey tail, poised and ready to curl around a tree.

The group of modern muralists gave only diffident admiration to the svelt intricacies of Galvan's arabesques and to Venado's abstract weaves. Bent on their own narrow pursuits, they felt closest to the social vindictiveness of the penny broadsides and the spiritual intensity of church ex-votos.

Retablos are painted thank offerings dedicated by the grateful recipient of a miraculous favor to the image of his devotion. As a rule, they are small oils on tin or temperas painted on cardboard and are piled high against the walls of the sanctuary around the venerated image, together with other testimonials of thanksgiving, such as crutches, daguerreotypes, trusses, and those silver cutouts that represent the miraculously cured bodily part—arm, ear, heart, eye, shank or spleen.

Retablos have run their uninterrupted course since the days of the Conquest. A sculptured one, still in place at the entrance of the church of San Hippolito in Mexico City, shows the victorious Archangel Michael hovering over loot made up of Indian weapons, swords of tempered hard wood, obsidian axes, slings, nets, bows and arrows, and the war drum, the *tonalamatl*, whose nocturnal beat gave many a restless night to Cortez.

The *retablo* was common in colonial times, in a near theocracy, and became even more vital as the War of Independence and succeeding wars and uprisings multiplied those close escapes from death that called for painted thanks. Despite the Marxist origin of the revolution of 1910–20, the *retablo* reached its spiritual culmination during this period. Dr. Atl, free-thinker, landscape painter and revolutionary leader, wrote as a disenchanted witness of the spread of the devotional retablo: "The revolutionist who fought church and clergy, by suggestion or because he did not know what he fought, remained deeply religious and deeply Catholic. After looting a church, he carried the little pictures to his barracks or his home, lighted a candle before them, offered a triduum, begged from them protection for his family."

Like the scaffold-sets of medieval mystery plays, the plastic dramas of the *retablos* are tiered vertically. Man is a kind of deep-air animal crawling on rock bottom, his face lifted to a stratosphere where the holy beings dwell. These in turn bend over the ledge of the dense pool, in search of their faithful. The pictures record cases where supplication produced recognition at moments when, to

the handicap of being human, was added an extra burden of accident or crime.

Sanguine, booted and spurred, man is crushed under an upturned horse; yellow, naked and in bed, man dies; bronzed and mustachioed, man faces a shooting squad; thrown from a window, crushed between the flanges of a water wheel, stripped by bandits in the country, jailed by judges in the city, drafted at dawn for war, knifed by drunks in the dark, man claims redress to God.

Bountiful God answers man's plea under so many disguises as to emulate single-handed the crowds of godlings that jam Aztec cosmogony. At times He is the blond Child of Atocha, in a Fauntleroy suit, velvet hat with white plumes, a beribboned shepherd's crook for a wand. Or an Ecce Homo, roped like a steer, flagellated, crowned with thorns, hair matted with sweat and beard with blood. Or the Señor of the Poison, crucified, coal-black, loins clothed in purple velvet spangled with gold sequins. Or a Lamb. Or a kerchief.

Mary too answers each and every call as she is bid: as a small pink doll nestling in a maguey, stiff in pyramidal brocades heavy with dangling silver ex-votos. Or in widow's weeds, crushing a damp handkerchief to her teeth, with seven poniards in her heart. Or wrapped in a blue starry mantle, her beige skin dark against the faded pink of her robe, with the moon underfoot.

Each *retablo* is a receipted bill for spiritual good or physical boons received, though some record less obvious

Posada: Apparition of Our Lady in the Heart of a Maguey.
Metal engraving

gifts. One shows a bare room and a bed, and in it a dead crone, green and very stiff. Its dedication reads: "Mrs. . . . having left her village and come to town, wished to die. Her family offers this picture to give heartfelt thanks in her name that her wish was happily granted."

Before the contemporary Mexican renaissance, critics found *retablos* laughable. In an article published in 1922, in the magazine *Azulejos*, Diego Rivera was the first to speak respectfully of those little pictures. "The anguish of our people caused this strange flowering of painted ex-votos to rise slowly up against the walls of their churches. . . . Unexpected comparisons come to mind: trecento masters and those of the dawn of the quattrocento, Henri Rousseau the *douanier*, and in certain ways the Orient and the frescoes of Chichen-Itza. . . . There is infused knowledge for the asking if one is endowed with purity, faith in the reality of the marvelous, love and selflessness. . . ."

The interest of the muralists in folk painting was shown in other forms than words. The personages of the *retablos*, and even the terrestrial portion of their subject matter, reappear in many a mural painting intended, as were the smaller pictures, to underline the wants of the people. But more important than the borrowing of an anecdote was the absorption of the mood and style. The subject matter of folk painting is the folk, and this was also the subject of our socially conscious murals. Our respect for folk art corrected the penchant that painters often indulge—to look at the people from the outside and, moved by both propaganda and pity, to place them with the best of intentions amidst garbage cans or their Mexican equiva-

lent. The folk and their artists have a better opinion of themselves. In the bare interiors represented in the *retablos*, the floor of beaten earth has been transformed into the luxurious red of brickwork. At the tip of the brush, necklaces and ear pendants are conjured up that, if they exist at all, are seldom redeemed from the pawnshop. The pallet one sleeps on, hugging the earth, has become a raised bed, often adorned with a canopy and curtains of colonial flavor that give away the dream substance of this piece of furniture. All men wear immaculate white, or brand new overalls; all women layers of petticoats, a throwback to the eighteenth century. Rags are strictly reserved for the villain—he who drains the bottle, paws the maiden, or wipes the bloody knife.

Even in more general terms, folk painting taught us much in matters of mental discipline. Respectful of Paris, we were reluctant in the 1920s to defy its reigning artistic idols, originality, and personality, and even less eager to commit the then cardinal sin of telling stories in pictures. Folk painting epitomized a virtue never mentioned by the French critics, that of humility. The strength of folk painting came of the racial, rather than personal, characteristics that the folk artists were quite content to echo. Their popular achievement, based on anonymity and communal feeling, taught us that in art as elsewhere man may lose himself to find himself.

This article first appeared in *Magazine of Art,* April 1949. Reprinted by permission of The American Federation of Arts.

GRAPHICS

Portrait of Latin America

Latin America encompasses such a variety of lands, climates, men and tongues that one would need to rise to stratospheric heights to survey it as a unit. And unity would only come with blurred vision, with all details leveled to foggy oneness. As varied as the land itself are the graphic arts of Latin America, and here also an attempt at inclusiveness is bound to fail. Because I write from Mexico, I will instead speak of the qualities in this land which echo those of its neighbors, try to uncover what common denominator, if any, permits the handling of the graphic arts of the twenty-one republics as "Latin American prints."

In Latin America as in the world over, beautiful prints have been made with an eye to aesthetic values alone, that hold their own on exhibition walls without clue to a special birthplace. One can appreciate these prints with ready-made universal standards, and there is no need here to expatiate on their obvious beauty.

Other prints, rather than being a frosting on the cultural

Charlot: Line drawing after The Man of Sorrows. Nineteenth-century original in The Metropolitan Museum of Art

cake, are so strongly rooted in Latin American soil that, to appreciate them, one must be aware of the milieu from which they spring, often quite divergent from the twentieth-century norm. I would rather speak of these, of what may not be readily learned by the northern neighbor, keeping silent as regards the aims, arts and culture shared equally by both Americas.

Despite affinities, basic differences mark two distinct concepts of art, north and south of the Rio Grande. The United States started its art career as a buyer, and art definitions and evaluations are even now colored by the peculiar problems of an art market. Latin America, only an indifferent buyer, has always been a lusty producer, and its concept of art, being the point of view of the maker, differs from that of the northern neighbor.

To give an obvious illustration, the murals of Latin American modern masters, though steadily labeled great art, cannot find their way into the United States art market, but remain worthless because of their bulk and their anchorage to an architecture. Nor can the genuine lighter output of the same men, geometric compositions for odd-shaped walls, broad, hasty charcoal studies of details from the model, three-dimensional maquettes of vaulted ceilings and domes, fit the Procrustean bed of museum requirements.

As regards graphic art, similar basic differences also breed awkwardness. In the United States print collectors are usually men of wealth, who hoard their treasures in portfolios that open only on rare occasions, and keep a sharp watch on what other collectors buy. They are

happier when their own prove exclusive, or nearly exclusive. To the collector, the rarest print will have a tendency to be also the most beautiful, being certainly the most desirable. A top example of this trend was a piece included in a New York print show, a drawing on paper with this proud caption, "Crayon portrait prepared for lithographic transfer, but *never* transferred." This may have been the rarest print in the world, rarer even than Goya's *Giant*, rarer than unique proofs, for here was a print with *no* proof.

Less learned in the wiles of *incunabula*, less interested in what others have or have not, sometimes even less skilled in the three childish Rs, the Latin American print-lover knows that graphic arts are the arts of reproduction, of the multiplication of an image, and cutting through the Gordian knot of sophistication, would affirm bluntly that "the rarest print in the world" is no print at all.

The North American collector dotes on etchings and drypoints. Let us not deny that some are magnificent, but it is on these mediums that the parasitic fungi of trial proofs, states, margins, *avant-la-lettre's*, etc., grow thicker. When Rembrandt's son tried to peddle his father's abilities as an illustrator to a publisher, this level-headed merchant answered that he had no use for them, as Rembrandt was only an etcher; and the son, eager for a sale, answered that this was a slander, that Rembrandt was indeed an engraver. This episode, which means less than it seems to as regards publishers' aesthetics, preserves for us an ancient and sound hierarchy of mediums in the ratio of plate fitness to stand a trade edition. What interests us in

this anecdote today is that collectors have reversed the scale, and that its very unfitness for the job puts etching at the top, *because* the plate tires easily.

For that very reason, etching is not a favorite medium with Latin Americans, who prefer blockprint and lithograph. The former will stand a pull of thousands of proofs before being smashed into illegibility. The latter, contrariwise from etching, gets better and better as more proofs are made. The professional printer knows that it takes some five hundred pulls to bring a design on stone or zinc to a state of clean perfection.

Where plate presses are still in current use, blockprint is favorite because of its technical identity with type. Raised to type level, the cut can be printed with no extra effort together with a caption, political or sentimental, whatever will tug at the public heart, for it is to the people at large rather than to a select minority that the print more often addresses itself. And the differences between *bois de fil* and *de bout* are of little concern to men who, following the logic that equates cuts and types, prefer to engrave typemetal rather than wood, to equalize throughout stresses and erosion.

Through the nineteenth century, revolutions have been prime movers of the graphic arts, for the hundreds of opposition sheets aimed at the liver of their political victims with the lithographic crayon. American Daumiers, men of the scope of Villasaña and Escalante, ground, grained, etched and inked their stone, week after week. As with Daumier, political police smashed press and skulls into silence, or political victory whisked the tyrant to

limbo, and both failure and success spelled a stop to the Philippic. Thousands of lithographs, some of them great works of art, were born of anger, of love of justice, of cussedness even, but rarely of an artistic urge. With the coming of the rotative press, the lithograph goes to metal, a zincograph now, but just as biting, just as fierce and crammed with unwonted art.

Come photo-engraving, the photographic process removes the print from the range of graphic arts, unless, making the same allowance that had to be made in the case of Daumier's late gillotypes, one decides that it is the standard classification that is wrong, for the artist's claw-mark is still there.

Even more than in France, where most Toulouse-Lautrec posters rotted on damp Parisian walls, benign Latin American climates call for outdoor displays. To this day posters are cut from wood or linoleum, at times by the hand of a master. Half-tones and four-color processes being too expensive for most, a dearth of economic lever enriches Latin American graphic art with some of its most impressive examples.

To understand better some of the print forms more exclusive to certain countries of Latin America, one should remember that there exist local traditions that shape modern graphic arts into century-tried molds. Not always the work of popular artists, these prints patterned after local standards can best be understood by digging deep to their popular roots.

Let us admit that it is in part backwardness that keeps handcrafts going in Latin America, where handlooms and

potter's footwheels are at work long after machinery has replaced them in the North. But let us add that, as far as aesthetics are involved, the slickest four-color illustration spewed at the rate of hundreds of copies per minute out of roaring gigantic presses lacks what the rough, tough pennysheet still retains of medieval candor. Only in Heaven and in art-making are worth and cost unrelated.

Museums treasure not only for their rarity but for their beauty what *santos* remain of the tens of thousands that were sold at the fairs and pilgrimages of the waning European Middle Ages, grotesque, stencil-daubed, innocent images that opened Heaven to dazzled peasant eyes. Not knowing that he was creating beauty of rare vintage, the level-headed craftsman saved time and labor by carving headless bodies, shifting heads and names on the anonymous shoulders as the time of the year and the calendar of saints required. Because they were cheap, the woodcuts were not allowed long life. Those we treasure now were saved by being glued as cardboard stuffing inside bookbindings, or pasted in a trousseau box or sailor's chest.

Still medieval are the penny publications of Latin America, printed to answer similar needs. A popular publisher's dynasty, for example that of Vanegas Arroyo in Mexico City, keeps the originality of author and illustrator corseted in a stiff, time-hallowed cycle of popular, political or pious needs. Each pilgrimage, each revolution, brings into being what sheet, what poem and what print fills the need of the pilgrim or the rebel, often the same man.

Don Blas, present head of the firm, listed for me some

perennials still a "must" in the year of grace 1946, describing better than any theory what objective springs move the Mexican printmaker.

New Year.	Prayer and thanks to the Supreme Being.
January 6.	Feast of the three kings.
February 2.	Oration and praise of the Virgin of the Candelaria.
Lent.	The seven utterances of Jesus on the Cross. Condolences to the Virgin of the Seven Dolors. Praises of the Virgin of Loneliness.
May 5.	Patriotic pennysheet.
July 13.	Prayers and praise to Saint Anthony of Padua, revered in Calpulalpam. Leavetaking from same.
August 15.	Leavetaking and praise to Mary on her Assumption.
September 8.	Leavetaking, good morning, prayer, praise and miracles of the Virgin of the Remedies, venerated in her sanctuary of Cholula.
September 16.	Mexican National Hymn, Commemoration of the Dolores uprising, and poem to the Flag.
October.	Leavetaking, salutations, praises of Our Lord of the Three Falls, revered in Jalacingo, State of Vera Cruz.
October 12.	Prayers, praise, visits and good mornings to the Virgin of Guadalupe.
November 1.	*Calaveras* (skulls) for the Day of the Dead.
December 16 to 24.	Pilgrims and Posadas, Mary and Joseph in search of an inn.

Politics and revolutions do not follow as steady a course as does the liturgical year, yet they swell the annual graphic

output with most pungent fare. One year, the print-maker cuts President Madero making a triumphal entry into his capital as savior of Mexico, a smiling top-hatted giant in a coach dragged by tiny white stallions. Three years later, Madero is pictured as a skull alive with maggots.

Latin America is also Amerindia, and print-making, even though originally imported from Europe, takes after a while a more mysterious countenance than it ever had at its source. Unknown to the wood engraver or lithographer, some of the sturdy, stocky quality of the pre-Hispanic Indian aesthetic creeps into his composition. There is a racial accent on blood and death in many prints, ancient or modern, popular or sophisticate. A similar streak links the Mayan frescoes of Chichen Itza, depicting human sacrifices, the Aztec tiger vessels made to receive the hearts of human victims, the flagellated Christs skinned to naked bloody ribs, and today's cartoons that pile corpses under the boot of some local dictator with a realism that makes of the subject matter more than a figure of speech.

I have stressed recondite differences, racial, stylistic, rather than the most obvious one of subject matter. As I write, placing myself on the borderline of two vast civilizations, the word picturesque loses its meaning, or acquires a *double entendre*. To be sure, the tourist finds most of Latin America picturesque and delights in what seems quaint and colorful. But he should beware of prints and albums that stress the regional curio, peg on men and women *sombreros, rebozos, guaraches, sarapes*, peasant embroideries, and tropical accessories to the point where

they lose all human meaning. One should not forget that Saxon America is a willing art buyer, and that the temptation is strong, even among good or great artists, to manufacture prints that will look the way prints from Latin America are expected to look.

My Latin American artist friends, immune to the sights of their native lands, find New York extremely picturesque in their turn. For who would choose to live in vertical bee-hives—men piled on top of men up to the reach of the clouds—when bush and pampa offer open spaces on an invigorating horizontal? Or who would fight his way through piles of snow when a plentiful sun spreads over half a continent? Most picturesque of all for the Latin American artist is 57th Street, where art is caged in rooms lined with wine-hued velvet and made to sing by neon lights, where *santos* just like those that sell at Indian pilgrimages for a few cents are chained to mats, jailed in portfolios where their devotional message is silenced, clipped of their function and prized for rarity.

Some print-makers of today switch from the praise of God to Marxist social topics. Still cheap, still printed *en masse* to reach numberless consumers, the prints are the work of the same masters who paint walls with the same purpose. Such newspapers of the 1920s as *El Machete* printed woodcuts that are masterpieces of the new mode, already hard to get since their very cheapness has scattered them to the ash bins. Some may have been used to strengthen a book binding or decorate a chest, to be rediscovered for the delight of unborn museum curators.

After centuries, the pious function of medieval images is forgotten by the collector who admires instead the plasticity of the thick black line that shapes draperies in abstract zig-zag folds, while his eye tastes the carmine of a stenciled blood-splash on the split pate of a martyr, without seeing the martyrdom. The Marxist message of some of our modern artists will fade out even more thoroughly, dealing as it does with earth and *Das Kapital*, not with a timeless Heaven—and naked plastic qualities will come to the fore.

All such prints born of a non-esthetic purpose raise the old argument of *l'art pour l'art*, and answer it all at once. Truly felt emotions leave lines, values and colors etched all the more deeply to match a warfaring purpose. The war over, win or lose, lines, values and colors keep imprisoned the vibrant heat of the message long after its topical meaning is lost.

Any attempt to define what makes Latin America tick in the graphic field on another rhythm than the United States, is bound to puzzle Latin Americans and paint to Saxon eyes a picture of forced quaintness. There are of course more points of contact between the Americas than there are differences, and besides art, a pioneering philosophy of the open spaces links north to south more closely than either to Europe.

I like to think of the Americas in terms of the Biblical episode of Mary and Martha. Martha was practical, handled her pots and pans with "Saxon" efficiency. Mary was "Latin" and mystical, and her mind wandered far above the regions staked by the rules of good housekeeping.

Martha muttered at the apparent uselessness of her sister, and Mary probably was bothered by the clash of crockery from the kitchen. Contrasts in temperament and in activities can be stressed, but we should not forget that Martha and Mary were sisters, sisters living under one roof.

This article first appeared in slightly different form as the Introduction to Anne Lyon Haight (ed.), *Portrait of Latin America as Seen by Her Printmakers* (Hastings House, 1946).

Mexican Prints

The power of the graphic arts lies in reproduction, multiplication. This very multiplicity points to the people at large as the potential users of prints, with which they, at least, share the quality of being many. This broad premise is attacked by a few print-lovers who advance, in dubious Malthusian fashion, that rarity is more desirable than plenty. Perhaps both theories may be reconciled if we admit two levels of art-making. Limited, numbered editions of prints are all very well for the kind of graphic art that is *de luxe* in truth or in pretense, and thus declares itself expendable. Another kind of art may be a true necessity that it would be as senseless to ration as bread.

The story of the Mexican graphic arts parallels that of Mexico, whose history is not all pleasure and leisure. Mexican art was never meant to be a hothouse flower, coddled in the rarefied air of the studio for the delectation only of connoisseurs. Since the pre-Conquest days of the *tlacuile*, who brushed painted magic on lime-coated paper to influence the conjunction of planets and insure the

Siqueiros: Worker, Soldier, Peasant. Woodcut for *El Machete*

fullness of crops, Mexican aesthetics have remained enmeshed in practicalities.

The birth of a Mexican art, as distinct from a purely Indian art, was attended by bloody travail. Yet the term "conquest," used to describe the forceful entry of the Spaniards in Anahuac but, none too accurate even on the military plane, is even more misleading if extended to describe the clash and the resulting blend of the two civilizations it involved. A cultural conquest required as its first step a taking stock of the Indian heritage. Of the men who were brave enough to run the gauntlet of this mental hazard, none emerged intact.

The Spanish Crown and its representative in Mexico, the Viceroy, labored hard to smooth over the rough colony culturally. When Baron de Humboldt visited Mexico in 1803, this cultured European marveled at the collection of Greco-Roman plastercasts housed at the Mexican Academy of Fine Arts as a gift from the Crown. Humboldt also witnessed how Aztec sculptured temple fragments, when accidentally unearthed, were speedily buried again. This was perhaps because they were pagan, but also because, for a taste attuned to eighteenth-century rococo, they were ugly. Baron Humboldt voiced a mild reproof, "Why not, side by side with the Apollo Belvedere or its plaster counterfeit, admit the exhumed monsters reminiscent of the art forms of Hindoos and Egyptians?" What the German baron visualized as a curiosity—the chance meeting of violently contrasting aesthetics—does in fact plague the inner eye of all Mexican artists. They hardly need see side by side Apollo Belvedere and

Coatlicue to realize what potent tension results from the churning of bloods that begat them and their art.

Their quandary is illustrated by the career of the first graphic artist of authentically mixed parentage, Fray Diego Valadez, born in Mexico of a Spanish father and an Indian mother. Trained to be a Franciscan missionary, well-traveled both in Europe and in his native land, Fray Valadez engraved a set of plates meant as visual aids to teach Christian doctrine to unlettered Indian converts. Through his origin as well as his calling, the artist had familiarized his eye only too well with the squatting figures to be found in codices, hugging the earth, knees to their chin, in the manner of his savage parishioners. Having tasted Indian humility at the sight of these geometrically defined human figures, their folded bodies inscribed in the cube or seemingly gathered back into the sphere of the womb, Fray Valadez, though possessed of great technical proficiency and keen anatomical knowledge, could no longer, in his engravings, be content with the display of swollen muscles and the extrovert gestures stamped on art by the European Renaissance.

The human form is at its loveliest skin-deep, awaiting only the added health and glow of Greek genius to become a Narcissus or a Galatea. The Aztec, immune to the sight of religious autopsies performed with a sacrificial knife, preferred to observe the same human body piecemeal—a necklace of steaming hearts, or a basinful of blood, or a hill of skulls. Unnice as is death in its plastic manifestations, it has nevertheless inspired great art. In Europe, bones, shrouds and worms were the *leit-motiv* of medieval dances

of death. In the America of the sixteenth century, the rattling of the imported Catholic skeletons was to find its perfect match in the staccato rhythm of the *teponastle*, the Aztec log-drum. In colonial times, Death triumphed in the showy funeral pyres that Mexicans, with outward sorrow and perhaps secret pleasure, erected at the death of emperors and kings whose absentee power they had experienced only at second hand. Crowned skeletons loom big in the engravings that adorn the resulting *pièces de circonstances*.

Early in the nineteenth century, Fernandez de Lizardi, nicknamed "El Pensador Mexicano," assisted at the birth of Mexican political independence with a rash of pamphlets—from four to eight pages each, on cheap paper—that he wrote, set to type, and distributed single-handed. A woodcut of a plain skull and crossbones modeled with deep chiaroscuro which embellishes one of his *Dialogues of the Dead*, between the shade of hero Hidalgo and the freshly-laid one of ex-Emperor Iturbide, marks the rise of the modern, wholly irreverent, comical *calavera*. It is dated 1824.

This graphic *calavera* (skull), passing through ever more complex forms, reached a climax in the metal cuts and relief etchings of Guadalupe Posada, undoubted master, versed in the low-brow art of illustrating pennysheets. His *oeuvre* was realized in a sharp black and white that spurned nuance, and, indeed, little nuance was needed as the engraver separated the goats from the sheep with a kick. With anarchistic gusto, the brown-skinned master lined before his graphic tribunal the mighties of this world,

generals and bandits, and coquettes as well, making of all a savory mess of mustachioed jaws and blunderbusses, of necklaces and collarbones, of ribs and ribbons. As the Revolution begun in 1910 entered into its giant stride, it raised measurably the number of sudden deaths among the mighties. Death and Posada then entered into friendly contests to see which one could first transform a live potentate into a grinning skull.

Another rich source of graphic art is the political cartoon at large, quite as far removed from the concept of art-for-art as the more specialized *calavera*. Mexico has a strong tradition of political newspapers, backed by the disinterestedness of men who have gone to jail, seen their presses smashed, had their skulls cracked and their papers suppressed, all for the sake of keeping an opposition alive. When official art tended to freeze into decorum, when marble Venuses tickled the taste of the bourgeois, cartoonists kept alive the quota of dynamism and unnicety without which Mexican art would quickly wither. Equally doomed by the success or failure of their endeavor, these pennysheets could not outlast the issues they raised. Only their names have kept a sting: *The Mustard Plaster, The Black Widow, The Gut-Grater, The Tickles, The Shark, The Carving Knife, The Loose-Mouthed, The Whip, The Scorpion, The Blind Man's Club.*

Mild-named and longer lived than most was the far from mild *La Orquesta* that featured Constantino Escalante's masterly lithographs. These cover the Juarez Reform, the French invasion, Maximilian's empire, the two Juarez Republics. Escalante was as a rule "against it." He lovingly

dwelt on the picturesque Zouave's uniforms, but their unhappy owners were impaled on the spikes of maguey, drubbed by barbed cacti. General Zaragoza funneled horse pills into a sick Napoleon III; a comical Maximilian lent his imperial foot to be kissed. Juarez was a tuna, the tasty fruit of the nopal, protected from French appetites by bristling vegetable bayonets. Mexico was a bronze-skinned, plume-skirted Indian maiden who lolled in a hammock tied to palm trees. She greeted the landing of the diminutive, pompous Frenchmen with a smile, and a popular refrain, "Here come the monkeys."

Through this vast graphic work, as a kind of hieroglyph that stands for the mechanical progress featured in that mid-century, Escalante drew variations of the iron horse. His locomotives, their valves and pistons rearranged in quasi-organic fashion, chug and puff with an animal life all their own. In 1868, as the artist and his wife were returning from a party in Tacubaya, they both slipped under the wheels of the local train they were to board, dying soon after.

Heir to *La Orquesta* was *El Ahuizote*, named after a *nahuatl* monster whose voice lured men to an aquatic death. It published Villasaña's great lithographs of the seventies. Truly a "blind man's club," it helped crush a democratic president, Lerdo de Tejada, and boosted as a hero young General Porfirio Diaz. A generation later, *El Hijo del Ahuizote* (*The Ahuizote's Son*) undid, in three decades that bridge the centuries, what its father had done. It swatted mature Don Porfirio until his senile exile.

In 1911–1913, a new *Ahuizote* kept its cartoons aimed at

President Francisco Madero up to the minute when he was actually shot in the back. In this paper, José Clemente Orozco cut his milk teeth to razor sharpness on the future martyr, Madero.

The Mexican mural renaissance of the twenties was especially concerned with true fresco, the mural technique par excellence. But its artists had not turned muralists primarily through a love of fresco, but rather in their desire to bring art to the people. In sharp contrast to what were then the tenets of the School of Paris, the Mexicans were bent on creating a didactic type of art aimed at a wider circle of men than the aesthetes. It is natural, then, that they would also try their hand at the graphic arts in an effort to reach an even wider public than could be touched by murals. With this purpose appeared *El Machete*, financed by the Syndicate of Painters, an irregularly issued, blatant newssheet of extra-large format. For it, muralists Siqueiros and Guerrero literally carved planks into brutal woodcuts. These were inked and run together with the type on a commercial plate-press, minus the niceties of special inking, graded pressure, and rag paper, that one associates with artwork. Poor as the resulting proofs undeniably are, these few woodcuts remain as a precious testimonial to a moment of heroic endeavor. They were done in between mural work by men familiar with scaffolds and mortar and totally disdainful of the finer points which constitute the pride of collectors' portfolios. As a result, there is a bigness in them that no later work by these same men could quite recapture.

In the next decade, the pioneer muralists affirmed their

technical proficiency and aesthetic maturity, mostly by hard, sustained work. Another generation that was then born to art found itself hemmed in, as it were, between the walls where their elders had frescoed brown giants shaking fists and holding banners loud with slogans. Naturally enough, adolescent scruples shied away from these hardened displays. The young artists took refuge from the very big in the very small. Leopoldo Mendez and others learned to cut wood so fine as to squeeze a content equivalent to that of hundreds of square feet of *buon fresco* into prints the size of an *ex-libris*. Mexican graphic arts then branched towards exquisiteness as a natural antidote, a phase perhaps best expressed in the few prints of short-lived Julio Castellanos.

In today's Mexico, it can be said that the function of public speaking so ably performed by murals in the twenties has been taken over by the printed poster. Perhaps simply because photo-engraving remains more expensive than obsolete methods, posters in Mexico are still mostly hand-made process or relief cuts. The print-lover would do well to follow the overalled man who walks the streets with a pastepot, a brush, and a sackful of new posters that he slaps all over the walls of the Capital. The yellow, pink or purple sheets, apart from advertising a sportfest or denouncing a politico, may also be first editions, strictly unlimited, of the original graphic work of some famous artist.

Another branch of the arts to which, indirectly, the revolution gave a boost is book illustration. It started with

the same practical intent as many another endeavor of which art constituted, so to speak, no more than a by-product. Modern book illustration was linked early with the campaigns launched by successive Presidents to teach an increasing number of citizens how to read and write. Typical is Rivera's childish primer, *Fermin Lee*, with its exquisitely primitive line drawings. Printed by the State, it was distributed free to rural schools.

More sophisticated and aimed at a smaller circle, the best of the later books still hold that technical excellence and human values are interdependent. Such is *El Sombreron*, illustrated by Alfredo Zalce, together with the preparatory studies that preceded the final lino cuts. It may come as a surprise to some to see how the artist's mind worked; how complexity meant for him only a first step towards simplicity.

In the effort to single out of Mexico what will seem to an outsider the most Mexican trends, there lies a danger of distortion. It is true that in the twenties much Mexican art was clashing with much Parisian art as to the why of art-making. It is also true that Mexican artists contributed their share to rounding out the international school. Rivera could hardly have become as convincingly the local realist that he is were it not for his earlier valid attachment to analytical cubism, which later on checked all backward glances towards Paris. In the work of Carlos Merida, of Mayan Indian stock, cohabit the knowledge of modern art acquired in Paris, when he shared a studio with Modigliani, and racial lore, with which he can communi-

cate simply by closing his eyes. Such are his wash drawings on stone for *Popol-Vuh,* which represent besides a complex technical feat.

If I had to choose, out of the whole panorama of the Mexican graphic arts, a single print, it would not be one by any famous master. Personality is often emphasized as the paramount ingredient of art; but, on the other hand, the better defined the personal idiosyncrasies of the artist, the more restricted the public that the art work reaches. I do not speak of the outward marks of appreciation that can always be conjured up by published critical estimates and the attendant publicity drummed around big names, but rather of the inner conformity felt before the art work when one is alone with it, and just looking. For the same reason, I would not choose either the biggest print or the loudest, impressive as is the Mexican version of both.

Of all the plates in the Mexican collection of the Metropolitan Museum, the ledger of samples of printer Murguia moves me most, and in it, the set of saints, or rather of *santos,* as stylized, as geometrized, as an ABC. These images, pyramidal Virgins or beribboned Crucifixes, are anonymous chips from a truly functional form of art, rich in didactic clarity, and meant for the people at large.

One of these would be my choice.

This article first appeared in slightly different form in The Metropolitan Museum of Art *Bulletin*, November 1949. Copyright 1949 by the Metropolitan Museum of Art.

Mexican Printmakers:
Manilla

In this land where artistic production is the norm, as in other countries commercial enterprise, art is perhaps underrated. Terra cotta statuettes as great as Tanagras sell here for a dime, ex-votos equal to the most precious Italo-Byzantines are worth the weight of the zinc sheet on which they are painted. Duly trained in academies and and refined by the expensive trip to Europe, professional artists could hardly make a living, unless the dangerous competition of the masses be challenged. For centuries it was enough to state that Mexican arts were done by poor Indians, thus socially inadmissible, but lately, because of revolutionary rumblings, such an attitude has become precarious and a more involved excuse had to be found.

None deny the excellence of the indigenous output, but admiration itself has become camouflage. A generic name of "popular arts" has been coined by which much ado can be made about art objects and none at all about their makers. Against this nameless background, the signed and dated work of the academician may retain its ugliness, exclusiveness, and price. To depopularize plastic creations, to give their authors the respect and recognition

they deserve, only good faith is needed. In the field of graphic arts we may with little research single out the case of Manuel Manilla.

Printmaking in Mexico does not proceed by limited editions or foxy selling schemes. It is narrowly linked to the penny pamphlet, the rhymed *corrido* or the prose *relato* which it illustrates. In colonial times Mexico received such sheets from Spain, of which a collection dated 1736 exists in the National Museum. But the mestizo did transform such models, as he had already put Spanish santos to somewhat heathenish uses. This Mexican style came to maturity with Don Antonio Vanegas Arroyo, circa 1880, when his staff of reporters, poets, and artists published works so homogeneous in style, so beautifully attuned to race and land, as to be almost immediately classified as anonymous.

One of his first draftsmen and relief-cut makers was Manuel Manilla, native of Mexico City. Their collaboration, started in 1882, resulted in some five hundred prints. Manilla carved on metal, with the whites scooped out as in wood. Like Blake, the artist was his own engraver, and used this opportunity which poverty gave him to compose with his tools, white line on black, within the logic of the medium. A few original blocks still remain on the shelves of the old printing shop; others were smoothed into nothingness through excessive printing; most were looted by thugs with an artistic flair, in a number of political raids aimed at wrecking Arroyo's outspoken presses.

Manilla: The Watercarrier and His Wife. Wood engraving

Manilla's work possesses a personal mental climate, a class-consciousness of its own. It does not hammer social lessons with political slogans and fighting postures; this attitude of a man who makes art for the people is an attitude of leader to led, creates an unbridgeable gulf between both. It is rather art by the people, the worker seen both at work and play, surrounded and explained by his family. We cannot picture Manilla snooping with open sketch book among popular rejoicings or dramas but rather laughing and weeping at his own. We find reflected in his prints Mexican characteristics, the love of love and war, the chumming with death, a familiar give and take with a spiritual world, the disdain of money which give a Franciscan hue even to the deeds of Mexico's bad men. Women wrapped in rebozos, tradesmen surrounded by their wares, workers and their tools achieve in his work nobility, reserve, and a patient knowledge that complaints are not as constructive as action.

Degas said that in art nothing must be accidental, that in painting even movement must have permanency. Such a stylistic peace pervades Manilla's work. When he depicts populous market scenes, the trotting gait of burdened carriers, the exertion becomes a symbol, as does the peculiar immobility of high speed photographs or of Seurat's drawings. He opposes static elements as a kind of architectural backdrop to dissymmetric ones suggestive of motion. In his print of *El Volador*, the verticals of railing and columns emphasize the activities of burden-bearers, vendors, and buyers. Benevolent devils kidnapping gay blades fly diagonally across the imperious geometry of a

landscape of cubic houses. In a circus poster, a juggler tosses dissimilar objects, bottles, balls, a cannon. He is caught at a moment when all are whirling in midair, the gun on the right balances the smaller objects huddled on the left; a poised instant out of a dynamic whirl. When his subject is itself static, as in the group of the water vendor and his wife, Manilla attains as much monumentality as a two-inch square admits.

For ten years his art did service through tens of thousands of pennysheets, peddled through fields and cities. In 1892 he stopped working with Arroyo, shifted probably to another manual trade, little dreaming that printmaking differs in kind from carpenter or mason's work. He died in '95, a victim of the typhus plague.

When Manilla met his Judge, if he did think at all of the work left behind, it must have been without bitterness, with the contentment of having pleased, stirred and immortalized hundreds of people as simple and wise as himself. He will not puzzle at this aesthetic yard stick we apply to his work, nor will he relish this certificate of artistic glory, for art critics, before they throw bouquets, make sure they will fall on a grave.

This article was originally published in Spanish in *Forma*, December 1926.

José Guadalupe Posada:
Printmaker to the Mexican People

The Mexican pictorial renascence of the 1920s and the rebirth of Mexican fresco coincide with the rediscovery of a Mexican tradition, an adventure that proved to be fully as exciting as the making of the pictures themselves. Part of this tradition had always been in plain sight, but some of it had to be hunted down the burrows of the past and especially of the near present. The muralist claimed affinity with Mexico's public monuments which bridge a stupendous time span from archaic Totonac terra-cottas to the walls that Tres Guerras frescoed in Celaya in 1810, at the moment that Hidalgo shook the Spanish yoke from a proud neck. Just weaned from cubism, the young artist looked with loving awe at the work of those Toltec and Aztec sculptors who plied cube, pyramid, sphere, and cylinder with a taut passion beside which Cézanne's own brand of geometry retains something of the pedagogical mustiness of the classroom.

The statues and *reredos* of the Hispanic period also proved masterly models of plastic elocution for the fresco painter of the twenties groping towards a formula for public speaking in paint. He now dared, as had the colonial

sculptors, to offend the rules of good taste and of plastic propriety in his urge to preach, to convert and convince. The would-be painter to the people undertook to forge a secular equivalent to the full plastic vocabulary used in the church: filigree halos, stuccoed fingers that point, bless, or damn, glass eyes bulging with ecstasis, clotted blood, flayed skins, gold damasks.

Paradoxically, the period of national independence ushered in a meagerness of taste that makes most nineteenth-century art, at least the art taught at the Academy, discussed in cultured circles, and hung in drawing rooms, little more than a provincial reflection of Europe. To the casual eye, the link with the past snaps. However, the great national tradition did not die, but went underground. Branded as folk art, a label that made it unpalatable to collector and connoisseur alike, Mexican art humbly persisted in the church *retablos* that were the people's pictures, in the *pulqueria* paintings that were the people's murals, and in the graphic works of pennysheet illustrators, rich in political and human implications.

While murals and ex-votos remain veiled in anonymity, graphic works conjure up the name of one man. Guadalupe Posada, who appears placed at the narrow neck of an hourglass where every grain of sand must pass as it slides between past and future. The bulk of an ancient and rich tradition funneled through his work at a time when it was fated to leaven modern formulas. That Posada's stature proved equal to this task is one reason why the painters of the 1920s failed to collapse into antiquarianism as had the pre-Raphaelites and the men of Beuron.

Artists of the generation of Rivera and Orozco acknowledge their debt to Posada, although he was not a teacher and would have been mildly skeptical had anyone addressed him as "Master." In the 1890s his open studio, or rather his workshop, was tucked inside the disused carriage entrance of a private house in Santa Inez Street. Posada worked in plain sight of the passers-by, housemaids on their way to market, urchins astray from grade school, even loitering art students from the nearby San Carlos Academy. To this day Orozco, then ten years old, remembers the fat brown man in an ample white blouse, who drew and carved on metal plates with a single motion of his engraver's tools such perennial best sellers as *The Man Who Eats His Own Children*, *The Two-Headed Stillborn*, *Lovers Go to Hell on Account of a Dog*, *Woman Gives Birth to Four Lizards and Three Boys*. At times the shy lad would summon up enough courage to enter the workroom and purloin pocketsful of the master's metal shavings.

A little further on as he ambled to school, young Orozco passed the shop where publisher Vanegas Arroyo sold Posada-illustrated pennysheets—wholesale to city newsboys and rural peddlers—retail to houseservants and schoolboys. The plates, now become pictures, were hand tinted in sight of the customers by the women of the Arroyo clan, armed with stencils and gaudy glue pigments. One could admire in the final display such exciting subjects as "The Massacres of Chalchicomula," piles of pink corpses

Posada: The printshop of Don Antonio Vanegas Arroyo, with self-portrait of the artist. Relief etching, 1880

gashed with scarlet wounds, trampled under the *guaraches* of stretcher bearers, faces averted under yellow *petate* hats. Hero of the guerrillas against Maximilian, a maroon charro lassoed an orange gun and galloped away with his booty, leaving behind him discomfited French zouaves who blushed to match their scarlet pants. Skies remained ever serenely blue.

The bold, brusque line of Posada, all the more muscular for being dug in metal, the blatant color patches smeared on a black and white web, made so strong an impression on Orozco that later years of studying anatomy and perspective at the art school could not unroot them from his mind or from his hand.

In contrast, the Academy of Fine Arts offered the young painter art of a far weaker character. Its halls were hung with lithographed charts of feet and eyes, clusters of ears and noses that he was enjoined to duplicate neatly in charcoal. One graduated to copying plastercasts, first in low relief, then in high relief, and lastly in the round. Relaxation was provided by a class in landscape drawing—after prints and photographs.

Such methods reached a zenith under the Catalan painter Fabres, imported by Diaz. His prideful tenure whipped Mexican artists into self-assertion at the very time when Spanish overseers were unwittingly driving Indian peons to arms.

The revolution was a Posada "still" come to life. Scenes he loved to portray—anti-Diaz meetings with bricks and bats flying, skulls bashed in, stabbings, shootings, chained prisoners hemmed in between men on horseback—what

had been but a line inked on paper found its consummation in a true depth and a true bulk. This monstrous Galatea moved in a quick staccato akin to the tempo of early newsreels, with a dubbing of deafening sound effects, pistol shots, bullet whizzes, clanking of chains, screams, sighs. Arms, till then frozen in the delicate balance of an engraved design, let fly the stones hidden in their fists. Paper machetes became steel dug into the "wicked rich," easy to spot in the cowardly uniform that Posada had devised for him, high collar and high hat, gold chain dangling on a comfortable belly soon eviscerated.

The revolutionary themes of Orozco paraphrase Posada not only because of his youthful affection for the master, but much more because the revolution was first rehearsed within this balding brown head, and its tableaux charted by this able brown hand before it had even begun. In 1922, as the scaffolds of the muralists mushroomed against the startled walls of ancient San Ildefonso, Orozco (who was far from knowing that he too would soon paint murals) smiled at the juvenile enthusiasm with which we denounced ivory towers and groomed ourselves for the role of painters to the masses. "Why paint for the people? The people make their own art." This aphorism of Orozco's, which we did not relish at the time, remains the most straightforward appraisal of Posada's function.

Posada's work falls logically into three phases, conditioned by the three mediums that he adopted in turn: lithography, wood and metal cuts, relief etching. The blandness of lithographic crayon permeates his youthful provincial manner, marks its accurate drawing and delicate

half-tones. These stones are often political cartoons, big heads on spindly bodies in the taste of the French caricaturists of the 1860s. A critic ignorant of the true sequence could point to Posada's first manner as an obvious refinement and elaboration of the cruder second manner. One expects a stylistic cycle to go from simple to complex, from archaic to baroque. Posada's lithographs are valued witness to the fact that he was one of the few who consciously order their lives from complexity to simplicity.

In the coarser second manner, he cut most of the illustrations made for the plebeian tracts of publisher Antonio Vanegas Arroyo. In the meantime Posada had suffered much. The widow of Don Antonio, a charming and able matriarch who used to call me with a twinkle "El Francesito," liked to recall Posada's often-told story: How in the floods of Leon in 1887, many members of his family drowned, how they would be carried past him by the churning waters and cry "Save us, Don José," until they sank.

The role of Don Antonio in the formation of Posada's new manner was crucial. As in the middle ages when the Biblia Pauperum edified countless humble souls, so did the penny pamphlets of Arroyo in Posada's Mexico. With customers to whom reading was slow work, the picture had to state the story in terms intense enough to smoke the Indian's penny out of his knotted kerchief. Horrifying, edifying, or comic anecdotes, broadsides on love and war, recipes for cooking and witchcraft, librettos of rustic plays,

Posada: Printers and Customers. Relief etching, 1880

reached the remotest crags of the republic in the haversack of the peddler and the saddlebag of the pilgrim. Anthropologists who spy on remote Indian festivals and take down in phonetic shorthand the chanting, the pastoral skits, the cruel and lengthy Passion speeches, the Mystery plays that evoke a world of sharp hierarchy, man sandwiched between Heaven and Hell, might rather politely ask the coach or prompter for his book, much thumbed and yellowed, where the imprint of Vanegas Arroyo may still be deciphered.

The firm catered to the city mestizo as well as to the Indian peasant. Arroyo's *Gaceta Callejera* startled the city with extras as hot as the handsetting of type and the handcutting of the pictorial reportage allowed. Recurring deadlines forced Posada to cynical economies. A standard picture "doubles" for every *Horrendous Fire*, a sign on the burning house being recut each time to fit the latest and best-selling conflagration. Another print shows a street demonstration. Men shout, women scream, fists fly, banners and streamers are displayed—left blank to allow the typesetter to dub in whatever rightist or leftist slogans, whatever religious or anticlerical grievances would transform the well-worn block into the news of the day.

These uninhibited short-cuts often result in extravagant fantasies. In the first state of *The Death of General Manuel Gonzales, Ex-President of the Republic* the bearded corpse, elegantly clad in black, lies in state against a sober background of thick draperies. A few days later a second state and a new title bring the subject up to date. In *The Burial of General Manuel Gonzales, Ex-President of The Republic* a

plumed hearse and high-hatted mourners, hatched out of the dark curtain, slowly cross the background of the funeral parlor with their burden and fade into its wall, watched by the corpse itself, a relict of the first state.

Each year, for the Day of the Dead, while children teased their appetites with sugar skulls and their elders prepared buffet suppers to be devoured on the family tomb, Arroyo's press let fly by the thousands broadsides known as "*calaveras*," the Mexican Dance of Death. With high glee, Posada conjured up the skeletons of politicians with tortoise-shell glasses and celluloid collars, of generals whose ribs sag under medals, of coquettes hiding their bald skulls under the funeral flowers of imported chapeaux.

The medium of this second manner is wood, or more often, type metal. The direct cutting with burin results in a white line on black ground. While in the making, the block was coated with *azarcon*. Digging into this red lead composition helped Posada to evoke all the more easily the flames that heat and the blood that splashes his visions. The furrowed line acquires a musculation the lithographed one lacked. Journalistic deadlines, improvisations in a hard medium, and an adjustment of his plastic vocabulary to a special audience, combine to give a primitive flavor that earned for this manner the approval of Paris.

Posada's third and last manner coincides with his discovery of relief etching, made in an effort to compete cheaply with the increasingly popular process of photo-engraving. In this unusual medium, zinc is drawn upon with an acid-resisting ink, all exposed parts hollowed in an acid bath. Unlike orthodox etching, the plate is inked

with a roller like a woodcut. The only other well-known relief etcher is William Blake, who claimed to have received the secret of its process in a vision from above. The result is a black line penned on white ground, and Posada, in a swagger of calligraphic arabesques, celebrates his release from the exacting bondage of the burin.

Showing no trace of naiveté, this last manner tends to irritate devotees of Posada who like to think of him as a Mexican Rousseau. Whereas the aging French master played "Clochettes" of his own composition on a three-quarter violin, we can picture the aging Mexican slapping his thigh and belching a Rabelaisian laugh as Death, his favorite model, tip toes in.

Not all of Posada's works are prints. The widow of Don Antonio knew of two large ledgers in which the artist had sketched many scenes, "Some very nice, some very horrible," as she remembered them. A humble man, Posada did not scorn such menial tasks as came within the scope of his craft. I saw one of his circus signs still in use in the 1920s. Painted on unsized canvas and fully signed, it represented the floods of Leon with his own people drowning. This use of a personal tragedy to drum crowds under the big top is a reminder of how deeply different good neighbors may be.

It has become trite to remark that Mexican murals export badly, that they need for a frame Hispanic patios and arcades, and for lighting effects the crystalline silver of Mexico's plateau or the golden pathos of its tropics. But Mexican graphic art, uprooted, labeled, priced, caged

behind glass, fares none too well either. Will the visitor to an American museum understand Posada's prints proven function? Will he believe that the guns shoot, the blades rip, that the ink is blood?

And if he does, will he not feel cheated of an expected aesthetic delight?

This article first appeared in slightly different form in *Magazine of Art,* January 1945. Reprinted by permission of The American Federation of Arts.

Posada's
Dance of Death

The four relief prints that are the reason for this essay were cut in Mexico City by José Guadalupe Posada in the very first years of this century. They are cut in metal, an alloy of zinc and lead used at the time by printers who cast and recast their own type. A genuine relic of Posada's immense *oeuvre*, they date from his mature period, after he had left his native León and come to the capital to work for Don Antonio Vanegas Arroyo. Publisher Don Antonio specialized in broadsides, street gazettes, and pennysheets. His trade was aimed exclusively at lowbrows, and cheap printing methods were essential. Nailed unceremoniously to a wood base, the metal plate was raised to type height, and both text and cut were inked and struck in one operation on a hand-operated platen press. The paper used was of cheap grade and texture, dyed in eye-catching colors, favorites being a sulfurous yellow, a shocking magenta, and a deep solferino green. To match these plebeian methods, Posada coarsened a style previously nuanced by the subtleties of lithography. In Mexico City, he forged for himself a plastic language so forceful that unequal pressures, rough stock, or gaudy hues could not weaken its impact.

Posada thought of himself as a craftsman. When at work he did not wear the smock of the artist but the green visor and large apron of the printer. Nothing in his life and work suggests that he ever felt ill at ease at his job or resentful of its ever present didactical requirements. Posada's own personal convictions fitted him easily within the narrow confines of this plebeian layout. Deadlines set by his publisher and a voracious curiosity for recording street scenes left no time even for a sigh toward far-flung aesthetic goals. Instead, Posada was ever eager to distribute his prints directly into the hands of the many, of the illiterate unwashed, of whom he was in a way the mouthpiece and for whom he lovingly evolved an alphabet of lines and values they soon learned to read fluently, though, for most of Posada's fans, the roman alphabet was to remain forever an unplumbed mystery.

For him, aesthetics never did exist in the abstract but only as the motor that moved his heavy body and kept it for hours bent double at his workbench over a tiny plate. Art was as one with the quick motions of the small-boned Indian wrist, with the deft staccato of the stubby fingers holding burin or graver. Across the street from his workshop loomed the imposing Academy of San Carlos, where art had been correctly taught since the eighteenth century. A fugitive from its classes of perspective and of anatomy, the youthful José Clemente Orozco would visit Posada at work and shyly stuff his pockets with curled metal shavings picked from the floor. For him they held, as indeed they did, some essence of the master's stocky genius.

Posada's posthumous fame threatens to enshrine his work in *catalogues raisonnés* and limit his public, outside Mexico, to curators and collectors. It is with Posada alive that I am most concerned, and how to outline his sturdy contours before they thin out in a haze of glory.

Concerning his life, its climate and habitat, Arroyo's publications offer contemporaneous and articulate clues. From Don Antonio's own words—that Posada fancifully lettered in a relief etching—we learn of the publishing business that was his own as well:

Founded in the year 1880 of the nineteenth century,
this ancient firm stocks a wide choice:
Collections of Greetings, Tricks, Puzzles, Games, Cookbooks,
Recipes for Making Candies and Pastries,
Models of Speeches, Scripts for Clowns, Patriotic Exhortations,
Playlets Meant for Children or Puppets, Pleasant Tales.
Also: the Novel Oracle,
Rules for Telling the Cards,
a New Set of Mexican Prognostications,
Books of Magic, Both Brown and White,
a Handbook for Witches.

Posada illustrates this with a view of the Vanegas Arroyo pressroom. In what must be a self-portrait, with the familiar green visor and printer's apron, the mustachioed master hands a proof sheet just off the platen press to bearded Don Antonio, splendid in a long overcoat, high collar, and high hat. On the floor lie bundles of pennysheets

Posada: The Proposal. Metalcut, circa 1910

ready for wholesale distribution. Idlers and passers-by hint at the street on which the workroom opened.

Another relief etching tells the sequel. We are now in the part of the shop reserved for customers. A large counter separates it from the work area where workmen in caps and aprons turn the wheels of the busy presses. Matriarch of this establishment, Mrs. Vanegas Arroyo sits behind the counter, in lace collar and high hairdo, with puffed sleeves and a wasp waist. She has just sold some broadsides to a flock of news vendors. The urchins, shoeless, coatless, straw sombreros frayed at the rim, scatter out into the street with armfuls of sheets, eager to cry their exciting wares. Two grown-up customers await their turn, one a country peddler, the other a city bureaucrat.

What these street vendors bought from Mrs. Vanegas Arroyo may well have been *calaveras*, or "skulls," specifically designed for All Souls' Day. Don Antonio, and after him his son, Don Blas, and after him, his son, Don Arsacio, struck from the same blocks, year after year, "Dances of Death" brought up to date by topical allusions. In that regard the Revolution of 1910 proved a matchless boon. One day generals, bandits, and presidents were on top of the heap; the next day they were in the grave. Posada relished the epoch.

Our four pairs of skeletons are not of such exalted rank. A drunk loudly remonstrates with his loved one as she warns him of the dangers of the bottle. A policeman drags a prostitute to jail. His nightstick swings menacingly

Posada: The Arrest. Metalcut, circa 1910

in one hand, but the other is busy pinching the fleshless buttocks of his catch. Chances are she'll swap lovemaking for an escape. The two other plates deal with a single couple. To read correctly the mind of these dead we may turn to the original broadside, dated 1906 and entitled *A Cemetery of Lovers*, that features both of our cuts, together with many another "skull." For subtitle, a ditty, probably penned by Don Antonio, is meant to whet the curiosity of the potential buyer:

> Lovers lie under this sod.
> Read, you who walk over it,
> Of events, joyful or sad,
> Stilled forever in the pit.

A street scene. A *charro*, all black leather and silver buttons, his modish pants open at the sides to reveal the flaring linen beneath. His broadbrimmed felt hat is set at a rakish angle. One fist manfully rests on the hip. He accosts a girl. She is in street costume, bell-shaped skirts, a shawl modestly hiding her bare skull. It is their first meeting. Don Antonio gives them voice:

> He: Is your leaning amatory?
> She: Each case depends on its merit.
> He: Let's walk to the cemetery.
> She: Cowboy, you talked me into it!

The next plate implies time elapsed. The two, now seated in a parlor, are in the midst of a lovers' quarrel. He half turns his back on her. Shyly she puts a hand to his shoulder:

She: Desist from such mad jealousy.
He: What! You wish me blind or one-eyed!
She: Catch a beau under my balcony,
 You may thrash him 'til he's died!

Posada's "Dance of Death" is rooted in the Gothic version that Holbein was to make his own. In Europe, Death teases, haunts, and eventually kills unthinking and unwilling humans. Posada picks up the thread of the story. Now, man and woman have crossed the momentous threshold. Their flesh has rotted away. From being the haunted, they have become hauntees. Yet comedy clings to their bones more articulately than does the implied tragedy. It is its very everydayness that gives Posada's version of the hereafter its unique flavor. The Gothic "Dance" ruthlessly equated beggar with emperor. In Posada's netherworld, social niceties, and social lapses as well, are all punctiliously observed. The skeletal bourgeois walks hand in hand with his bourgeoise, with cane and umbrella displayed, along what promenades exist on their funereal planet. They give a passing nod to other genteel couples of ghosts similarly occupied. The defunct general, all bones under his plumed shako and bemedaled uniform, still brags of victories. In hellish wineshops the busy waitress is still bussed by the drunk, even though her frame has long ago spilled its stuffing.

Posada's manly art throve on revolutions, the biological one that is death and the political one that engulfed him and his beloved Mexico. Yet he remained aloof from another revolution that raged literally at his door, one

that had to do with art. At the old academy next door, circa 1910, youthful students besieged and eventually roundly routed their academic teachers. The banner these hotheads rallied under was that of impressionism. It was the one revolution that sophisticates and art lovers applauded. It was the one revolution on which Posada resolutely turned his back.

This article first appeared in slightly different form in Jean Charlot, *Posada's Dance of Death* (Pratt Graphic Art Center, 1964).

The Lithographs of
Alfredo Zalce

Try as they may, neither archaeologist nor ethnologist has pinned down by statistics of factual minutiae the spiritual complexities of the Mayan, as intricate as his own jungle flora and fauna. In this album, Alfredo Zalce, in true artist fashion, does what the scientist fails to do, reconstructs whole breath-taking vistas from the one legible modern glyph, the Indian body, naked or swathed in white, busy at rustic activities or relaxed in rustic leisure.

Dating from another millenium, Yucatecan bas-reliefs embody an ideal plastic concept as far abstracted from realism as the Greek. Eagle noses, caved-in foreheads, skulls shot backwards, bulging eyes—the ingredients of Mayan beauty—while they seem strange to the lover of classical art, please the modernist, hell-bent on aesthetic deformations.

The scenes sculptured and frescoed on ancient monuments are enacted daily in Indian huts and Indian fields. In Chichen-Itza, in the Court of the Thousand Columns, a stuccoed name glyph shows a hand kneading dough over a stone metate. In nearby huts of twig-woven walls and thatched with palms, living hands perform the same task

daily, their cinnamon arms issuing from the short sleeve of the *huipil*, immemorial raiment of the land, white square blouse loose over a loose white square skirt—a costume that removes the female body from the indiscretions of artistic anatomy into the severe realm of geometrical forms. In no sense a frill, Indian beauty exists in terms of function—as when the mother, a few weeks after giving birth, offers her substantial hip for the infant to straddle ceremonially, as an initiation into childhood.

The traveler that brands as lazy the plateau Indian, squatting with his knees to his chin, bundled block-like in his *sarape*, may also wish to pep up the bush-born Mayan, long and lean muscled, elegant to the point of ambiguousness, who moves in a slow motion synchronized with the lazy rhythm of hammocks rocked by the motor of one big toe, alone watchful in a siesta-relaxed body. Yet the stone platforms on which temples sit, as large as modern city blocks, the pyramids that raise to skyscraper heights the frescoed altar rooms, were put together by men like the Mayan stone mason whom I watched once, lifting a heavy block to a flat-shaped forehead with misleading languor.

In this album, Alfredo Zalce also does what the tourist fails to do, by substituting aesthetic intuition for bonded fact. He weaves anew in this superb set of lithographs on Mayan themes rustic present to imperial past, the intricacies of jungle shapes to those of spiritual meanings as local, and not a whit less complex.

Zalce: Mestiza and Child, Yucatan. Lithograph

Zalce: Mangrove Swamp, Yucatan. Lithograph

To read these beautiful prints correctly, one must realize the cleavage between the pretext, physical sights, and the deep spiritual insights that are at the core of the work. A jungle is picturesque, but for the painter it is also a place of awe, where the deer hunter still propitiates with copal incense stelae erected by kings long dead. The worker bent over the spiked maguey leaves, booted like a knight in rags, the fisherman pitting his eagle profile against a changeless ocean, may themselves be of the royal blood of Xu, whose coat-of-arms is the blue bird against azure skies. These rustic women, who glide past jungle flora which dip finger-like roots into black swamps, think thoughts that in their turn dip roots into a past as splendid and as long-forgotten as that of the lost Atlantis.

The technique used is symbolical of the subtle process of osmosis by which the artist came to learn all by refraining from asking specific questions. These lithographs are in the black manner of which Zalce is a master, the light being scraped off from a black inked ground, so that even the more dazzling whites—crystal salt mounds drying under a zenithal sun, starched *huipils* in the white heat of noon—gather enough gray between scratched lights to make clear that the lithographer's goal is not at all that of reproducing the tropical sheen, nor of duplicating its gamut of leaf greens against strong magentas, even though he succeeds in doing this *en passant*.

This article first appeared as the Foreword to the album *Imagenes de Yucatan* (Talleres de Grafica Popular, 1946).

TWENTIETH CENTURY

On the Completion of
Rivera's First Mural, March 1923

This man has erected amidst small intrigues and petty
vices those monolithic breakwaters, this battalion of
Virtues with its insignia and assigned duty each, unwinking
sentinels guarding the glyph of God.

Bureaucrats have paraded their white ties in front of
this majestic page. They say "Very good, but somewhat
expensive." The painter is accused of extravagance, of
skipping working schedules. He does not answer but, with
hermetic bitterness, climbs back atop his scaffold, for he
is a worker with every day a day's work ahead. Queer
planet, ours. Why are the prophets stoned?

Take patience, you will die. So will those ministers and
cashiers. Your thought will be voiced tomorrow clearer
than today, for the dwarfs will stop their bellows. This wall
will witness comical scenes, lay processions, guidebook in
hand, gaping in awe at the Old Master. Ciceroni will earn
their penny. Statues will perpetuate this flesh of yours in the
rhomboid shape it had. You will be well-haloed, subjected
to political speeches and art historians. Meanwhile pursue

Charlot: Diego Rivera at Work on His First Mural, in the
Escuela Preparatoria, Mexico City, 1922

your task. You have enough wit to maneuver your heavy shell, enough philosophy to be flippant.

Our trade differs somehow from the carpenter's and the roofer's. People do not agree to its good or bad; we alone know. To paint is a trade, but good painting is more of a virtue, persecuted as such for useless. We must grumblingly join the ranks of the martyrs; when we die and the feast begins, white robes will be slipped over our maculate overalls. This repast may turn to be an artist's picnic, misers and potentates preferring the outer darkness.

Written in March 1923, this is a strictly contemporary reminder of the opposition to mural painting in the early stage of the Renaissance. This article first appeared in slightly different form in *Art from the Mayans to Disney* (Sheed and Ward, 1939).

Postscript to a Destruction
of Frescoes

Non intrabit eunuchus, . . . Ecclesiam Domini.
Deuteronomy 23:1

The murals of J. C. Orozco and D. A. Siqueiros, even though unfinished and the painters still at work, have been stoned and mutilated by a group of students of the school on whose walls they are being frescoed. Newspapers and magazines have reported the event as if it was a jolly joke; the kick of the ass to the dying lion was given with fervor by a young poet whose connoisseurship is deficient enough to say that Orozco is a follower of Diego Rivera. As artist and as adolescent, he could have used his energy in behalf of a more generous cause. We will give the community the benefit of the doubt and say that those who succeeded in this wholesale lynching of art works were students refractory to studies. Though they do not know it, they acted according to a sort of unholy logic, as did other moronic minds which remain branded forever in the pages of History.

Much as the painter wishes to be considered a workman, it is true that his craft differs infinitely from other manual crafts. No solid citizen may question the usefulness of a

piece of plumbing well soldered, or of a wall laid straight; between him and their worker a mutual respect intervenes, based upon the laws of production and consumption. Such professions are of this world, inasmuch as they contribute to its cosiness.

In the same way, bad painters come within the scheme of established things. Their style, subject matter, and mood are in function of a demand. For patrons whose souls have poetic leanings, a painting of flowers hath charms. Less dainty folk can still be tickled by a peep at the inside of a harem bath. Such pictures are haloed with righteousness in the eyes of people law-obedient and of good taste. So popular are they that, minus their veneer of art, they are scratched on the wash room walls of our schools and even our ministries. This kind of art is aboveboard, obeys the laws of offer and demand as did the work of mason and plumber, acquires social status.

But when we consider painters who create their work with a straight intent, unwarped by any commercial lure, whose painting has been shaped by laws as unfathomed and painful as those which rule the birth of man himself, we come socially face to face with the unknown.

To be complete, a painting must be a channel for an idea, as language itself should be. But we know by past experience that whether it is hated by its public does not depend on the ideal expressed, but precisely on whether it is good painting. Habit and sloth accrue to things known long and well. When a pioneer creates a novel

Headline from Manifesto in Defense of the Muralists, July 1924

EL ARTE NO ES UN BIEN NACIONAL
SINO INTERNACIONAL
LOS EXTRANJEROS PROTESTAMOS ENER-
GICAMENTE POR LA SALVAJE DES-
TRUCCION DE PINTURAS MURALES

standard of beauty, it clashes with those already labeled and embalmed. If the work transcends an average instinct, it becomes an insult in spirit and letter, for, to contact it, one must look upwards. It is also a creation, and eunuchs never look with favor on virility.

One cannot explain the true painter in everyday terms. He sometimes works for a salary, but more often without. He is alien to a world where activities are spurred by the profit motive. Nor is painting included in the list of things necessary, as compiled by those sages who know that man lives only on bread. Good art exists rather on a spiritual plane, must experience disdain as do those other anti-social virtues of humility and poverty which are for their devotees a sentence to suffer and often to die.

This stoning of frescoes is but a link in a chain of similar events: the equestrian clay model of Leonardo shot to pieces by the arquebuses of drunken mercenaries; the Sistine Judgement condemned by Aretino on behalf of moral conventions; Rembrandt bankrupt; Gauguin poisoned, hiding in the mountains with the hope that ants would devour his body. The work mutilated is important, including as it does the admirable *Saint Francis Helping the Poor* of which no man could in good faith deny the grandeur.

What could the authorities do? What they did: stop the work in course, punish the painters for having attempted to bring beauty to those who have no need for it. Those great works, unique of their kind in the art of today, may be hastily whitewashed, a monument to the feigned candor

of those unjust judges. Will they beautify those walls by having their family photographs enlarged, to mirror and multiply, to the satisfaction of their sentimental bellies, the very image of their fruitless lives and of their immortal mediocrity?

A combat piece originally published in August 1924 in *Eureka*, the student paper at the Preparatoria School, at the time of the most intense opposition to the mural decorations in the school.

Diego Rivera at the
Academy of San Carlos

Toward the end of the nineteenth century, Mexico City was quite different from the cosmopolitan metropolis of today. Interesting sights, now disappeared, still surrounded the eighteenth-century building that housed the Academy of Fine Arts of San Carlos of New Spain, known since Independence as the National Academy. Facing it, at the corner of the Cerrada de Santa Teresa and the street of Santa Ynez, was the open workshop where the Indian craftsman, Guadalupe Posada, carved on type metal masterly engravings. Close by was the printing establishment of Don Antonio Vanegas Arroyo, who turned out on hand-manned screw-presses popular editions, strictly unlimited, of pennysheets, pious images, and street gazettes, reckoned today among the more authentic witnesses of their era.

Only two city blocks away from the Academy were still to be seen the last live vestiges of a time when Mexico-Tenochtitlan was the Venice of the Americas, its commerce gliding on the criss-cross web of its waterways.

Rivera: Self-portrait, as a youth walking with one of his teachers

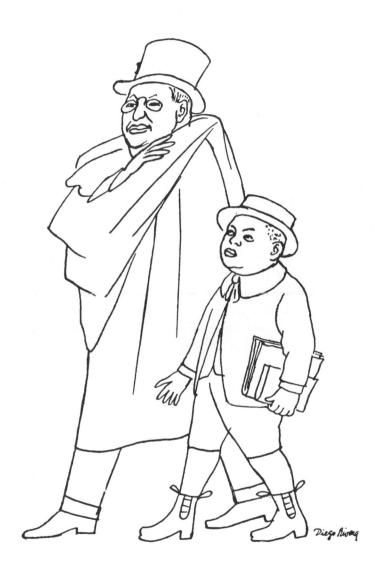

Diego Rivera

In the vicinity of Roldan Street the scene had scarcely changed from the one that Cortez sighted on arrival, and not at all since 1855 when Castro lithographed his busy plate, *The Roldan Bridge*, for the album that described Mexico City and its suburbs.[1] On feast days, and especially on that of Santa Anita, the usual traffic loads of vegetables gave way to boat-loads of flowers brought from the countryside on primitive canoes by Indian paddlers in white, and girls in native embroidered blouses and full skirts of hand woven material. Less gracefully, the city sewage flowed into the canal, and neighboring wine-shops catered to the noisy busy crowds gathered at the landings.

Diego Rivera entered the Academy of San Carlos in 1898, being then twelve years of age. What went on back of the school building interested him at least as much as the stuffy classrooms where, for the first two years, he drew exclusively from prints, mostly charts of noses, ears, feet and eyes. His fellow students, among them Ignacio A. Rosas, remember how Diego came to school in short pants and shocking-pink socks, his pockets full of fearful boyish things, bent pins, old strings and live bait that wiggled freely, minus the luxury of a container. Between classes, and presumably more often, the fat boy would sneak out along the back streets with lowbrow names—de la Alhondiga, de la Leña, de la Pulqueria, de Machincuepa—and, sitting by the canal, feet dangling close to the stinking waters, fish. At that, he must have found time to draw too: at the end of the first year his teacher, Andrès Rios, consulting with other members of the

faculty, pronounced Rivera's work "Very good, unanimously"; and the second year this estimate was topped with a "Perfectly good, unanimously."[2] Dating of one of these two first years is the most childish among his preserved student drawings, a medley of putti and garlands imbued with a naïve rococo flavor.[3]

From the copy of prints after plaster casts, Rivera graduated in 1900 to the rendering from actual plaster casts. Two of these drawings are still filed in the school archives. One is a bust of Homer, and the other a Venus of Milo, of fair semblance though standing on her head; such unconventional postures were meant to sharpen in the students an appreciation of proportions as such.

Diego's new teacher was the painter and etcher, Julio Ruelas, who has left a name and a work of enduring interest.[4] Dean of the faculty was Don Santiago Rebull, a born Ingrist and a disciple of Pelegrin Clavé, Catalan director of the Mexican Academy for twenty years of the mid-century.[5] Since youth, Rebull shared Clavé's admiration for the theories of the Nazarenes, German pre-Raphaelite expatriates who had lived and painted in Italy. As a result, the leaders of this forgotten art sect, Overbeck and Cornelius, were still worshipped in 1900 at the Mexican school. Like the Biblical personages that they painted, the Mexican Nazarenes grew apostolic beards, disdained fashion, and adopted an austerity of dress and deportment that the tiny salaries on which they raised large Catholic broods would alone have justified. Perhaps they overshot the mark in their disdain of niceties: it is told of Felix

Parra that, while correcting a student, he would reproach him mildly, "Move that line just a trifle to the left. Look here, no wider than the black under my nail."[6]

In 1901, Rivera added to his curriculum perspective and anatomy, and the drawing of landscapes, presumably after French lithographs. The next year, he began to draw from life, and to paint, but only from other paintings. In 1903, he "took" art history and painted from nature, both life and landscape. The latter class was under José Maria Velasco, who rates high in the history of Mexican art.[7] Velasco had been a student of Eugenio Landesio, an imported Italian teacher who rendered landscapes in a tight, sharp, and enameled manner, to which the genius of his gifted student added the silvery glow and spatial immensity of the Mexican plateau sights. It is through Velasco's teachings that Rivera was spared the stage of impressionism that he would have contacted at that date in Europe; Velasco's severely logical approach to optical problems prepared instead the young man for the further rationalizations of cubism. Rivera tells how the Mexican master introduced him to the classical concept of color, when correcting one of his juvenile essays, "Boy, you cannot go on painting in that way. In the foreground you put side by side yellow spots for sunlight and blue spots for shadows; but yellow comes forward and blue recedes, so that you destroy the very plane that you pretend to describe."

The final examination in landscape painting for that year took place in November. The locale was the park of Chapultepec, famous since pre-Hispanic days for its

ahuehuetes, gnarled ancient trees with a foliage subtle as mimosa's, that Velasco himself so loved to paint. "Having selected a site adequate for studies from nature, the jurors assigned a place each to the students registered for the test, and left. The students worked from 9:00 A.M. to noon for six successive days, under the supervision of one of the school prefects." The coveted medal went to a girl, Maria Enriqueta Gochicoa, with Rivera receiving a mention.[8]

That same year, 1903, a newcomer to the school faculty was Antonio Fabres, a Catalan like Clavé. His masterpiece, a Bacchanal, combining the subject matter of Velasquez and the style of Meissonier, had just been bought by the Mexican government for 12,000 pesos.[9] Fabres also was the inventor and exponent of a teaching method that he claimed to be no less than a shortcut to genius. Whatever the more seasoned members of the faculty may have thought of him, they kept it wisely to themselves because Fabres had just been named sub-director of the school in a personal move of the Dictator and President of the Mexican Republic, Don Porfirio Diaz, who befriended him. The director, Don Antonio Rivas Mercado, was a Mexican architect of some renown and of a lymphatic disposition.[10] At the beginning, at least, he made an honest effort to work in harmony with Fabres, but the task was to prove impossible. The school archives bulge with the irate haughty letters that the sub-director wrote to the director to coerce and frighten and bully him into submission.

Fabres failed totally to understand how respect was

due to the older teachers who were not only his betters as artists, but meant an irreplaceable link in the national tradition. In one of his written complaints, he referred to Parra, who continued, as he had done since 1882, to give to his students for models prints after the Masters, "You know very well that, in my system of drawing, approved by the government so that today IT IS THE LAW, there is no such thing as drawing from prints. If we keep it for the first years it is only with the understanding that, eventually, we shall be able to replace prints with photographs."[11]

Out of his own mouth, this ambitious man emerges as something of a charlatan, for example in this self-appreciation, "Sr. Fabres is the discoverer of the fact that, to insure quick progress in drawing and painting from the model, there is nothing equal to a certain sort of photographs that only he knows how to achieve. . . . Now that his claim has been approved, the Mexican school will lead all other schools in the whole world in this matter."[12]

It became the responsibility of the school photographer, Caboni, to put into practice the mysterious method. The explanations furnished by Fabres lacked technical explicitness, if we judge by the following note, "Fabres to Caboni:Please be present at the life class and at that of costume, there to take, by the use of magnesium and all other customary accessories, the photographs that I will tell you to take."[13]

The faith that Fabres put in the art of Meissonier, deemed indeed by most of his contemporaries to be the leading master of the age, went further than to favor

photographic exactitude over the great styles of the past. Meissonier was also famous for a zeal for accurate detail that, for example, made him borrow Napoléon's greatcoat from the Musée des Invalides, to give added historical validity to his tiny picture of the retreat from Russia. Fabres collected whatever paraphernalia was judged an indispensable adjunct of artistic success: old uniforms of grenadiers and musketeers, armors, spurs and leather boots, helmets, rapiers and daggers, rags of damask, velvet and goldcloth. These treasures, that he brought with him from Spain, became a never ending source of squabbles with harassed Rivas Mercado. Wrote Fabres, who spoke of himself decorously in the third person, but with an occasional lapse: "Señor Fabres reports the following to the Directorship of the school: the individual who models for the class of costume has put the one I gave him to wear in such a condition of filth that he [Fabres] asks how to proceed in this disagreeable occurrence, as he is loath to see this clothing depreciated from its artistic state. To give it to be washed would impair this quality, and its owner is equally unwilling to let it out of sight. In another case, a helmet was injured as well as a cuirass, and other clothing was unstitched and ripped." [14]

The true ambition of Fabres, that was far from secret, was to replace Mercado as director. His impatience in this respect led to an incident that afforded Rivera the opportunity for a first recorded act of rebellion. July 29, 1903, Fabres gave a paper to his students to sign, implying that it was only a routine class checkup. As the paper was folded in such a way that its contents were not revealed, the

signers had to take his word for it. A majority obeyed, but two of the adolescents refused to comply, saying that they would gladly give their names but not their signatures. The following day, Lino Lebrija, head janitor of the school, reported to the director, "Last night, students Rivera and Gutierrez were expelled from the costume class of Señor Fabres, because they refused to put down their names and qualifications."

Queried by Mercado, Fabres gave a heated version of the incident, "These two gentlemen, Rivera and Gutierrez, not only do they disobey in everything, but I know from what other students have reported, that they also attempt to recruit other boys, equally non-conforming, and loudly proclaim my actions and advice to be no better than nonsense and madness; . . . Despite my indignation, I did no more than to point out to them the exit door.

"If I may state my true feelings, it is that both may never again be seen in my classes. As they themselves have put it, of what possible use could it be to themselves or to myself that they be present only as active impediments?"[15]

August 1st, both students volunteered their own version, "Respectfully do we ask: How long is this punishment to last? . . . Are we at fault for refusing to sign a paper that was handed to us closed or folded, without disclosing its contents. . . . All that was said is that our names were needed, and we are at a loss to understand why our signatures were also asked for.

"Furthermore we suspected that this was another document, meant, it was rumored, for the President of the

Republic, disregarding orders issued by the Director."

A week later, Mercado received a surprise communication from the Ministry of Education that proved the shrewdness of these youthful suspicions: "The attached petition was sent to the President of the Republic, and was signed by sixty-four students of the school. . . . We answered the petitioners in the sense that they should obey the authorities as well as the rules of their school."

The enclosed document read, "Sir, . . . it is thanks to your generous initiative that we possess a great teacher. After surmounting initial jealousies, he won us by his vast learning, his fruitful lessons and the rectitude of his conduct. . . . Alas, Mr. President, we feel impelled to state that the Director does not share our views, perhaps because, being an architect, he is somewhat removed from our interests.

"Could it be possible that architecture be separated from painting, sculpture and engraving? Thus securing for Don Antonio Fabres the needed independence to fulfill the mission that brought him to Mexico. . . ."[16]

Enlightened, Director Mercado reinstated Rivera and Gutierrez. It must be said for Fabres that he held no resentment: in the final tests for his class, that were held in November, the medal went to Natcho Rosas, but Rivera received a mention.

The next year, 1904, the breach widened still further between director and sub-director. In a huff, Fabres took his famed wardrobe out of the school building. Mercado complained to his superior, the secretary of education,

Don Justo Sierra, "Since February 6, the students are drawing from the model just as he happens to be; that is in the clothes of the lower classes to which he belongs."

Whatever later generations of artists, who prefer to paint the Indian in his white *calzoncillos* or, even better, in overalls, may think, this was dismal news indeed at the turn of the century, and Fabres was begged to reconsider. Still referring to himself in the third person, he refused to comply in no uncertain terms: "Señor Antonio Fabres, as owner, sole owner, of the costumes . . . feels moved to answer, I repeat, AS THEIR OWNER, that he is resolved not to lend them any more."

April 19th, the students, reduced to the plight of painting Mexicans as they are, humbly approached the director, "Is there not a way of helping us to follow the opportunity of studying the costume? Such classes, besides being instructive, were also most entertaining, as much because of the knowledge gained of the diverse styles of clothing according to periods, as for the wealth of color and the artistic interest that it added to the model."[17] Having made his peace with Fabres, Rivera appears among the signers.

That year, 1904, Rivera got the coveted medal. The catalogue of the class show, that was held at the school, gives his first published biography: "Diego Rivera. Age: 18, Entered the school in 1898 and, after four years, was admitted to life-class."

In the next contest, held January 13, 1905, Rivera was again adjudged a medal, and this repeated success brought official repercussions:

"Office of the Ministry of Justice and Public Education.

"The President of the Republic graciously allows to student Diego Rivera a pension of 20.00 pesos monthly, payable at the School of Fine Arts and starting the first of the current month . . . as a reward for the medal obtained by the aforementioned student in the contest of painting from the costumed model. Mexico, January 17, 1905."

A student thus favored by the government was closely watched for progress. Every semester, the director gave a personal report, and a corresponding printed form, such as the following, was filled in, "The President of the Republic, considering that the student *Diego Rivera* has been of good conduct and of sustained application . . . graciously renews his order of January 17, 1905, to pay to *the aforementioned student* the sum total of *pesos 120.00* in monthly sums of *pesos 20.00*, so as to further the studies of *the aforementioned student*. July 1. Signed Ezequiel A. Chavez. Sub-Secretary of Education."

Rivera's pension was short-lived. The last document that concerns it in the files of the school also gives the reason; it is a curt reply by the sub-secretary of education to the next semestrial director's report on progress and conduct, "From the contents of your communication of the 8th of the current month, notice is taken of the fact that the pensioned student Diego Rivera entered the contests of life-drawing and coloring without obtaining any positive results. Mexico, January 12, 1906. E. A. Chavez."[18]

Soon after, Fabres lost favor with official circles. His epitaph as a teacher was written by Rivas Mercado, in a letter to the secretary of education, Justo Sierra, "It is by now public knowledge that photographic cameras are used in his classes, but Señor Fabres and his group may not any more have this supreme recourse to dazzle laymen and to waylay their own selves.

"His incompetence as a teacher should be easy to demonstrate, once he is despoiled of his only weapon in the competition of lawful teaching. I refer of course to the *camera lucida*, with whose powerful help he surprised the good faith of men unversed in matters of art." [19]

That same year, 1906, an exhibition was held at the Academy of the work of twelve artists pensioned to go to Europe, or who sent their contributions from there. To recoup his loss of a federal pension, Rivera had just received another one, this time from the Governor of the State of Vera Cruz, General Teodoro Dehesa, and was making ready to go abroad. As a result, Rivera was also included in the group show. His display was substantial enough to constitute a first one-man show, and has been referred to as such by his biographers. The paintings, listed in the printed catalogue of the show, were all Mexican landscapes, brushed under the star of Velasco: *Vera-Cruz; Foggy Day, Xalapa; Queretaro; San Angel; Mixcoac;* etc.... Rivera's earliest style of landscape painting can be gathered from the small picture of the volcanoes that he still owns, where the pigment is applied with circular rhythmical strokes of a sensuousness that was not to outlast his European experience.

Gerardo Murillo, better known under the name of Dr. Atl, was busy in 1906 at an inventory of the ancient pictures piled in the storerooms of the school.[20] It was Atl who, acting as a friendly salesman, sold enough of Rivera's landscapes to buy him his passage to Europe, that the meager State pension could hardly provide. It was also Atl who wrote a personal letter of introduction to a painter friend, Eduardo Chicharro, who became Rivera's teacher in Spain.

[1]"Mexico y sus Alrededores," V. Debray, editor and publisher, Mexico, 1855.

[2]Archives of the school. 1905–10, "Alumnos certificados." It contains a detailed account of Rivera's activities as a student, up to December 2, 1905.

[3]Collection of student drawings, in the care of the school librarian, Señor Lino Picaseño. 1763–1913.

[4]Born Zacatecas, 1870. Died Paris 1907. Studied at the University of Karlsruhe, Baden, Germany. A pre-surrealist, working under the influence of Boecklin and of Félicien Rops.

[5]Rebull: Born at sea, from Spanish parents, 1829. Died Mexico D.F., 1902. Rome prize, 1852. Professor at the Academy since 1859. Was Director of the school under Emperor Maximilian. Clavé: Born Barcelona, 1810. Died there, 1880. In Mexico, he was official dictator in matters aesthetic from 1847 to 1868.

[6]Parra: Born Morelia, Michoacan, 1845. Died Mexico, D.F., 1918. Professor at the school since 1882. His best known picture: "Father Las Casas, defender of the Indians."

[7]Born Temazcaltzingo, Mexico, 1840. Died Villa de Guadalupe, D.F., 1912. Professor at the Academy since 1868.

[8]Archives, "Libro de Actas," p. 165.

[9]Papers relating to the transactions in Archives, 1905–2.

211

[10] Mercado's best known work is the Column of Independence, in the Paseo de la Reforma, where the ashes of national heroes are enshrined.

[11] Archives, 1903. "Asunto Fabres," March 29.

[12] *Ibid.*, 1904–7, "Comunicaciones del Sr. Fabres."

[13] *Ibid.*, April 29, 1904.

[14] *Ibid., n.d.*

[15] *Ibid.*, 1903–41, "Expulsion de dos alumnos," for both documents.

[16] *Ibid.*, 1903–33, for both documents.

[17] *Ibid.*, 1904–7.

[18] *Ibid.*, 1906–8, "Pensiones," for both documents. The first one is a printed form. The italicized words are added by hand.

[19] *Ibid.*, 1906–34.

[20] *Ibid.*, 1908–23.

This article first appeared in slightly different form in *College Art Journal*, Vol. X (1), Fall 1950.

Diego Rivera
in Italy

Until 1920, Diego Rivera was a bona-fide member of the School of Paris, consciously lost in esoteric pursuits that held more than a touch of plastic alchemy. His return to Mexico, late in 1921, marks the beginnings of his present fame as a leading muralist, painting for the people at large. What were the reasons that brought about this sudden change of heart and radical change of style?

Rivera left Mexico in 1908 at the age of twenty-two, returning briefly in 1910, only long enough to hold there a one-man show. In 1920, if Mexicans thought about him at all, it was as an expatriate. Writing of the work of Saturnino Herran, a stay-at-home Mexican artist, the critic Manuel Toussaint stated:

"When he refused to leave his country, Herran made it impossible for Europe to tear apart from us his spirit and his art, as it had done with Zarraga, Diego Rivera, and many another artist who, though Mexican by birth, by fame and works is European."

Mexico's loss was Europe's gain. In his *L'Art vivant* (1920), the French critic André Salmon included Rivera— with reservations born of personal enmity—in the narrow

circle of the Parisian group. There was even what amounted to a consecration of this recognition, the publicity attendant on a mild aesthetic scandal (in which the dealer Léonce Rosenberg also figured) that came to be known as "*l'affaire Rivera.*"

Ramon de la Serna described the Mexican artist in Paris:

"In this studio hung with black curtains . . . Diego lived between colors and bottles of Vichy mineral water that he fed to his voracious liver. . . . With the coming of night, he would further his inventions by candlelight."

André Salmon went into details concerning one of these inventions:

"He had built a curious tool, a sort of articulated plane, like the one made of paper that engravers use to make their tracings. . . . Rivera even claimed to have found the true secret of the fourth dimension."

A co-worker with Rivera was Gino Severini, who in 1917 published in *Le Mercure de France* a summary of their joint experiments. It mentioned also the "curious tool" that Salmon attributed to Rivera, but claimed by Severini as his own:

"In my personal researches, I carried my experiments to the point of combining together planes made of paper and cardboard, which could be made to move by rotation and by translation. . . .

"To satisfy my curiosity I looked into qualitative geometry for the most evident demonstration of the

Charlot: Portrait of Diego Rivera, 1922

fourth dimension. I knew beforehand, however, that geometry could do no more than strengthen convictions already arrived at in our group by common artistic intuition. . . .

"Placing oneself at the point of view of the physical sciences, it is possible to create a new world in a space of four or of *n* dimensions. Thus, a parallelism may be drawn between the phenomena existing in world 1 and those existing in world 2. Inventors (wireless telegraphy, etc.) proceed thus, and it is equally licit for the artist to do so.

"As the painter Rivera, following Poincaré, justly observed, 'A being living in a world with varied refractions, instead of homogeneous ones, would be bound to conceive of a fourth dimension.'

"This milieu with distinct refractions is realized in a picture if a multiplicity of pyramids replaces the single cone of Italian perspective. Such is the case with certain personal experiments made by Rivera, who sees in Poincaré's hypothesis a confirmation of some intuitions of Rembrandt, El Greco, and Cézanne."

By 1920, in faraway Mexico, the military revolution begun in 1910 gave signs of cooling off, somewhat uncertainly, into a period of civic reconstruction. One of the young politicos violently risen to power, José Vasconcelos, Secretary of Education, now dreamt of a vast plan of cultural renaissance: music, poetry, architecture and mural painting were to be put at the service of the people at large. Vasconcelos' slogan, repeatedly expressed, was: "If genius has such an exalted standing,

it is because of its capacity to serve the people best." To further his plans, the Secretary not only commissioned works from artists already in Mexico but zealously started a roundup of those who had strayed abroad. Rivera was among these.

From the correspondence now filed in the national archives, it appears that Rivera was loath to return to his *patria* without first having visited Italy. Vasconcelos, for his part, felt grave reservations as to the fitness of cubism as a means of edifying the masses; perhaps an Italian trip would prove a shock treatment to cure the painter of his prideful isolation.

In November, 1920, the Secretary wired Rivera a sum of two thousand pesos—then the equivalent of a thousand dollars—ostensibly for fulfilling a mission connected with a reform of art teaching. In practice, by mutual understanding, the money served to pay for the coveted Italian trip.

Doubtless Rivera had heard of the cultural slant of his patron in aesthetic matters, and thus knew what to look for in Italy—some formula that would ease the transition from ivory tower to public walls, in preparation for the kind of job that he hoped awaited him on his return to Mexico. His conversion was genuine, at any rate, as his interest veered from occult experiments towards communal manifestations, so splendidly and publicly realized in ancient Italian towns. He described his reaction in a letter to the Secretary, dated January 13th, 1921, and posted from Venice:

"Thanks to this sum, I am now realizing that tour of

Italy for which I so longed. . . . It would be superfluous to state of what crucial importance it is for everything that concerns my craft—but even I failed to realize in what measure, and how emphatically so. . . .

"Here one feels, sees, touches and apprehends how the diverse materials manipulated by the different crafts unite, collaborating with, merging within, and exalting each other; until they make of the whole—building or city—a sum total that is function and expression of life itself, a thing born of the soil, organically tied to life— the living life of today, and past and future—a thing lifted above all the factors dependent on time."

Some such feeling is reflected even in the hasty land-scapes that Rivera sketched, perhaps from train windows: medieval towers, square and crenelated, soaring over vineyards and low walls, their tops level with those of the rounded hills; cypresses and towers—nature and archi-tecture—grown together in geological compactness.

Early Christian and Byzantine mosaics, in close inter-play with architecture and outspoken in their public message, proved a corrective lesson that Rivera could never forget. In Ravenna, he sketched the processionals of San Apollinare Nuovo and heads from the twin mosaics of Justinian and Theodora; he drew the outlines of the river god who witnesses the Baptism of Christ on the ceiling of the Arian Baptistery. An unidentified sketch stresses the theme of murals linked with architecture, and the relation of both these arts to life: men kneeling in

Rivera: River god. Detail from Baptistery of the Aryans, Ravenna, 1921

prayer are seen against the backdrop of a mosaic saint, gigantic in scale, geometrized to blend with the surrounding architecture. Slight as was this scribble, the sensation it recorded proved a lasting one. *Creation*, the first mural that Rivera painted on his return to Mexico, followed to the letter the style and scale delineated in the sketch.

Rivera's conversion to muralism, experienced in the presence of Byzantine mosaics, had no need to take the form of a *mea culpa* for lost time. It was rather an overt expansion of what, as a cubist, he had discovered and experienced in secret. The same letter, quoted above, had this to say concerning his experimental Parisian period:

"The little I did was always meant to be shared with all, even though it happened between the four walls of my studio and far away. . . .

"During all these years, all my efforts were bent on gathering all the data I could, up to the limit of my strength; so that, once back there with you and our people, I would attempt to make it work."

There is hindsight growing out of his Italian trip in this justification of his recent past, politically addressed to Vasconcelos; but it remains true that a passion for geometry stamped the ancient murals as forcefully as it informed the best of cubist works.

Rivera could feel at home in yet another period, as starkly intellectual as his own, when painters who were also geometricians computed the laws of Italian perspective and defined the "divine proportion." In the proud words of the cubist Severini:

"Sympathy for science existed also in the times of Paolo Uccello, Andrea del Castagno, Domenico Vene-

ziano, Luca Signorelli, Leonardo, etc. . . . These were realistic painters in the widest sense of the word, just as we are."

Indeed, in Florence, Rivera drew an intense set of sketches after Uccello's *Rout of San Romano*. Stressing the fan-spreads of ruled lines, he exaggerated the artificiality of horses and armor to such a degree that they seem to become the cogs and pistons of Rivera's own machine age. Intent on muralism, he must have longed to know how the Uffizi panel, together with the companion pieces in London and Paris, blended with each other and with the lost architecture for which they were originally planned.

Rivera's Parisian experiments spectacularly touched on the topic of a fourth dimension; but also, more sedately, on the problem of illusion in depth and its proper degree of relationship to the flatness of the canvas. It was with iconoclastic gusto that the impressionists had collapsed the backdrop used by classical masters to dam in the pictorial space. In turn the cubists—Rivera included—questioned the impressionists' spatial nonchalance, eschewed its doubtful freedom and returned to the older concept of a measurable space.

As Rivera began to think in terms of murals, additional problems were raised that cubism had as yet had little occasion to meet. These were concerned with the tying together of the picture and the surrounding architecture— the ordering of illusionistic painted space to fit the inner space of the sustaining building. The Mexican looked to the old masters for a key to the solution. This uneasy intercourse between the two-dimensional and the three-dimensional elements made Rivera forget for a while his

search for a fourth dimension; but the system of analysis that this search had bred, based on the translation of lines and the rotation of planes, proved as fruitful when applied to the Italian masters as it had already in the case of "Rembrandt, El Greco and Cézanne."

Even though Mantegna was omitted from Severini's list of precursors of cubism, his steel-hard compositional solutions, his passion for perspective riddles and impersonal goals could easily qualify. Rivera's sketch after Mantegna recalls the murals at Padua with the hallucinatory bulk of their Roman architecture—perhaps, more specifically, the *Baptism of Hermogenes*.

Rivera noted on this sketch:

"Construction where the actual partitioning of the surface follows guidelines relating to depth; thus creating a surface harmony shot through in make-believe style by the architecture. The frightening relief does not violate the surface."

In Verona, Rivera called "magnificent" Bonsignori's *Madonna*, steeped in Mantegna's spirit. In Rivera's sketch, the Infant Christ, sterner than in Bonsignori's painting, lies forlornly on the slablike cube of cubism and reveals even more clearly than does the painting its indirect prototype, Mantegna's *Dead Christ*—its drawing cruelly foreshortened on the aesthetic rack of scientific perspective.

It was also in Verona that Rivera studied Stefano da Zevio's *Virgin and St. Catherine in a Rose Garden*. He skilfully isolated the geometrical backbone of the delightful

Rivera: Sketch after Stefano da Zevio, Verona, 1921

hortus conclusus, dividing the surface into halves and quarters, with diagonals abutting the golden sections. The basic heptagon is apprehended more readily in the sketch than in the picture, where it is overgrown with quaint accessories that seem to turn the initial scheme in depth into a *millefleurs* tapestry.

Writing as always in French, all over the remainder of the sheet, up and down and sideways, Rivera managed a word picture of the tender epidermis he had so ruthlessly skinned off in his drawing:

"Excellent surface composition. Birds the size of angels, angels the size of live birds. St. Catherine seemingly feeds a bird while receiving from an angel the palm of martyrdom.

"Angels' heads are as big as are the roses in the mystical rosebush of Stefano da Verona.

"The Virgin and Child. All is gold outside of paradise. Within, all idea of optical scale is destroyed and all is in the spiritual order. It is extremely truthful and gentle."

Here was a new, or rather a forgotten, kind of fourth dimension, different from the cubist one. Rivera could not remain insensitive to its spiritual depth, even though its extent was not to be measured by rotating or sliding the parts of a cardboard device.

A thirty-five degree tipping of the upper left corner of the picture, sliding around the golden section, was Rivera's way of expressing the dynamics of Giovanni Caroto, *The Temptation of Christ*. The note scribbled in the margin of the sketch is partly autobiographical:

"Surface composition with golden section, the half and

the square of the picture.

"Mediocre painter. Construction depending too much on figures *inscribed* with too many foreshortenings and *accidental postures in depth*, stressing surface lines.

"Try to avoid this defect; danger for myself."

Problems of technique and color at times took precedence over those of composition. In Venice at the Scuola di San Rocco, Rivera puzzled, pencil in hand, over a fragment of a frieze by Tintoretto. Off-size and folded back high on the wall where the mural canvas belonged, this fragment had been recovered intact in 1905, unvarnished and apparently unfinished. Maurice Denis had already lucidly written in 1910:

"In it were apples painted in a pale green and bright red on a ground of Veronese-green leaves. *It is all color.* One would call it a Cézanne. Perhaps it lacks the finishing touch of umber that would have sobered it, but, such as it is, that precious fragment indicates in Tintoretto an effort at chromatism altogether similar to that which I have explained in Cézanne."

Rivera wrote in turn:

"It seems as if one is looking at a thing of *père* Cézanne, painted in casein. The grain of the canvas is much in evidence and one feels how the brush, agile and hurried, acts with the rather liquid pigment.

"There is no varnish whatsoever. Perhaps the coat of varnish was added after the canvas was put up in position? Perhaps one worked slightly with glazes in the fresh varnish to harmonize once the thing was done?"

Notes on color are scattered over the drawing: "Earth-

red with accent of pure vermilion. Orpiment yellow. Cold neutral tone. Green warm and transparent. Blue-gray identical to that of *père* Cézanne."

This Mexican, thinking aloud in Venice, jotted down his thoughts in French. Gallic habits showed more deeply than in the language alone. The whole glorious *décor* of San Rocco with its painted giants twisted in holy and violent actions was gently outweighed for Rivera, as it had been before him for Denis, by three apples, Cézanne-touched.

In the Doge's Palace in the same city, Rivera sketched Tintoretto's *Three Graces and Mercury*. He felt at ease while ruling the diagonals that divide the surface area of the picture into quarters—more so than when rendering the spiraling depth, with its streaks of chiaroscuro disembodied from actual plastic form. He noted: "Quite close to a window. A picture in which the composition is arrived at by color, determined by the effect and dynamism of the physical light."

A point that Vasconcelos, in his desire to lure back the artist, had perhaps failed to make clear was that the Mexican art renaissance was launched practically minus a budget. Rivera dreamt active dreams under the baroque ceilings of the Doge's Palace, jotting down blueprints and recipes that in time to come could help enhance his own mural paintings with sculptured panelings and embossed gilded reliefs. He noted of the *Sala delle Quattro Porte*: "Ceiling by Tintoretto. Architectural scheme by Palladio. Color alternating cools and warms"; and of the *Allegory with Doge Girolamo Priuli* and attendant panels: "Pictures

in frontal perspective with very low horizon. The imitation bas-reliefs in monochrome painted in very warm tones."

That the artist was not craning his neck in idle awe of the unattainable is proved by his very practical sketch of a mural scaffold:

"A scaffold for working on ceilings, very simple to move by sliding it over planks greased with lard, slipped under the front legs raised by means of wooden screw-levers.

"To apply the canvas to the ceiling it is raised from the ground in this way, after having fixed the suspending screws in place very exactly by trial with the stretcher alone. The scaffold is put back in place after that."

Back in Mexico, Rivera managed to put to use his splendid Venetian experience—with simpler accessories and cheaper materials, it is true—in the partitions that artfully divide the ceiling of the chapel at Chapingo.

In Chapingo, Rivera embodied still another Italian memory—Sienese this time—when he painted two panels on the contrasting themes of good and bad government, in homage to the Lorenzettis, the first muralists to deal openly with political themes.

The long-range significance of the Italian trip turns on the artist's disaffection from the esoteric in favor of a means more suited to painting on public walls. The Italian sketches prove how reluctant Rivera was to move toward a representational painting style, how he clung instead to geometry as the one safe common denominator between his work and that of the old masters. The con-

temporary aesthetic etiquette of Paris decreed that story-telling was unbecoming in art; thus conditioned, Rivera's thought habits automatically played down the rich subject matter found in Italian masters and shied away from the human moods inescapably attached. He understood, however, how a dramatic change of approach was implied if he was ever to become painter for the people at large. Notes that the artist himself dictated on his stylistic evolution, after his return to Paris from Italy and just before his departure for Mexico, show this awareness:

"1914–1915: deductive cubism.
"1915–1917: transition cubism.
"1917–1920: comes close to Cézanne and Renoir.
"1920–1921: trip to Italy; a new tendency, to humanize."

As the careful wording implies, this humanization was as yet only a tendency. Even later, back in Mexico once more, Rivera's first mural, Byzantine in style and content, was thus planned so as to postpone for a while longer the unavoidable conversion to realism.

There was, however, another facet to Rivera's work, perhaps begun as a form of relaxation from the abstruse research cited by Severini. In Paris, Rivera had drawn a series of heads keenly observed— The Nun, The Laborer, The Widow, The Bureaucrat, The Boss—with a touch of nineteenth-century humor à la Grandville or à la Cham. On the Italian trip, he also made a few sketches in this realistic vein, such as one of a female addict giving herself a

Rivera: Sketch of a Mural Scaffold, Italy, 1921

hypodermic. In a similar strain Rivera was to jot down on his arrival in Mexico market scenes and provincial types. Even before the completion of his neo-Byzantine mural, these notes after things seen eased the way towards the long-delayed change of style.

Not until 1923, in the frescoes for the Ministry of Education, did Rivera combine his abstract computations with realistic observations in an openly dialectical style.

This article first appeared in slightly different form in *Magazine of Art,* January 1953. Reprinted by permission of The American Federation of Arts.

Diego Rivera:
Watercolors

Among the figures of the first rank in contemporary art, Rivera stands out as the more objective master, meaning perhaps that his head consistently retains a priority over his heart. This also explains why Rivera is unashamedly an eclectic, who backs his own style with chips out of a history of art that he knows and appreciates better than many a scholar. Even if he were a less gifted artist, this position would single out Rivera from among his colleagues, who prefer to tug at their own heartstrings and to perform strictly personal antics with the brush.

Thus, what comes perilously close to a lack of originality —at least according to the contemporary usage of the term—has come to constitute Rivera's originality. While the passionate output of Orozco exhibits all the idiosyncrasies expected from the composite personage known as the modern artist, Rivera's work remains out-of-bounds.

Those who have looked too long and too exclusively at the School of Paris are apt to dismiss Rivera, especially in his later manner, with a shrug and an epigram such as "an academician in wolf's clothing." Other less impatient minds, by taking time to relate his work to past periods

of art, are able to follow its filiation through Ingres and David to the *peinture d'histoire* that was considered the one noble genre in the eighteenth century. One may indeed marvel at the sturdiness of the painter's convictions as he builds slowly through a lifetime his challenge of hard work, good craft and common sense, setting it as a potential dam against the tumultuous eddies of today's taste.

This portfolio deals only with the least difficult facet of Rivera's vast *oeuvre*. Its plates are tastefully chosen from among the many watercolors that are to the muralist both a relaxation and a merchandise—as Degas inclined to call his own pastels—trimmed to reach a public that huge immovable walls cannot tap. Other watercolors of this same vintage have already proved best-sellers in the field of color reproductions, thus suggesting a publisher's reason for this expensive publication.

Even though it does not represent Rivera at his greatest, this work, sound in plastic and in human content, deserves a more thoughtful presentation than is apparent here. A dispassionate appreciation of the quality of the four-color plates would raise perforce a question as to the integrity and power of mechanical reproduction, even when of relatively high caliber. Cool minds usually take it for granted that photography can do no wrong, and yet, in this case, the original image can hardly be said to emerge intact. The range of the printer's ink fails to follow the nuances of its fluid washes, and the clarity of its lineal statement is fuzzed over by the requirements of plate-

Rivera: Women from Tehuantepec. 1922

making. It looks as if the originally crisp watercolors had been left in a tubful of water to soak overnight.

In the field of art criticism, this publication does little to increase our understanding of Rivera. The text—written by Samuel Ramos and handsomely printed—is an amiable paean of praise for the painter, rather than the general dissertation that its title, "The Style of Indian Mexico," would lead us to expect. To make of Rivera the single pivotal factor of Mexican art is to disagree with the facts. He returned to Mexico in 1921; but already in 1913 and 1914, Francisco Goitia and Dr. Atl had penned manifestos as detailed as blueprints for the coming renaissance.

According to Ramos, Rivera, on his return from Europe "is seized at once by the idea of creating a native Mexican style to give adequate expression to the Indian world." And yet Rivera's first mural, an encaustic unveiled in March, 1923, over which he labored a year, was so heavy with reminiscences of Byzantine Italy that his biographer, Bertram D. Wolfe, saw fit to label it "a false start."

Similar oversimplifications, intended to bolster Rivera's posture in art history, fail to explain the telltale *volte-faces* that stamp his early frescoes with an unrest close to greatness. Those who worked with and near him at the time of his return to the *patria* remember still the fierce inner conflicts—exploding at times into outward crisis—that marked his conversion to fresco and to Mexico.

The Paris where he had lived for eighteen years held beliefs opposed to those of post-Revolution Mexico. Nowadays, after surrealism has again made storytelling,

or at least a certain kind of storytelling, fashionable in painting, it is difficult to recapture the narrowly puristic creed held as the only truth in the best-informed Parisian circles around 1920. Then a dash of the literary in its make-up was enough to brand a picture as unworthy. It was the period when Jean Cocteau defended Pablo Picasso with vigor from the unwitting "insult" of an innocent newspaperman who had referred to a group of two nude figures painted by the Catalan as representing *Adam and Eve*. The same Cocteau proclaimed still-life as the supreme genre, because it was less tainted than others by psychological inroads. If anyone had had the audacity to attempt it, a cardinal sin in 1920 would indeed have been a didactic painting with historical subject matter. Just this the Mexican painters were set to do.

Rivera had shared for a decade in the lore of prejudices, loves, and taboos that inspired the small group of pioneer cubists who were his colleagues in France. After his return to Mexico, even though he soon became a leader of the local movement, his cubist-trained conscience could hardly stomach, at times, the resurrection of didactic painting that surged as an aftermath of the Revolution. His early frescoes even attempted the impossible: to reconcile his cubist manner, bred experimentally in the hothouse of a studio, with the very different plebeian requirements of dialectical painting. States Ramos blandly, concerning that time, "Rivera began his creative period already with complete awareness of his stylistic aims."

What constitutes the more original feature of this publication, and one that by itself makes it worth owning,

are the illustrations scattered through the text. They are in the manner of simple linecuts after originals in brush-and-ink of a bold type, and never before reproduced as successfully. These are the kind of apparently simple drawings that most American publishers, alas, esteem just right to suffer substantial reduction in layouts. These brave studies are reproduced here at what could be their original size, and thus escape the weakening of impact and content that accompanies a shrinkage in size.

It is revealing to compare the stylish make-up of this portfolio, issued in a limited edition, with the graphic means favored by the Mexican artists in an earlier phase of the movement. Then the organ of the group was *El Machete*, a sheet printed on the cheapest paper, made to sell on the streets for a penny. Its biting woodcuts were woefully lacking in what attracts decorators seeking a certain kind of picturesque, neatly packaged and "suitable for framing."

A review of *Diego Rivera, Acuarelas: 1935–1945*, intro. by Samuel Ramos (Studio Publications, 1948), this article first appeared in slightly different form in *Magazine of Art,* March 1952. Reprinted by permission of The American Federation of Arts.

José Clemente Orozco

1928

". . . and the King strolled proudly over the streets of his capital, dressed in magnificent garments, the weaving and embroidering of which had cost several fortunes. No one could see any clothes at all, yet no one dared a question. And the King said nothing for his regal eyes could not perceive less than those of his vassals. Courtiers bowed and crowds cheered. A child shouted: 'He hasn't any clothes on!'"

We, post-cubists, are likewise strolling, proud of our metaphysical garments, golden section, fourth dimension, tactile qualities, etc. The critics laud our regalia, the public stands in awe—each stroke of Orozco's brush echoes the child's voice.

His sources are genuinely American. The United States contributed the mechanical element to his work, Mexico the dramatic. The Italianate rash from which he suffered a while, his dipping into cubism, show his irritation at being different from the herd. A failure as a plagiarist, he now resignedly explores his own untrod jungle, blasts his own road.

Every valid artist lives ahead of his era, connives with

and enriches those not yet born. Pitted against contemporary taste, he remains alive when his epoch dies. The artist of today, terrified of the spirit, remains bogged in the letter. Cubism dictates his output, clamps onto art an inflexible carcan. Lone rebel, Orozco maintains the supremacy of the spirit, unafraid of describing facts and raising issues.

Compared with orthodox moderns Orozco appears romantic. This dubious dubbing comes from the lips of those who idolize geometry in paint, devotees of the golden section and priests of dynamic symmetry. They are right for this instant of time, but in a few years, when cubism and neo-cubism will have receded into the past, this romantic label will wash off, a more essential quality will appear, Orozco's work will be called monumental.

This tectonicity grew in ratio to the limitation of means that the painter imposed upon his work, a technical famine that would have crippled a less heroic personality. In his latest and greatest frescoes, the multiplicity of colors gives place to a palette of vine black, ochres and bluing blue. Having shed much academic pride, his drawing is now audaciously simple. His murals are at ease within an architecture, not because he paints people gigantic in scale, but because of a symphonic quality that stresses mathematical intervals, a denominator common to music, architecture and painting.

Such discipline answers an ascetic urge. Blessed with uncommon craftsmanship and thorough anatomical

Orozco: Detail from The Flag. Lithograph, circa 1928

knowledge, the painter casts aside all that was his already, and to better commune with his daemon, lets go of accidentals. Looping the loop, his most recent works seem so easily begotten that many a pedant, granting that they are good sketches, insists that he could not carry them through. This digestion of man by his own blazing vision is indeed a perennial drama. This drastic purification denies everyday necessities, laughs away the advice of friends and critics alike. The struggle left aesthetic scars in his early frescoes, but the peace won is also strength, not the languid state of the weak, in which no conflict exists, nor passion. A climax of emotion permeates this art, suiting the esthete who sees there abstractions, enthusing the moron with its melodrama. The painter, vomiting both, fears mostly the nudge of the intellectual.

In his work, the processes of ideation, composition and technique succeed each other quickly and are so interwoven as to be practically simultaneous; the artist himself cannot dissociate them. He said once, "painting comes as natural as eating." But Nature is not simple, and the phenomena of nutrition, digestion and assimilation, in its complexity which the man who eats blessedly ignores, is an excellent parallel to this phenomena of painting, physiologically latent in Orozco.

The core of his work is this inspiration which neither recipes nor example can transmit, whose rules can be mastered only by spiritual experience. When at work, the painter must remain in a mediumic state of passive expectancy, for all efforts to press a conscious logic on the wall in

gestation would result in injuring those imponderables more vital to his art than articulate laws.

Orozco expresses his concepts anthropomorphically: man reigns in his work, his tools, his architectures; landscape appears only in shorthand version, to strengthen by contrast the theme. This obsession with man is not eulogistic, for the artist relishes the debility, the inconsistency of his subject. He describes the human search for logical and beautiful aims, but the gesture lacks reach before, and fruit after, its apparent consummation. His men are not actors in the mimicry of despair; they just huddle together, bathed in a super-human, even anti-human influence which fills their lungs, oozes from their vitals. If Orozco was a true pessimist, his art could not match the positive affirmation of an architecture. Man frustrated affirms a potentiality of grandeur. Thanks to the three positive virtues, Introspection, Force and Grace (fresco in the House of Tiles) man harmonizes in the end with the invisible.

His plastic solutions are simple and lucid. To fill an arch he arches a human spine (St. Francis). He frames a door within two diagonals whose optical junction functions as pediment (entrance to stairs, Preparatoria). An unbuttressed diagonal crosses a whole area (The Trench). Orozco, inch-rule in hand, does his best to compose in two dimensions, to carve a plane into appetizing portions, as his post-cubist colleagues do. But he is born to greater things, to compose in depth, ordering orbits for the revolution of volumes in created space. Projected upon the

vertical of the wall, such depth composition will leave a two-dimensional residue only as its corollary.

Though saturated with dangerously dramatic elements, Orozco's painting remains plastically sound, for he is an artisan well able to handle his tools. He himself has a hand in the slacking of his lime, the sifting of the sand. Rather than for psychological reasons, his colors are chosen for their permanency in fresco. He gave proof of his respect for the physiology of murals when he asked his master mason and his gang to repaint frescoes partially destroyed by a mob. Having built up the wall and ground the color, their physical intimacy with the job seemed to him an ample corrective to their lack of aesthetic training.

The ideas expressed in those murals sum up into an impressive creed. When cornered, Orozco denies being responsible for those thoughts, admits they are his only as they tie technically with the wall.

He does not bow to the Past in the solution of his daily task. If his compositions clash with historical precedents and euclidean postulates, the artist begs forgiveness, but does so with a smile.

1947

In an epoch when hearts were stouter—or purer—than now, Flemish justices saw fit to decorate their courts with murals warning against the dire punishments meted out to unjust judges. A favorite was the story of the magistrate who was skinned alive, and his pelt used to upholster the judicial bench. When José Clemente Orozco was com-

missioned to decorate the Supreme Court Building of Mexico City, had he known this anecdote, he would have rejected it as too mild. As it stands, his painting is more disquieting than the ancient ones, being a sweeping indictment of all human justice rather than that of a single scoundrel. To the doubtful enjoyment of Mexican judges who must pass the murals every day on their way to court, Orozco chose to literally broil human lawmakers and justice dispensers on a set of divine spits.

The walls are painted in a kind of *buon fresco* pressed into the service of untried ends by a powerful and esthetically lawless personality. Orozco's technique has only its chemistry in common with the delicate washes of ancient Italian frescoes so blanched by the centuries as to meet spinsterish tastes. His come closer to the opaque, lime-thick Slavonic murals; and the modelings, contrasting dynamically active hatchings of black and white, could be a muscular free-hand adaptation of the delicate webs of gold that highlight the veils of Byzantine Madonnas. But the little that remains of the routine wisdom of ancient recipes is done violence to by sustained inspired improvisation. Seen at arm's length, the disjointed brushstrokes are only a puzzling giant calligraphy. A far greater distance is needed before the walls are ready to disgorge their searing message.

As to subject matter, compact diagonal columns of Heaven-sent fire are the one flaming accent in an otherwise colorless world, conjured up mostly with moss green and corpse gray. A timid, vitiated echo of this burning red are the Phrygian caps with which respectable-looking masked bandits attempt in vain to deflect the well-aimed lightnings.

Massive bookshelves, raised like skeletal skyscrapers, and shaken by the attendant earthquake, pour out books and stacks of legal documents as if they were wounded innards. On a high pedestal in front of a tottering, half-split palace of justice, Justice herself lolls through the conflagration, sword and neck limp, snoring mouth agape. A giant empty closet opens, and before its disclosed vacuum, a kitchen table parades as a legal bench. The judge's chair, stuffy with plush and gaudy with gold, lies upset, buried in a mounting sea of notaried papers curled by the flames. The inhabitants of this, Orozco's private planet, hide their judicial features behind safe-crackers' kerchiefs, give false weights on the scales of justice, pronounce loaded decisions, or, less subtly, sock and bind poor adolescent orphans, gag and rope night watchmen, stuff a hastily gathered loot inside bulging knotted sheets.

One of Orozco's latest mural ensembles, this one, like all the others, has the power to irritate layman and art critic alike. The former resents the indecency latent in the totally unabashed exposure of romantic inspiration, fears the nugget of truth latent in the gross indictment. The latter, whose delight is to burrow a sniffing way under the surface of an art work and retrieve with canine fidelity what influences, trends and comparisons are hiding in there, is stopped still in his tracks by an originality not yet catalogued in history.

José Clemente Orozco was born in 1882, in Zapotlan, State of Jalisco. His family mapped out for him a career as an agronomist, and the willing youngster went to the Capital and won a diploma as an agricultural engineer

after three hard years at the Escuela de Agricultura de San Jacinto.

Six years later Orozco, deciding belatedly upon an artistic career, entered the Fine Arts School of San Carlos, sitting in class with moppets of seventeen. The art academy was a forbidding place, its courses devised as an elaborate set of rungs and traps to smooth to academic polish whatever individual asperities were in the initial make-up of the student. Orozco remained Orozco, yet remembers with gratitude the conventional grind that forced him to take stock of his innate capacities. After having drawn from the cast and from lithographic prints his share of noses, toes and ears, he was admitted to life class. An elaborate stand could rotate the model, or raise her to successive levels, bathed in alternating layers of diffused and reflected lights by a panoply of bulbs and screens. Each pose lasted a month, and a photographer was then called in to take a picture, against which paragon the students could correct deviations from nature in their drawings.

The academy was only the more sedate half of Orozco's art education, important inasmuch as a thorough knowledge of perspective and anatomy was the one safe way eventually to throw both overboard. More easily traceable in his present work is the other broader lesson that he gathered from the many sights of Mexico City, either taken in the raw, for which Orozco already showed a fondness, or transmuted, digested into an esthetic alloy, by the masterly burin of the popular engraver, José Guadalupe Posada.

Retailed by street peddlers, each one of Posada's four

thousand prints illustrated some paroxysm of passion meant to smoke the penny out of the poor man's knotted kerchief. Sophisticates and the well-bred turned up their noses at his art in disdain. His street gazettes, gaudy color sheets, ghastly depictions of horrendous crimes, emotional renderings of passionate adventures, gave Orozco a feeling of delight as acute as the tug at the heartstrings of the servant girls who were Posada's more constant buyers. To this day, Orozco shares the older man's esthetic philosophy, which rated emotion above craft, cared little for the delicate balancings of abstract art and much for the intricacies of the human heart.

Orozco's further aesthetic training spans in time the bloodiest era of the armed Revolution. The harsh unartistic succession of political and military incidents supplemented with lead and iron the academic knowledge gathered at the Art School and the romancing of the pennysheets. The unseating and exile of Dictator Diaz, the enshrining of Madero as Savior and President, the uprising of Felix Diaz, backed by artillery belching its shells on the Capital, the treason of Huerta, Madero's assassination, the come-uppance of Huerta, who tumbles from the Presidential chair to a sick cot in a United States jail, the royal battle between Carranza, Zapata and Villa, the whole newsreel with its *obbligato* of slugging, looting, shootings, rape and arson, is the paradoxical background against which the delicate springlike unfurling of Orozco's genius asserted itself.

Poet José Juan Tablada recorded in 1913 a visit to the painter's lodgings: " . . . Woman is the perpetual theme

of all these works Young women meet and kiss endearingly, furtive looks and affected gestures rehearse nascent perfidies, weapons are being tried and sharpened for the coming duels of passion. . . . It is with reluctance that I close the portfolio of Claudines, with a last look at childish heads made larger by the coquettish note of a knotted ribbon, at bodies where svelteness and plenitudes express a first try at the mature form."

It is true that, if his watercolors of schoolgirls were all tenderness, Orozco was already sharpening boar-sized tusks in another genre. His Rabelaisian and Falstaffian cartoons, printed by successive opposition sheets, hounded impartially whichever man happened to sit in the Presidential chair, up to his customarily violent unseating. Another set of early works are the series of bordello scenes, midway between the tenderness that informs his sketches of schoolgirls and the tiger claw with which he lunged at the powerful.

All this work, the sweet with the sour, was thrown pellmell in his first exhibition, held in Mexico City in 1916. The usually silent Orozco was moved by the resulting scorn and critical fury to publish one of his few recorded rejoinders: "I live in misery. Each sheet of paper, each tube of paint, is for me a sacrifice and a sadness. Is it fair to subject me to scorn and hostility and furthermore to insult me publicly?"

A trip to the United States where necessity forced him to accept menial jobs, such as the tinting of photographs of Old Masters, did little to increase Orozco's faith in a world he could hardly stomach. Back in Mexico, 1920

is his low ebb. He confided then to José Juan Tablada that "Those people have even ceased to insult me." It seemed as if his career as a painter was at an end.

When the mural renaissance started, idling Orozco watched with cynical amusement his overalled brothers painting with a socially conscious brush. Perhaps because of a past political affiliation with Carranza, once the foe of art patron Vasconcelos, perhaps because he was pigeon-holed as a cartoonist, it seemed at first that Orozco would be by-passed by the renaissance. But in mid-1923, Vasconcelos relented, and gave him the walls of the Preparatoria School to decorate.

Orozco came to mural painting late—close to forty— and possessed of a strong personal style. Newspaper cartooning, with its deadlines on wit and its political, quickly fading allusions, watercolors depicting gestures and postures surprised with a snapshot eye keyed to translate emotion into plastic playacting, had been up to then his trademark. They contrasted sharply with the manner of his fellow muralists, come to walls via cubism.

Orozco had never been to Paris, had not experienced Parisian training, could not validly lean in his mural work against the architectural tenets that ruled the modern art of the twenties. As is true of his whole life, he was not eager to learn either, and somewhat skeptical of what his colleagues erected with a great show of giant compasses and stretching chalked strings in lieu of giant rulers.

When Rivera unveils his first mural in March 1923, Orozco writes pertly, "Some verses are spelled very nicely and polished magnificently, yet they are worth a

peanut. Some paintings boast of the golden proportion and that famous cubistic technique, they are worth another peanut."

Discounting the flippant wording, the comparison between painting and poetry comes naturally to Orozco at a time when the more advanced critics and painters preferred to compare painting to scientific endeavors. To his Paris-anointed colleagues, proud of being in the know, his romantic approach seemed a provincial flaw. And yet the element of Parisian fashion present in some of those other Mexican murals dates them as of the first third of the twentieth century, while the frescoes that Orozco painted at the same time escape dating; so subjectively engrossed was he as to be impervious to the chant of the cubist siren.

The negative creed expressed as he faces a Rivera is soon complemented by a positive one. On the eve of beginning his career as a muralist (July 1923) Orozco writes: "My one theme is HUMANITY; my one tendency is EMOTION TO A MAXIMUM; my means the REAL and INTEGRAL representation of bodies, in themselves and in their interrelation."

In his first frescoes painted in 1923–24, now mostly destroyed, the artist elaborated this statement. The human body was their one subject matter, stripped of racial tags, stripped of clothing, stripped even of those nondescript draperies that classical masters were too prudent to shun. "Time, the present," was waved aside as just another pettiness. Landscape and accessories were x'd out.

However classical Orozco's intent, to the eyes of most outsiders, to the grumblings of students and parents, the

249

patio walls of the austere Preparatoria School became covered with giant rust-red heroes bulging with excessive muscles. In 1924 critic Salvador Novo described with scorn the "repulsive pictures, aiming to awake in the spectator, instead of esthetic emotion, an anarchistic fury if he was penniless, or if wealthy, to make his knees buckle with fright."

In his first set of murals, Orozco progressively took stock of the possibilities of *buon fresco*, of the requirements of public plastic elocution, and deepened as well his philosophical slant on the world. With great conscientiousness, he would scrape one morning what he had done the day before, rework entire panels to insure the paroxysm of emotion that was his avowed aim. The more expressive his thoughts, the more did the frescoes run counter to what college students should believe of life.

On a morning in June 1924, one year after Orozco had turned muralist, a mob of students armed with rotten eggs, sticks and stones, assaulted and defaced the Preparatoria murals. Public opinion was largely with them. The newspapers, and even the critics, excused the gangling iconoclasts on the ground that they were "lovers of the beautiful driven to fury by the sight of these monsters." To make sure that such outrage would not be repeated, an indignant government official dismissed the painter and talked of white-washing the unfinished murals. Now past forty, Orozco once again sought his livelihood in newspaper cartooning, and once again his career as a "serious" artist seemed at an end.

From this forced interlude in his government-sponsored work date the wash drawings on revolutionary themes. Critics who assume that this famous series is contemporary with the events depicted discount both the working habits and the mood of the artist. At the opposite pole from the impressionist painter hunting for a motif and bagging it on the spot, Orozco needs to turn his back on the model to see it clearly. This unphotographic strain made him paint delicate watercolors with women for a theme while before his eyes the revolution staged its bloodiest tableaux. In 1925, with peaceful reconstruction deemed just around the corner, while politicos exchanged pistol holsters for fountain pens and their horses for swivel chairs, Orozco's paradoxical retina chose to relive in brusk black and white the colorful episodes of an earlier decade.

Of the same year is the mural that he entitled *Omniscience*, painted for Francisco Sergio Iturbe, owner of the ancient and beautiful Casa de los Azulejos. The climax of his classical period, it is also an important statement on aesthetics. It complements with forms what the artist had already said in words, "Art is first of all GRACE. Where GRACE is not, there is no art. GRACE cannot be conjured up by so-called cubistic recipes." The core of this saying is a belief in old-fashioned inspiration to be achieved only by spiritual experience. In the fresco, Grace, with commanding gesture, orders both Force and Intelligence, while her upturned face receives in turn the light from above. Her expression implies a mediumistic state of passive expectancy, suggests that all effort to press a

conscious logic upon the work in gestation can only injure those imponderables more vital to art than articulate laws.

In 1926, Orozco returns to the Preparatoria School to finish its decoration. In a chastened mood, he abandons the gigantic scale that he affected as a mural beginner, casts aside an earlier pride in craftsmanship and anatomical display. Instead of relishing godlike nudity, Orozco's men now keep their shirts on. Once-swollen torsos exhale their lungful of pride and cave in. The shrunken heroes go through valiant motions, strike, revolt, kill and die, roll their sleeves up for peaceful reconstruction, but the gesture lacked conviction before, and fruit after, its apparent consummation.

Abandoning accidentals, drawing and palette became audaciously simple. Orozco's only model for this series of murals was the stout elderly mason that elbowed him day after day on the scaffold. His semblance, multiplied, mans a world of gray, vine-black, terra-rose, ochre, and blueing blue.

This superb series closes Orozco's first period. Soon after, his provincial innocence suffered severe jolts. Feted in New York, touring Europe, being commissioned to paint in Pomona and Dartmouth, the painter now took conscious stock of idiosyncrasies in his work hitherto rationally unperceived, paid tribute to Byzantine mosaics and puzzled over the Saxon world. Foreign respect forced recognition at home, where a substantial series of frescoes in Mexico City and Guadalajara round out his oeuvre to date.

To state that Cezanne painted apples is a somewhat

meager clue to his art, for his scruple built a high China wall between what he painted and the confidences a scopolamine shot could have induced. But a description of Orozco's subject matter is relevant to a study of his aesthetic, for in his case, ideation, composition and execution succeed each other so quickly as to be practically simultaneous. Where the Frenchman's wisdom isolates subject matter from art, and light from form and color, Mexican Orozco is quite satisfied to let nature and inspiration, means and ends, agglutinate in the same monochrome, shapeless mess in which living organs are revealed under the surgeon's scalpel, so unlike the red, blue and yellow wax organs that stuff anatomical dummies.

When Orozco is at work, hieroglyphs of passion pour forth from his inner recesses onto wall or canvas, with not even a pause after birth for them to get accustomed to the new climate and new milieu, to be slapped and bathed and decently swaddled, as are statements, in words or forms, that are meant for public exposure. The strength of his work does not come from any strangeness or keenness of idea, but from its lack of make-up. Orozco's system of plastic thought is a chain of clichés forcefully expressed. I do not know if great poems can be made on themes as simple as "the world is in a mess," "things are getting worse," but Orozco's great pictures are built around a similar core.

Because of such negative emphasis, many a critic, and more keenly his communist colleagues whom he alternately raises to hope and sinks into despair, brand his thought as anarchistic. It would so, an old-fashioned

bomb at that thrown haphazardly, and scattering its small shot on such an expanded radius as to prove mostly ineffectual, if Orozco was only a scoffer and a denier. The closest literary approach to his work is that of Léon Bloy, who could impale his victim on hot words as efficiently as any devil on a cherry-red fork. If Bloy is recognized today as great, it is not because of his attacks on personages now mostly forgotten, but because his constructiveness so immeasurably transcended his aggressiveness. Bloy's—and Orozco's—positive faith and positive vision are so radiant, even though jealously kept to themselves, as to make them dust and vacuum and scour, with an excess of muscular vigor, their private universe of the stains and specks of all persons and things that fall short of an ever-pulsating ideal.

Orozco the cartoonist could represent man in his variety, from president to pimp, from schoolgirl to prostitute. Man is still the theme of his later work, but the mature Orozco forgets the many masks, plows under the motley moral and psychological nuances. His murals are peopled with generalized men, as clustered, as naked, as intertwined as putti in a Fragonard cartouche, but of a more bitter hue. So intense is Orozco's preoccupation with man that landscape is reduced to a shorthand version, even in country scenes, and his few still lifes are anthropomorphic. A large tempera of late date features a kitchen cabbage that somehow becomes a human cranium, while the curling edges of leaves mimic a crown of laurels, and the whole becomes a comment on the perishable nature of fame.

This obsession with men is not eulogistic, for the artist

admits, in fact relishes, the shortcomings of his subject. Yet he is not a true pessimist, for in his paintings man, however cruelly frustrated, never ceases to declare his potentialities of grandeur. In the Martyrdoms and Golgothas that he paints today, Orozco's affirmation of faith is none the less impressive for being unconsciously uttered and consciously denied.

One should not assume that a belief in God would soothe the artist's frenzy. Far from a salve, faith is for him a means of enlarging man's distresses to God's size, a point of view that coincides by instinct with the one cogent reason advanced by theology in explanation of the Passion. On the type of faith that is conceived as a social appendage to gracious living, Orozco gives an unflattering comment in his "Father God," who holds a geographical globe instead of the medieval macrocosm, winks the rich into Heaven and shoos the poor off to Hell. Translating the Magnificat into Mexican terms—"He has humbled the proud and exalted the meek"—Orozco expects to witness in a next world the last and best of all revolutions.

The first part of this article was originally published in Spanish in *Forma,* No. 6, 1928. The second part, reprinted by permission of The American Federation of Arts, first appeared in slightly different form in *Magazine of Art,* November 1947.

Orozco at the
Academy of San Carlos

The first mention I found of José Clemente Orozco in the archives of the Academy of San Carlos dates of May, 1906. He was then already twenty-four years of age, older than the average art student at the school. This is explained by the fact that his first serious pursuit having been scientific agriculture, art had, up to then, fared as no more than an avocation. That Orozco must have already studied at the Academy before 1906 is implied, however, by the fact that, typically, this first recorded activity was part of a collective motion for self-expulsion!

In 1906, Don Antonio Fabres, Sub-Director of the school, was on the way out. Three years before, as the personal nominee of the President of the Republic, General Don Porfirio Diaz, he figured as a political power, with a salary of 7,200 pesos that exceeded even that of the Director, mild-mannered architect Don Rivas Mercado. Now that the lengthy feud he had fought with Mercado neared its end, Fabres realized that he would never reach his goal, which was no less than the directorship of the

Orozco: Self-portrait. Pen and ink drawing, before 1916

school. He still gave two night classes, one of the nude and one of the costumed model, but attended them only half-heartedly. Oftentimes he failed to come, or left before time. The model would leave early too. A few students would follow the model, and, soon after that, the class would exit *in toto*.

The janitor, Lino Lebrija, posted notices at strategic corners, to remind the students how it was absolutely forbidden to leave between class hours, and he and his helpers stood guard by the main entrance, reprovingly. It was his duty as well to redact reports of such incidents for the Director, wherein he used to refer to himself in the third person, dispassionately:

"Disobeying your orders, two of the students of Professor Antonio Fabres started a rumpus the evening of the 7th. of the current month, May, 1906. Its outcome was the exit of all the students out of these two classes, when the janitor and his aids found themselves helpless to restore order. . . .

"Such a scene was reenacted yesterday, and student Garcia Nuñez, while wrestling with the janitor, tore loose the bell-pull of the door . . ."[1]

Two of the more pugnacious youngsters, Garcia Nuñez and a fellow agitator, Carlos Zaldivar, were expulsed for fifteen days. Promptly, a petition in their favor was placed before the Director; it was signed by ten of Fabres' students and given added weight by the following postscriptum: "The other students who were not there at the time of signing are nevertheless in agreement with what it says."

The petition ran:

"It is with intense surprise that we heard of the order to expulse from the school our fellow students because they left before time. . . . Had this happened with a view to promoting disorder, such punishment would be justified. . . . However, if we left, it is only because there was no model—he was gone at 8.00 P.M.—and so no further purpose in keeping to the classroom. If these two students deserve punishment, then we shall consider ourselves as equally expelled together with them, that is, all of us who left the building that night"[2]

Among the ten signers was José Clemente Orozco. Probably with an eye to resulting demerits, some bureaucrat checked beside each student's name what classes he attended. One name received only a cross, with the remark, "Is not a student of the school." Orozco's name rated also a cross and nothing else. This suggests that, at the time, he was not as yet a registered student.

The next year, 1907, Orozco was included in the alphabetical list of registered students. By 1910, he was referred to as a senior student of life-class when his contest drawing was adjudged *hors-concours*, a rating which implies that he had previously received his full share of honors.

1910 was Centennial Year, with many festivities planned for September, to commemorate Hidalgo's uprising that resulted in Mexico's political independence from Spain. The President of the Republic, Don Porfirio Diaz, with a kind of surrealistic illogic, ruled that a gigantic display of contemporary Spanish art should add fitting gloss to the celebration. Towards this end, a government sub-

vention of 35,000 pesos was readily earmarked, and a specially constructed exhibition building thrown in.[3]

Young Mexican artists, mostly students of the Academy, were naturally nonplussed. Had national art been totally forgotten or wilfully slighted by the Presidential decree, they decided to put up their own display. In the name of the members of the Society of Mexican Painters and Sculptors, Gerardo Murillo—the future Dr. Atl—wrote to Director Rivas Mercado, July 18, asking him for the use of "the classroom of first year of architecture, the exhibition hall, and the corridors of the second floor, to make possible the exhibition that the Society has planned for the Centennial Year."[4]

Not only did Mercado let the young patriots have the use of the building, but he also contributed 300 pesos of his own towards expenses. In turn, Justo Sierra, Secretary of Education managed to add a subvention of 3,000 pesos.[5]

Hung without fanfare in the corridors of the school, this "Show of Works of National Art" overshadows in retrospect the other, more blatant, display of Spanish painting. In the Academy show, racial consciousness anticipated the creation of a truly Mexican style. Saturnino Herran exhibited *The Legend of the Volcanoes*, after an Indian myth; Jorge Enciso contributed *Anahuac*, a life-size Indian silhouetted against the dawn. Orozco was represented by cartoons and charcoal drawings, now lost, but recorded in print in the official memorial album of the festivities, "J. T. [sic.] Orozco exhibits many caricatures and compositions. The former are typical, of strong draftsmanship, with lines bold and firm, supremely ex-

pressive and full of very deep intentions. The latter are in the same vein. Their tormented and convulsive attitudes bring somehow to mind Rodin's drawings."[6]

One senses justified pride in the thanks that the Association sent Mercado at the close of the show: "The signers, members of the Society of Mexican Painters and Sculptors, are deeply grateful for the active and great good will with which you helped us realize this first exhibition of National Art." The letter is signed by Gerardo Murillo as manager, and, among the members, by Orozco.[7]

The Society celebrated further with a "victory" dinner held in Santa Anita, to thank Murillo for his exertions. Besides hot chile dishes there must have been more than soft drinks, if we may judge from a news photograph of gesticulating artists hoisting a beaming bearded Murillo onto their swaying shoulders, with Orozco at the bottom of the pile, facing the camera and squinting in the sun.

Orozco's further studies at the Academy of San Carlos spanned the more tempestuous days of the military Revolution. If the artist gained, then and there, the knowledge he expected to gain of anatomy and of perspective, he also came, as a student, in astonishingly close contact with the dynamics of civil war that constitute the other pole of his complex stylistic formation.

The fall of Porfirio Diaz—after a semi-benevolent dictatorship that lasted nearly forty years—happened soon after the Centennial festivities. His political opponent, Francisco I. Madero, made a triumphal entry into the Capital in mid-1911, bowing to cheering crowds from a landau drawn by white percherons and manned by

liveried coachmen. The young art students, drunk with the taste of new freedom, lustfully injected unrest in the hallowed routine of the sheltered Academy. As studies suffered, the faculty retaliated with demerits. In May, 1911, in the contest of coloring, a class taught by German Gedovius, Orozco failed to pass.[8]

The next month, a great student strike began. It paralleled within the school the political revolution that was to rage for a decade outside its walls. At first, the strike was limited to the class of anatomy taught by Don Daniel Vergara Lope. His students objected to his dictatorial leanings, at variance with the novel political trend. They also rebelled at having to pay the instructor for each of the mimeographed sheets that served as makeshift textbooks, comparing them disdainfully with the pennysheets of the publisher Vanegas Arroyo, blind to what meaning future generations would read in these folk productions.

As the strike spread, the janitor was increasingly busy tearing subversive posters and slogans off the walls and dumping them on the desk of the Director, from where they eventually found their way safely into the archives. One of the mildest of these papers, hastily scrawled in blue ink and still gummed at the back, reads, "Because of the stupidity of Professor Vergara Lope, no one should attend the class of anatomy."

With the fall of Diaz, his brain trust of technocrats, nicknamed by the masses *los cientificos*—the scientific ones—fell equally into discredit. Another school pasquin ended loud and raw, in true revolutionary style, ". . . Long live Democracy! Down with the scientific ones in this school! Freedom of election. Liberty and Constitution.

"Mexico, July 15 of the Year of Freedoms."[9]

August 17, an ominous plea from Francisco Urquidi, the school secretary, reached General Rodrigo Valdes, Chief of Police of Mexico City, ". . . Please send us four policemen to keep order in the Institution. A number of discontented students station themselves by the door at 7 P.M., to dissuade their schoolmates from entering."[10]

August 28, undaunted by police measures, the strikers staged mayhem upon the Director. Though handicapped both by his age and his girth, Rivas Mercado withstood the assault with gallantry, if not with coolness. His own version of the affray, redacted that same day for his superior, the Secretary of Education, Don Justo Sierra, still exists in the archives. It is a first draft, and hard to read, scrawled that it was in the heat of righteous indignation, and filled with erasures and corrections meant to preserve dignity in the midst of mild ridicule:

"As I reached, this noon, the Institution, together with my lady, I was faced by a group of dissatisfied students voicing threats and insults. Far from intimidated, I descended from my automobile and, immediately, was attacked by the strikers who hurled various missiles— eggs, tomatoes, stones and other things. One of the projectiles hit me on the nose, producing a nose bleed.

"Though under attack, I advanced towards the group, my objective being to catch one of them; this I managed to do in the person of trouble-maker Francisco Rangel. The rest having scattered, I proceeded on foot towards the second police precinct, accompanied by a policeman holding Rangel. . . ."[11]

The strike was still on when, eight months after the

affray, stubborn Rivas Mercado resigned. Orozco, now thirty years old, acted throughout the disorders as elder counsellor to his fellow students, who were mostly still in their teens. A news snapshot shows him holding a sheaf of diplomatic looking papers and peering owlishly through thick lenses, ready to enter the office of the Secretary of Education for an attempt at mediation.

President Madero was shot in 1913. His successor, General Huerta, was in turn forcefully removed by First Chief Carranza. The latter's choice to head the school fell on Gerardo Murillo—alias Dr. Atl. Forthright documents remain in the archives that tell of Atl's tempestuous passage through the school, backed by the vivid memories of those who worked with him.

A memorandum, dated October 6, 1914, was sent by Atl to Ingeniero F. Palavicini, Secretary of Education: "I will submit a plan of total reorganization of the so-called teaching of the Fine Arts, beginning naturally with a thorough clean-up of teachers, class-rooms and store-rooms, given that everything within the school is filthy dirty."

Another note, addressed to the Inspector General of Physical Education, was written that same day: "I can assure you that, if ever a class of physical culture was started in this school of Fine Arts, the whole Institution would collapse instantly. Once insured the organic equilibrium of the students, they would lose interest in such intellectual masturbations as are the sole fruit, up to now, of all academic institutions.

"I intend to reorganize this so-called School of Fine

Arts along practical lines, changing its name to that of workshop, where workers will be able to do three things: bathe, work, and make money."[12]

Orozco felt grateful towards Atl, who acclaimed him as already a great artist, and decided to follow his political fortunes. When the troops of Pancho Villa, closing on the Capital, forced Carranza and his followers to take refuge in the State of Vera Cruz, Atl followed, and established a "school in exile" in Orizaba. *La Vanguardia* was printed there; it was a sheet meant to bolster the morale of the troops in the field, illustrated mostly by Orozco.

The next mention of Orozco dates of the next decade. January 12, 1922, the Director of the School, Ramos Martinez, wrote to José Vasconcelos, Secretary of Education, "I earnestly recommend that you name the citizen José Clemente Orozco to the post of fourth Professor of Elementary Drawing. Vacant at present, the post is already included in the budget of expenses for the current year."

The request was granted, and Orozco taught night class, for a daily stipend of 7.00 pesos. The class was attended by fifteen students.[13]

In January, 1923, Orozco received an additional job as assistant to the draftsman of the Editorial Department of the Ministry of Education. The procedure included an oath,

" 'Do you swear to fulfill loyally and patriotically the post of —— that the Constitutional President has conferred upon you; to be zealous in everything and care for the major good and prosperity of our Union?'

"The person thus interrogated having answered, 'I

swear it,' the Citizen Secretary proceeded, 'Should you fail to do so, the Nation will bring you to account for it.'"[14]

This text being a standard printed form, with only the particulars of the job left blank, to be filled in each individual case by hand, one may doubt that this impressive scene ever took place. However, the filled-in form is duly signed by José Vasconcelos for the Government, and by Orozco as its employee.

As assistant draftsman, Orozco took a small part in the publication of the Classics in a low price edition that was one of philosopher Vasconcelos' favored projects. The artist designed the chapter-heads and tail-pieces of the *Dante*.

As teacher of elementary drawing, Orozco dutifully put his signature to a number of the collective circulars that all members of the faculty were bid to read and to sign. The bureaucratic wording of most of these documents makes it doubtful that Orozco, or any of the other artists-teachers, always knew what they were about. Typical is an unnumbered circular, issued January 18, 1923. "Incumbent to the initial payment of salary to Federal employees, Paragraph 82 of the Law promulgated May 23, 1910, specifies that a copy of the corresponding nomination be produced. This provision was rendered obsolete after the Fundamental Charter creating the post of Controller General became operative, but, subsequently, the dispositions therein included have been revalidated by Circular No. 25, issued by this Department. . . ."

<div style="text-align:right">

Orozco: Soliciting. Pen and ink drawing, circa 1916.
Charlot collection

</div>

Other texts were clear enough, such as No. 5, issued February 6, "After the second unjustified fault committed by a member of the faculty of an institution of learning, a fine will be levied, to be in a ratio proportionate to the amount of his salary, to be repeated for each further offense. . . ."

Circular No. 13, April 23, "Notice has come to this Ministry that a number of teachers and employees of the School in your charge fulfill their duties with slackness, arriving late to work or failing altogether to come. . . ."[15]

The last of the circulars that Orozco signed, and thus the last that he presumably read, is No. 17, announcing a faculty meeting to be held June 6, 1923. It is doubtful that he attended it, and probable that from then on, Orozco could have been described by strict bureaucrats as ". . . arriving late to work or failing altogether to come . . ." for, on June 7, he began the full-time work on the mural decoration of the main patio of the Preparatoria school, having completed the gigantic plan and some of the detailed studies in the little time left between his two clerical jobs.

One last document marks the turning point in Orozco's career, when he stepped from the local stage of his *patria* into the spotlight of international fame:

"José Clemente Orozco, 316 W. 23rd St. New York City, N.Y. U.S.A.

"To the President of the National University of Mexico.

"The petitioner, professor of modeling in night class at the Academy of Fine Arts states:

"That, finding himself in this City for the purpose of

opening an exhibition of his works and needing to remain
for a while in foreign parts, he requests that you be willing
to grant him a leave of absence without pay, valid for six
months; its purpose that of dedicating himself to the
previously mentioned activities. . . .

<div style="text-align: center;">

New York City, N.Y. February 1, 1928
José Clemente Orozco." [16]

</div>

[1] Archives of San Carlos, 1906–34.

[2] *Ibid.*

[3] *Boletin de Instruccion Publica,* T. XV, 1910, p. 710.

[4] Archives S. C., 1910–18.

[5] *Vid.* 3.

[6] Genaro Garcia, *Cronica oficial de las Fiestas del primer Centenario,* Mexico, 1911.

[7] Archives S. C., 1910–19: "Circulares."

[8] Archives S. C., 1911–29: "Concursos."

[9] Both papers, *ibid.* 1911–36.

[10] *Ibid.,* 1911–13: "Correspondencia del Secretario Francisco Urquidi."

[11] *Ibid.,* 1911–36.

[12] Both papers, *ibid.,* 1914(1): "Asuntos varios."

[13] Nomination, *ibid.,* 1922–105: "Personal Docente de las Clases nocturnas." Report on class, *ibid.,* 1922–75. The report is dated April, 1922.

[14] Archivos de la Secretaria de Educacion, 1–25–10–63.1/131 (IV–3)/80.

[15] All circulars, archives S. C., 1923–14, "Circulares."

[16] Archivos de la Universidad Nacional. Archivo general, carpeta 1562. Orozco's show opened at the Marie Sterner Galleries, on 57th Street, in June, 1928.

This article first appeared in slightly different form in *College Art Journal,* Vol. X (4), Summer 1951.

Orozco's
Stylistic Evolution

As is customary in treating of the work of important artists, critics have attempted to interpret Orozco's stylistic evolution. Such attempts remain premature until the different parts of his work fit into a more definitive chronological sequence than is the case at present. For example important sources of style have been overlooked or underestimated: for a decade Orozco was preeminently a cartoonist, following the great Mexican tradition of Constantino Escalante and Villasaña, and his monumental work of today still shows the conditioning of hand and brain working at the grinding job of issuing daily topical satirical drawings. Some of the critics who analyzed the sources of Orozco's style, more easily aware of scholarly influences such as those of Byzantium and the Italian Renaissance, ignored these less learned, if most vivid, models. Other commentators, though well aware of this, preferred to bypass the early period in order not to displease the quick tempered artist, mistakenly disdainful of the less dignified productions of his youth.

Charlot: Orozco at Work on His First Mural. August 1923

The major obstacle to an understanding of Orozco's *oeuvre* remains the insecure dating of much of his work, a state of affairs unusual in the case of a contemporary artist. The main object of this analysis is to propose a correct respective dating of the early drawings and wash drawings that divide naturally into two series, that of women: schoolgirls and prostitutes, and that of episodes of the Revolution. Present dating, such as that used in the National Show of 1947, held in the Palacio de Bellas Artes, Mexico City, presents the two series as overlapping in time regardless of the wide divergence of styles. To correct this generally accepted dating we quote from what passages bear on the sequence of the artist's work in the writings of contemporary critics.

Earliest public mention refers to his contribution to the all-Mexican show that took place in 1910 at the Academy of San Carlos.[1] It divides his contribution into two groups, caricatures and compositions. Of the latter group, presumably serious in intent, given that it is contrasted with the caricatures by the reviewer, nothing remains today. The artist remembered only that they were charcoal drawings.

What did the caricatures look like? They showed "strong draftsmanship, with lines bold and firm, supremely expressive and full of very deep intentions." This description fits as well a slightly later set of cartoons—and the earliest still preserved—that Orozco did in 1911–1912 for *El Ahuizote*. We may surmise in turn that the caricatures shown in 1910 were of similar vintage, minus the added zest that the fall of Porfirio Diaz and the rise of Madero

gave to Orozco's political outlook soon after the close of the San Carlos show.

The next description of Orozco's work is found in the Tablada interview of November 1913, written after the assassination of President Madero, while General Victoriano Huerta was dictator and president.[2] The live stuff of which the Revolution drawings of Orozco are powerful reflections permeated the scene. Mexico City had experienced a few months before *La Decena Tragica*, the tragic ten days, a city-wide civil war that had strewn so many corpses in the gutters that funeral pyres were hastily improvised to minimize the danger of a plague. A young painter Alfredo Zalce remembers of these days how as a child going to grammar school he had failed to return one afternoon from his classes. His alarmed parents, scouting the neighborhood in despair, finally located the lad squatting entranced beside a sprawling corpse, watching flies caper along its frozen features. Doubtless, Orozco too drank in the strong spectacle with a deeper insight and optical persistency than many a citizen. But it appears that none of his reactions took the form of sketches. The artist's reputation at that date, his aesthetic preoccupations and actual realizations are all clearly set down in Tablada's article, whose title emphasizes the difference between the young Orozco and the mature master of today: "A painter of woman."

Tablada reports on a surprise visit by the young artist, lugging his drawings, "I place him mentally. Orozco; the cartoonist? Now I remember certain cartoons in *El Ahuizote*, rich in intention, in energy and cruelty. . . . As

I ask what his favorite subject matter may be, he answers that nowadays he paints exclusively women, limiting himself to college girls and prostitutes." Of the writer's visit to the artist's studio: "On the walls and in portfolios the water colors, pastels and drawings that are up to now the whole work of Orozco. As the artist said, woman is the perpetual theme of all these works. . . ."

By 1914 Huerta was in flight; Carranza, Villa and Zapata were engaged in a royal melee around the vacant presidential chair. Channeled into politics by his friend and exalted mentor, Dr. Atl, Orozco sided with Carranza, following him into hasty retreat when enemy hordes overran the capital. In and around the staff headquarters in Orizaba, Orozco witnessed another chunk of active revolutionary turmoil, including the looting of churches and the daily shooting of white-clad Zapatistas. We have a series of drawings dating from this very place and period, those that the artist made for *La Vanguardia*, a periodical printed through 1915 to uphold the morale of the Carranzistas at this the leanest moment of their political and military fortunes.

Comparing the *Vanguardia* illustrations with those that the artist contributed a few years before to *El Ahuizote*, one realizes how his style has matured in the ratio of the simplification of his means. No more washes of intermediate grays, no more intricate cross-hatchings. The 1915 drawings are evoked in a kind of plastic shorthand, a thick crinkled line jotted down with an ink-loaded brush or reed. An oriental economy of statement tends to cram the fewest possible lines with saturated emotion. As to

subject matter, there are searing political attacks on Huerta and on the Villa puppet, President Roque Gonzales Garza, comical renderings of ladies, presumably of reactionary leanings, also anticlerical cartoons. The more direct references to the raging civil war are carefully contrived to present the Revolution at its alluring best, an understandable editorial slant in a paper whose purpose was to buck up the spirit of momentarily defeated troops: these propaganda drawings are variants of the previous school girl's series, with a caption designed to give a novel slant to the pre-revolutionary types. Under a set of girlish heads, with hair-ribbons and wide eyes appeared "Soldiers of the Revolution, your mates are awaiting your return to give you your well-deserved reward!" Or a girl of the same pattern, with the ribbon replaced by a military cap, and a cartridge belt and bandoleer slung over the school girl skirt and blouse, smiles widely, arms raised against an apotheosis of sunrays. Nowhere is there even a premonition of the bitterness and hopelessness that are synonymous with the Revolution drawings that we know today.

In 1915, Carranza returns victorious to the capital, and Orozco's political tutor, Atl, is instrumental in the sack of one of the city's churches, with Orozco presumably again an attentive witness, again storing up memories. All through the revolution the artist seems to have followed the method that Tablada relayed in 1913, "He tells me that he had drawn much from the model at the school of Fine Arts, and that now, to shake off academism, he prefers to observe the model in movement, storing mental impressions that he paints later." How much later than the

events depicted were drawn and painted the episodes of the Revolution?

In May, 1916, Orozco contributes to a group show—some watercolors of prostitutes similar to those that Tablada had seen in 1913.[3] On this occasion, the artist's friend Atl gives us a total listing of Orozco's works that brings up to date the one given three years before by Tablada: "The series of works shown here is but one of the facets of his temperament. To judge him *in toto*, it is imperative to look at his drawings of school girls, his political and anti-clerical cartoons, and his strong symbolical drawings"

The following September Orozco gives his first one-man show. Its catalogue lists as the *pièce de résistance* the twin sets on feminine subjects, school girls and prostitutes. Besides, it lists political caricatures, and two studies for the major 1915 oil, *San Juan de Ulua*, a first government commission. That the artist was not keeping any important thing in his portfolios, such as a set of revolution drawings that would have been a striking departure from the style and subject of his known work, is made clear when, in 1923, he reminisces, "In 1916, I gave an exhibition that summed up my technical progresses and my aesthetic ideas up to then."[4]

The emotional letdown resulting from the rebuffs and unkind comments evoked by his first one-man show ushers Orozco into a period of relative inactivity that was to last until mid-1923. Writing in 1922, Tablada reluctantly considered the career of the artist whom he had helped discover at an end, "Orozco gave up his life work

when he sadly realized that he meant nothing to a public hopelessly incapable of appreciating his gifts."[5]

When Walter Pach visited the artist's studio in 1922, he was shown the same water colors of women that were exhibited in 1916, and it is on the strength of this evidence that he wrote the clear-sighted and enthusiastic appraisal that renewed Orozco's waning faith in his star.[6]

In December, 1922, to the show "Art Action" organized by friend Atl, Orozco contributed a number of the same water colors, and again, in March, 1923, sent some of them to the New York Independents, with the Mexican group.

From June, 1923, when he begins painting frescoes in the Preparatoria, to August, 1924, when work is officially stopped and the painter bruskly dismissed, Orozco's attention remained centered on his mural work, and a crop of related studies preceded the execution of the giant nudes (Tzontemoc, Maternity), of the religious themes (Christ Burning His Cross, the Franciscan series), of the blown-up cartoons (The Rich Sup, the procession of *fantocci* of the second floor). The now famous Revolution murals in the same building belong to a later period. That Orozco was not pursuing at the same time that he painted these murals any innovations in subject and style on a smaller scale is made clear in Tablada's article published in the International Studio, March, 1924, "Orozco, the Mexican Goya." Tablada describes the well-known themes, school girls and prostitutes, using in part the text of his 1913 article, reproduces a number of works of the same period, and prophesies a brilliant mural career for the artist.

Orozco's first authenticated depiction of scenes wit-

nessed in the civil war is to be found in the Orizaba fresco, painted in the lull between the stoppage of work at the Preparatoria and the resumption of the same work in 1926. Revisiting the scene of his *Vanguardia* days may have prompted the painter to re-create with the brush the models he had stored for so long at the back of his retina. This first step remains cautious. First to be painted, the top frieze, an overdoor panel, arranges men with guns and spades in a stiffly symmetrical diagonal pattern that remains more symbolical than factual. But the two uprights that flank the doorjambs are closer to things remembered, and already imbued with the bitter pessimistic mood that will stamp other Revolution scenes. A *soldadera* dries the sweat off an exhausted soldier's features, weeping rebozoed women huddle together for comfort.

When Orozco returned to the Preparatoria at the beginning of 1926, he amplified this first Revolution statement. He tore down the more damaged panels of the ground floor, both because of their ruinous condition and because the neo-classical flavor of the muscular giants did not satisfy him anymore. He was now content to have his master mason volunteer as model, whose round shoulders, and paunch, and bushy mustache, are multiplied in the frescoes of that period. He worked against extreme odds, in the often aggressive turmoil of students' pranks, plodding painfully towards an individual technique, hampered by a salary far below a family's living standard, with the menace of a second suspension of the work hanging threateningly over his head. It is then that he painted on the ground floor symbolical tableaux on revolutionary

themes (Revolutionary Trinity, The Trench, The Destruction of the Old Order), and in the upper corridor the series of revolutionary themes (Rearguard, Reconstruction, Grave-digger, Women in the Fields, The Adieu, etc.) that remain unmatched in his work for concentrated depth of statement.

My personal recollection places some time in the period that followed the stoppage of work at the Preparatoria the beginning of the revolutionary wash-drawings. Anita Brenner in *Idols Behind Altars*, published in 1929, but whose writing is contemporary with these events, confirmed my recollection as she states, "The fresco in Orizaba, the third pier of the Preparatoria School and the changed panel in the first, several oil paintings and about fifty ink and pencil scenes of the Revolution are all of a piece in period, mood, control and expressed passion."

I asked Anita Brenner to elaborate on her published statement, and she answered:

"Dear Jean:

"I have delayed writing you the data you asked for about the personal history behind Orozco's famous Revolutionary Series, because I have been expecting my books and papers to arrive from New York, and I am quite sure that the details are in the notebook I kept at that time.

"However, since I know you need this material, I am sending you this memo, and will supplement it with excerpts from the notebook when I have it again in my possession. . . .

"You will remember that at this time, in view of the

financial and emotional hardships Orozco was facing, his friends scouted around for solutions. His most insistent friend in that respect was Manuel Rodriguez Lozano, who used to come to see me often, sometimes with and sometimes without Orozco, insisting that I help. Of course I was willing to, but there wasn't very much I could do. However, I suggested we invent a mythical *gringo* who was writing a book about the Revolution, and who wanted illustrations. We told Orozco that this *gringo* would like to buy six black and whites about the Revolution, but that he was away at the moment and had left me the money to pay with, at the same time stating he was willing to take whatever I suggested. This mythical *gringo* was me, of course, and I think I borrowed the money, because I am sure I didn't have it. It was necessary to invent him, naturally, because we were afraid Orozco would not have taken the money from me, even in exchange for work.

"You will remember the excitement of Lozano and other friends when these drawings—which turned out to be no drawings at all but pen-and-ink gouaches—were completed. Orozco had the whole pent-up volcano of his experiences and his feelings in the Revolution in these. What happened also was that he himself got so interested in what he was doing that he continued with the idea after the six originals were done, as I remember the series came to something like 30 or 40. These first six I still have. . . ."

When the expected notebooks arrived from New York, in May, 1947, we checked our common recollections against the strictly contemporary entries in Anita's diary. I quote what passages I deem pertinent, either because they

bear directly on the birth of the Revolution series, or because they help visualize the circumstances surrounding it: The entries start at the end of Orozco's long wait before he could resume his mural work at the school.

"December 14, 1925. Orozco to lunch. . . . Hopes to finish his Preparatoria frescoes and may do some oil work and lithographs."

"January 26, 1926. Clémente Orozco has the Preparatoria back. He is mad with joy."

"February 9. Saw Orozco. Went over Preparatoria with him about photos. He begins to paint tomorrow."

"May 2. Went out this morning to Orozco's studio with Edward Weston. Edward made some portraits of him. Orozco showed us some of his old things and a few studies for the frescoes he is doing. . . . The frescoes he is doing now is revolution stuff. On a background of ultra blue, swift volumes of gray—swirling hurried skirts of women, tramp of guaraches, guns, and rose-colored city walls—. . ."

"May 26. José Clemente Orozco in very good mood. He is working very hard he says. Wants to do 'fresco' on cement: entirely new procedure and it means new aesthetic, technique, values, everything. He says it will be 'horrible de tan fuerte.' "

"July 24. Saturday. Came José Clemente *con mucha buena voluntad* and talking through his teeth of how sick he is of being bothered at the Preparatoria. The boys make quite a fuss pro and con."

"Tuesday August 17. José Clemente brought some old newspaper clippings in which he is called many vile

names. 'Shortsighted, sentimental, psychologically blunted, romantic, uninformed, cartoonist, critic reformer, impotent, lascivious, frustrated, can't draw, etc. etc.' Session of raucous laughter."

"Monday, September 6. Saw Orozco. He says he is all mixed up and does not know what's what in painting. He has been quite ill. He suffers a great deal but he is doing beautiful work. I am going to get him to do a group of revolutionary drawings. Pretext of customer—He wouldn't sell to me."

"Sunday September 12. This morning went to see José Clemente. He has been told that there is no more money in the University to keep on painting with, and therefore the work at the Prep, which is going so splendidly, must stop. . . . He painted a picture to put in the book [the future *Idols Behind Altars*], a scene of the revolution. It is a palette of four colors, black, white, burnt sienna, and natural yellow. They are *tierras*—that is corresponds to what he has been doing in fresco. With the black and white he gets a fine dull blue. The whole thing is rich and full of emotion."

"September 15. Went to Universal to take an article about Orozco, hoping thus to raise some dust about this ridiculous business of stopping his work. Have already gone to see Jimmy (Puig's secretary) about it and wrote also a spectacular letter to Pruneda."

I now quote from the carbon copy of the letter:

"Sr. Doctor Alfonso Pruneda, Rector de la Universidad

Orozco: Dance of the Top Hat. Pen and ink drawing, circa 1926

Nacional de Mexico. . . . I further wish to bring to your attention the unexplained stoppage of the work of José Clemente Orozco who wields, as you know, one of the greatest among the brushes of which Mexico may pride itself. Furthermore, the work that he is now executing is of deep value, as it means, for me and for all who see it, the true aesthetic of the Revolution. I have seen his projects for the lower floor, that is now nearly the only missing stretch, and those plans, seen under such circumstances, have moved me to carry before you this protest, with which you will doubtless identify yourself, given your good judgment in such matters. I repeat that it would be an attempt against Mexico's honor to allow that, for obscure reasons that can surely be mended, this work be stopped at its emotional and technical climax. . . ."

Further diary entries:

"September 18, 1926. Only incident of importance was an interview with Dr. Pruneda about Orozco. He said that it was all right and that he had no intention of letting the work be stopped. That as further proof of his interest, I could tell Orozco that next year he would be put 'where nobody could touch him'—in the official budget as a decorator of the Prep. . . ."

"Sunday, September 19. Had lunch at Orozco's. . . . In the two first of the series of scenes of the revolution bought by a fictitious American—he came to a fusion of the grandiosity of his frescoes and the intimate curtness of his drawings. I am trying to persuade him to do enough for an exhibition. He rather fears the effect. I told him Goya was an antecedent and he says: 'But Goya is superficial.

He draws carefully. He hasn't my monstrosity—nor the reality.' He speaks of striving for less motion and emotion now as a thing of 'good health.' . . . He has begun using abstract planes, semi-architecturally incorporated, to splendid effect in both fresco and small stuff."

The comparison with Goya's *Desastres de la Guerra* imposed itself, and the budding series was informally baptized *Los Horrores de la Revolucion.*

"Monday, September 20. Went and phoned Jimmy and was delighted to be told that Orozco is safely arranged."

"Wednesday, September 22. . . . Came also Orozco with another 'horror.' "

"Monday, September 27. In the evening came Orozco with two more 'horrors.' Scenes of the looting army. . . ."

"March 7, 1927. Orozco came in the evening and brought seven of those marvelous ink and wash drawings —revolution stuff. I have never seen anything like it."

"Sunday, March 20. Orozco had four more 'horrors.' That makes twenty-one. . . . Had breakfast at Sanborns with Ella, Lucy and Ernestine Evans. . . . So it is arranged that the opening of the Whitney Club will be with Orozco's things."

"March 22. This evening, Orozco came with four more 'horrors' that makes twenty-five."

"May 26. Orozco came with seven more drawings as usual breathtaking. A new quality of tranquility apparent."

"August 20. Orozco's to lunch. . . . He had two new 'horrors' and also a funny thing called 'Las Delicias del Amor.' . . ."

"Monday, August 21. Orozco told me Atl went to

see him and told him that he just had to see those drawings that everyone was talking about and that Orozco told him he would ask me. . . . Until I get those things safely over the border I shan't rest easy."

Remembering that many of the early water colors of Orozco had been destroyed as "immoral" by the American customs on his 1919 trip to the United States, one understands the note of anxiety on which these excerpts close.

Anita left for New York August 4, taking with her the bulk of the Revolution set. As she remembers it, "I took the drawings with me to New York, with the idea of getting an exhibition for him. At that time, the Mexican painters were so little known that I got a rather odd reception, and it was pointed out to me that these things weren't really art, they were drawings and cartoons suitable for the New Masses, and I was seriously advised by an art dealer who is now one of the Orozco 'discoverers' to take them to that magazine."

Soon after, Orozco left in turn for New York, with only an overnight bag for luggage and only myself to bid him adieu, and it became my responsibility to choose and take with me what finished works remained in his studio when I left Mexico for New York in October, 1928. A few remaining "horrors" and large charcoal studies for the frescoes I artfully mingled with my own milder brand of art and all passed the customs unquestioned.

The Revolution drawings were first publicly shown in October, 1928, in New York, at the Marie Sterner Gallery, and first reproduced in their entirety in 1932, in the

Delphic Studio monograph edited by Alma Reed. There it is stated explicitly that the drawings are not contemporaneous with the events, "Drawings and lithographs from sketches made between 1913 and 1917." Those who know Orozco's lightning way of working believe the purported earlier sketches, never mentioned before or since, never shown, published or seen, to have been rather mental notations.

If the preceding circumstantial recital of facts carries weight, the Revolution series of wash drawings and the few related easel pictures should be advanced from the time of their subject matter—1913–1917—to the period beginning September, 1926, when the first drawings of the set were commissioned and executed, and ending in the year 1928, when Orozco, working in his little room on West 22nd Street, New York, added a few new subjects and made replicas of some of the early drawings.

Main interest of this rectification will be to free the master's work from the implausible duality of styles implied in the assumption of an overlap in time between the delicate lines and tints of the series on feminine themes and the black-and-white of the Revolution series, both brutal and architectural, that reflects Orozco's growing mural experience in its increased grandeur and assurance.

[1]Genaro Garcia, *Cronica oficial de las fiestas del primer centenario* (Mexico, 1911).

[2]José Juan Tablada, "Un pintor de la Mujer: José Clemente Orozco," *El Mundo Ilustrado* (November 9, 1913).

³In the magazine *Accion Mundial* of which Atl was the editor, June 3, 1916.

⁴Quoted from a manuscript of Orozco, unpublished.

⁵José Juan Tablada, "Mexican Painting Today," *International Studio* (January, 1923).

⁶Walter Pach, "Impressiones sobre el arte actual de Mexico," *Mexico Moderno* (October, 1922).

This article first appeared in slightly different form in *College Art Journal*, Winter 1949–1950.

Orozco in New York

Between December 1927 and February 1929, Orozco wrote me from New York the thirty-six letters that are the core of this study. They reached me either in Mexico City or, between January and June, in Chichen Itza, Yucatan, where I was draftsman to an archeological expedition. Most of the letters are concerned with a bleak interim in Orozco's life, after he had left home, and before the first stirrings of the international fame that was the lot of his later years.

Orozco left a country in turmoil. President Calles had just brought to a harsh climax his persecution of the Church, November 23, 1927, with the shooting of the Jesuit, Father Pro. That October, a General Gomez had engineered one more military revolution. Peasants roamed in armed bands, part underground heros, part bandits. In March, 1928, my mother wrote, from Cuernavaca:

"The revolutionaries encamped between Jiquilpan, Sahoya, and Zamora . . . They just looted a neighboring hacienda with such refined cruelties towards men and women both that it seems a throwback to the days of

Attila. Battles are a daily ocurrence at places I so well know, with many dead and wounded on both sides. One sorrows at the thought that these poor peasants die only because they ask for the return of their priests"

Rome had placed Mexico under interdict. Priests were in hiding and churches were closed.

Orozco left Mexico an embittered and a lonely man. He had concluded his cycle of frescoes at the Preparatoria School despite the jeers of a majority of teachers and students, and the physical destruction of much that he had previously painted. Painful had been to him the defection of Rivera, a fellow muralist, in his hour of need. Rivera's friend, Salvador Novo, published an article that all but justified the vandalism. In it, Orozco was referred to as a pupil of Rivera, and a quite unworthy one at that.

December 11, 1927, Orozco boarded the evening train for Laredo at the Colonia Station. I was the only friend present to bid him Godspeed. Our plan was for me to join him in New York within the coming year. Ten years before, on his one previous trip to the States, American custom officers confiscated and destroyed most of his paintings as immoral. Fearful of a similar fate for his present works—the now famous washdrawings of the Revolution—Orozco had beforehand entrusted twelve of them to Anita Brenner, who reached New York in September. This time, Orozco took with him only a change of linen packed in a small valise.

Orozco traveled coach to avoid extra fare. "Some trains have individual seats that are extensible, exactly like

those of barbershops. One may sleep in them not too uncomfortably. I slept that way for two nights, very well."

December 21, "Only now have I a chance to write since I arrived last Friday. It was night. I felt deadly tired and the cold has been frightful

"I crossed the border as an immigrant: declaration under oath and an additional ten dollars, eighteen dollars in all. They scolded me because that last time, I stayed two years instead of six months. I argued that it had been the fault of the Revolution. This time, I am allowed to live here as long as I wish.

"Material expenses are *forbiddingly high*, even more than before. . . . What costs a silver dollar in Mexico is worth here an American dollar, plus ten per cent."

The next letter gives a return address, 316 West 23rd Street.

January 3, "I did no more than to settle down and to survey the city. I visit galleries and museums, and battle against the cold that seems to me awful, coming as I do from Mexico."

January 4, "What pleasure it would be to have you here! There are lots of sights, local as well as imported. Through the sheer power of money, Europe is carried over here bit by bit. One of these days they will plant the Eiffel Tower in Central Park, close by the obelisk. One should see the machinery with which rock is scooped out, and planted the steel frames to uphold a skyscraper. Ten minutes away there is a collection of El Grecos, and Egyptian tombs thirty-five hundred years old."

In March, Orozco moved to a new address, 431 Riverside Drive.

"My studio is now in a most elegant part of town, Riverside, close to the Hudson River, a block away from Columbia University. There is a private entrance direct from the street and a fantastic hall, painted dark red with black linoleum. On my own, I rounded out the effect with a skull and crossbones. It had been the studio of a German lady painter who left for Europe. It is like a cellar, but with a good light. It is furnished, has gas, a bath, and above all total independence.

"You will find me here if by then I have not died of hunger. I have enough left for another two months, but after that, who knows?"

Poverty became a leit-motiv:

June 8, "Now I cannot think of art or any such things. I must look for work, any kind of a job. The situation is rather tight here, and also at home in Mexico. You know how awkward I am in regard to practical pursuits but, willy-nilly, one must live."
July 21, "These days, my financial situation worries me exceedingly. Nobody offers help, either here or in Mexico. I do not know what I am going to do. *Please do not stop writing me.*"
August 16, "I too have been going through unbearable moments, but guts will have to make up for lack of heart."

One of Orozco's first visits on arrival was to the artist

and art critic, Walter Pach, who had befriended him while in Mexico:

"I went to see Pach. Most amiable. Magnificent studio. Lectures at the Metropolitan Museum. Does NOT take me seriously as a painter. Is a rabid admirer of Picasso.

"He told me that he is writing a book, *Ananias or the Bad Painter*. It appears that this Ananias was a biblical character who gave Saint Peter half of his wealth, but hid the other half. The bad painters of our day are like Ananias. They wish to side with the moderns who fight for beauty, etc. . . . However, when at home, they manage their business, give little parties with the critics for guests. You see why I exclaimed instantly, 'I say, is it a book about Diego Rivera!' Pach got mad at that, and maybe for keeps. From what he said I should make out that, 'We, the failures, let us kneel before the Masters.' Rivera, then, is on a par with Picasso; the latter much appreciates the former. Pach has a set of photographs of the [Rivera] murals. Granted that they show many influences, Picasso too has stolen galore. Let us kneel before the Masters! Hosanna!!"

Another friend, Miguel Covarrubias, had been, in Mexico, an adolescent camp follower, encamped at the foot of the muralists' scaffolds. In New York, while still in his teens, he had made meanwhile a lightning success as cartoonist for *Vanity Fair*, under the aegis of Frank Crownenshield.

"Covarrubias had a show at Valentine and sold over three thousand dollars. . . . It is said that it does not please

him at all when more painters arrive from Mexico. That I can well believe given the way in which he received me. Not even as a courteous gesture did he suggest that he would introduce me to people or help me in anything. God repay him! He is making pots of money."

These and similar experiences put Orozco in a black mood:

"So-called friends do not exist for me. In New York, one meets only with selfishness, duplicity, and bad faith. I stand quite alone. I count only on my own strength of which, as luck goes, there is still much left."

"As to the so-called friends I had here, I sent them to the devil. They received me with shame and humiliated me. I find myself totally alone. Just as well, as I have no use for patrons, tutors, managers, critics, panderers, trainers, or helpers. All of them are but a bunch of double-faced egotists. All they see in one is material for exploitation."

Come summer, the few people Orozco still talked with left town, and his solitude increased:

"All activities stop in summer. The little that remains is so trifling as to be hardly worth sampling. No theatres, concerts, or art shows, or any such things. . . . Worst of all, civilized people leave for the countryside, or Europe, or Mexico, for anywhere at all

"New York is physically dead at this time, even its business. For entertainment, obsolete movies with few patrons, and those in shirtsleeves. Only we, the most unlucky ones, stay put, while even poor people manage to go on vacation.

"I have not heard from Pach. Probably he left town. If not, he is in hiding, because, come summer, such a well-known person cannot stay in New York for fear of ridicule."

I wrote Orozco that I had no news of the Carnegie Institution of Washington, where the coming archeological season was planned. He attempted to reassure me:

"Americans are responsible people in winter but, come summer, they slip back into childhood and forget all else. They play golf, or fish as does Coolidge now, who is fishing in Wisconsin. The pool is stocked for the occasion. Underwater, a diver is kept busy hooking fish onto the Presidential fishook.

"Summer over, the fishing stops and back he goes to the White House, there to bother anew the Nicaraguans.

"Rest assured that your bosses at the Carnegie are also fishing, or maybe spinning tops! Do not feel disheartened and write me!"

I mentioned that I was painting a "Tiger Hunter," a scene from the Yucatan jungle:

"An excellent thing this thinking about tiger hunters. That is what you will have to do here, as you come face to face not only with tigers, but with all kinds of wild beasts, most infamous and ferocious.

"I wonder why you failed to write me of late. If it is due to your feeling low, then buck up and smile! They have that saying here, '*Keep smiling.*' It holds good even when one happens to be in the worst possible of fixes, for example on the gallows. I swear that neither is New York exactly a bed of roses."

Being Mexican, Orozco well knew the circumstances in which the expression was coined: Cuauhtemoc, last of the Aztec Emperors, thus attempted to console one of his courtiers, while both had their feet roasted on glowing embers by the treasure-hungry Spaniards.

In Mexico, Orozco had studied at the National Academy of Fine Arts. There, he graduated from student to professor. As he left for the States, he apparently neglected to ask for a formal leave of absence. February 1, he repaired the omission, belatedly asking from New York for a six months' leave without pay, for the purpose of opening an exhibition of his works.

Characteristically, despite poverty and a lack of present and future prospects, he decided in mid-year to let go of the only job he had:

June 3, "It is time I got busy with some means of living. Mine are getting pretty low as usual. . . . I sent my resignation as professor. They were reluctant to accept it but I insisted forcefully."

Before Orozco's arrival, Anita Brenner had contacted art dealers on his behalf. Their reaction to the set of drawings of the Revolution had been indecisive to say the least. A tentative plan to show the set at the Whitney Club came to naught. Now it was Orozco's turn to make the rounds of art galleries and to contact art dealers:

"I managed to have Kraushaar come to my studio. He is quite a personage and the owner of one of the best galleries. I went to see him. He said 'NO,' but that he would see my paintings. Days later he came. I showed

him the drawings. He did not like them! 'Show me the oils!' From then on his interest was aroused. He likes the paintings but the subject matter horrifies him. He said that such topics are not for the American public. I must paint other things and see him again next Autumn, when he returns from Europe.

"I forgot to mention that Zigrosser also came. He is in charge at Weyhe and a great booster, agent, and devotee, of 'that other one' [Rivera]. I asked him to come as a kind of a lark. He saw everything and said nothing. I asked him if he was planning one more show of 'that other one.' He said he didn't know, that he had no news from Russia He seemed disappointed and totally at a loss."

In New York, Orozco contacted for the first time on a generous scale the modern masters of the School of Paris. Museums rounded out the lesson with their display of Old Masters. Perhaps too subjective to be valid art criticism, Orozco's comments *à la diable* and in the first flush of recognition rate high in the story of his own evolution.

By birth and training, Orozco felt at home with the Spanish Masters. In February, they were gathered in a major display:

"At last, I have seen painting! A stupendous exhibition of Spanish painting, with El Greco, Goya, Velasquez, etc. . . . The pictures are loans from collectors in the million-aire class, at the Metropolitan Museum. Sixty-seven pictures, of which thirteen are El Grecos. How can I put into words the impression received? Among the moderns, there may be 'great men,' or 'great masters,' but El Greco is a god.

"As to Goya, what can one say? Against Velasquez I had certain prejudice, but before the proofs, one must bow. If to paint is to cover a plane with pigments, his mastery and perfection in so doing is matched only by his peers. One of them is Goya. There is a picture of his, a portrait, 'Pepe Hillo.' The Goya who did it is not the Goya of the anecdote, but a Goya who does a job–like labor of laying a mortar of pigment. Here Goya is a workman. Before this, admiration, pleasure, study as well, all are out of question. Indeed, the only feeling one dares feel is humility, as if one was confronted by a storm, a planet, or any other one of nature's spectacles."

Orozco went to the Hispanic Museum with high hopes. They were not all deceived, but he could not stomach the mural room:

"A great hall decorated with great (?) murals by Sorolla. What an idiot! This fellow confused painting with flamenco yodeling. Ole! and thirty feet away, El Grecos, Goyas, and Velasquez."

For still another Spaniard, Picasso, Orozco had mixed feelings. His first contact, it is true, was with his neo-classical style, at Wildenstein:

"Drawings. Figures copied, or so it seems, from Greek vases seen in museums. Two lines, or three at most; quite repetitious. Pen-and-ink drawings with 'lots of volume.' I made desperate efforts to enthuse, but in vain. You and I have drawings a hundred times better."

For Orozco, Picasso was to become an acquired taste:

"More Picassos. He disconcerts, disquiets, wounds, impassions, repulses, only to suddenly attract forcefully. One cannot forget him."

"New drawings by Picasso. After seeing gallery after gallery of tired and mediocre pictures, a drawing by Picasso is like a glassful of water, cool, limpid, but oh! so desirable. It is water to be rated above the plethora of elaborate banquets."

Orozco felt at home with the Spanish Masters, but a stranger to the School of Paris, then in the full flush of fashion. French art imposed a reappraisal, even though it signally failed to weaken Orozco's faith in his own tougher "provincial" idiom. After a visit to the Gallatin Collection, displayed at New York University:

"One of the Matisses was something new to me. Its color was extraordinary and so fine, so fine, that it could have been crepe paper or the sheen of silk. Yet, never did it lose its plastic identity."

After seeing a joint show of Matisse and Derain, at Valentine's:

"For the first time I did look at modern art, art of today, without missing ancient art. Pure painting without flourishes. Grace. Natural. Joy. To look at these pictures gives much pleasure. One remains at peace and happy for the rest of the day.

"Those are painters who dwell in a garden where their girl friends join them for the five o'clock tea. A drawing room with good society, good drinks and a good bed.

As to us, we are the revolutionaries, the cursed ones, and the hungry ones.

"Here in New York, French art means the cream of the cream. It stands for the ideal, is tops, most prestigious, the paragon. To praise anything, one compares it to the French. It is most exquisite.

"We, the Mexicans, perhaps will come to have later on some sort of influence, but it will have to be along other lines. Nothing about us is exquisite. *Do you know what I mean?*"

Reporting on a one-man show of Jacques Villon, at Brummer's:

"The painting of Villon is truly beautiful: small pictures of great simplicity. Obviously, they are the fruit of a milieu of which I know nothing: Paris. Nor do I know the reason why they are made that way. Doubtless, behind it are many doctrines and intellectualities, but in spite of it, they please me. They procure a pleasant moment, without shakes or shocks. Everything is sweet, elegant, 'nice,' 'peaceful.' Imagine that you bypass a group of girls. They are young and pretty. They smell good. You greet them. They smile. That done you do not give them another thought."

Orozco felt closer to Rouault:

"George Rouault has some aquatints that are stupendous and a unique self-portrait. After seeing it I began to study feverishly etching and aquatint. Already I have much information, some copper plates, acids, etc. . . . I visited

some workshops and I now know etching from A to Z.

"Tell me: did Rouault come in contact with Mexican things, like the santos in the churches, the flogged Christ of Holy Week, folk pennysheets, or pulqueria murals?"

Of the nineteenth century French Masters, not all rated equally:

"A show of lots of Degas. He hardly enthuses me."

"Degas by now bores me. I refuse to look at any more Degas, whatever the pretext."

"More and more do I detest Mr. Degas. He should hang in some barbershop in Peralvillo. Impressionists are increasingly hard to suffer. I agree they have a place in art *history*, but do they have any place whatsoever in *Art*? What the devil am I doing in art *criticism*! Curses! Forget it!"

Lautrec did not fare better. "What idiot said that Lautrec is a painter. He is not even a newspaper illustrator." Renoir at first pleased him, seen at Durand-Ruel:

"Renoir impressed me deeply, pleased me in extraordinary manner. One hour and a half went by looking at five or six small pictures. The rest, not so good, must be sketches or youthful work."

"I cannot forget Renoir. Could I only own one of his small paintings!"

"The second or third time one looks at Renoir, disillusion sets in. Why?"

Cézannes gathered by Rosenberg and presented by Wildenstein:

"A few days ago, another very important exhibition of twenty-four Cézannes, half loaned, and half owned by Rosenberg. I went there eight days in a row every morning to study Cézanne. Perhaps very close to El Greco. The good man Matisse vanishes."

A group show of French Masters, at Durand-Ruel:

"Returning to Durand-Ruel, I received a lesson in painting as obvious as it was final. It seemed done on purpose: a still-life by Cézanne side by side with one by Manet, same subject matter, same size. The one by Cézanne is like a closed fist. The one by Manet disintegrates. The former *lives*, the latter is dead.

"A man full-length painted by Cézanne and another by Manet. The Cézanne is as solidly planted in the ground as a rock. The Manet is falling down: he stands on one foot, *leans on a cane* (O irony!) and is out of place in the picture!"

The figure paintings Orozco mentions are Manet's *Jeune Homme en Costume de Majo*, and Cézanne's *Jeune Homme Nu*.

Seurat, seen at Wildenstein:

"The first Seurat I ever saw. He must have been a man pure of heart and simple. One feels guilty and sinful before this luminous painting. Other pictures appear dirty, even Cézanne, Renoir even.

"If there was any necessity—for sure there is none—for religious art, Seurat would be the man, instead of the ugly daubs one sees on the altars. Religious art, altars and religion, what place have they in this hellish world."

A show of Old Masters, at Reinhart:

"Best of all, a small Chardin, so subtle, so gracious, so beautiful, that its very presence seemed a mirage, something like our first illusions, when one is eighteen and sighing for the first loved one."

Jotted down as instantaneously as they were felt, Orozco's opinions nevertheless fall into a sort of informal pattern. Pure painting attracts him. He admires, as he forcefully expresses it, "the job-like labor of laying a mortar of pigment." He remains keenly sensitive to qualities at the opposite of his own: peacefulness, goodness, purity, a delight in balance and light. In contrast, he curtly dismisses these masters that seem to us closer to him: Degas, with his cruel probing of the form divine; Lautrec, punning pitilessly at the expense even of the models he liked best. To this implied pattern, Rouault is the exception.

New York had first seen a group show of Mexican artists at the Independents of 1923. The impact had been null. February, 1928, a second group show, collected by Frances Paine, opened at the Art Center. Still, the reaction was cool; Orozco writes:

"Exhibition Art Center: a total failure, absolute, final. FACTS: the gallery is bad, for beginners and amateurs only. The hall is dark. The director is an idiot. Complete disorder. A week after the opening the catalogues were not ready. They mixed all the pictures and, because those of Pacheco and Montenegro were the largest, they hung in key places. Also present, wax dolls and dressed fleas by

Hidalgo. Those who came joked and mocked, or felt disappointed."

"In the fatidical and sinister exhibit at the Art Center, the director, Bement, told me that the Brooklyn Museum wanted to buy the painting that Times reproduced, 'Soldiers and People on the March.' Fact is nothing happened, and Bement never explained. Now, Mrs. Paine says that Bement told the director of the Brooklyn Museum that the picture was painted on very cheap canvas, and that is why they did not buy.

"Worst still, they ruined my poor picture. To fit it to an old frame that was too small, they had no scruple in paring it down. You may cut an impressionist picture at wish, but one based on composition is wrecked, once it is cut."

The heartbreak was heightened by the success of a one-man show by "that other one," Rivera, at Weyhe:

"Diego Riveritch Romanoff is still very much of a threat to us. Deeply rooted is the idea that we are all his followers. To speak of 'indians,' of 'revolution,' of 'Mexican Renaissance,' of 'folk arts,' of 'santos,' etc. is all the same as to speak of Rivera. . . . Even the 'syndicate' 'proletariat,' 'Maximo Pacheco,' 'agrarians,' etc. all those terms are synonymous with Diegoff. Perforce, we must with every means at hand rid ourselves of this hot potato of Mexicanism of which Mrs. Paine and Anita Brenner are today the prophets.

"I heard that, up to now, people were kindly inclined towards things Mexican . . . but that is all ended with the

Art Center show. I rejoice, should it mark the beginning of a new era, wherein each one would be appreciated at his own worth, rather than for the *exotic-picturesque-renaissance-Mexican-Rivera-esque.*

"The *Mexican fashion* or *mode de Mexique*, whatever you wish to call it, or more simply this joke, is over. Proof of it is the exhibition they gave Diegoff at the Gallery Wheye, so-called, or Wyhe. It is more like a bookstore . . . a sort of flea market in miniature where one may find something of everything, even old irons. In season, their shows are at the rate of one every three days. You imagine the quality. One show was of Diegoff, and I saw there his cubist follies. One canvas had a toothbrush glued to it. Another was in the style of Zuloaga. Watercolors there were, in the style of Cézanne.

"Of course, the newspapers reviewed the show kindly. They brought out the Mexican Renaissance, indians, and the Revolution. They dubbed him 'many-sided' and 'great man.' Renaissance with a toothbrush!!!!!

"I doubt if he sold any.

"As to potentate Rivera, here the problem is worse than in Mexico. The amount of publicity is incredible, and deeply rooted the idea that he is the great creator of everything, and that all others are his followers. Each time that one is introduced as 'a painter from Mexico,' they say, 'Oh! then! You know the great Rivera, don't you?'."

Absorbing new sights and new attitudes, the sufferings of a displaced person, the round of galleries and museums, were but the passive side of Orozco's days. Soon, he went

to work, translating into his own idiom the lessons received and the sights absorbed:

"*Lithography*: I am going to do some. It is easy. There is no need to do it on stone, but instead on specially prepared plates. Already I have two. There is a Mr. Miller who owns a lithographic workshop. He prints plates for the art galleries. The plates I bought (9" × 15") cost fifty cents apiece. To print them costs ten dollars for the first twelve proofs and twenty-five cents each for the following ones, plus the cost of the paper. For me it is dear but I will chance it and try to pay.

"My first lithograph! It came out lovely. Two others are drawn and I will bring them tomorrow to the printer. The new technique enchants me. It is a most entertaining toy and will last me for a spell."

This first lithograph that "came out lovely" was *Vaudeville in Harlem*." Two more prints—mentioned as drawn but not yet printed—would be *Rear Guard*, and *Requiem*.

Orozco also painted in oils. Here is the genesis of the haughty self-portrait peering through thick lenses, since then often reproduced:

"A month ago, Mrs. Paine let me know through Anita that Eastman, the Kodak millionaire, wished for a good portrait of himself. Many had been painted but none suited him: there was an opportunity for me.

"Because I lacked samples of portraits, I painted a self-portrait just for the pleasure. Very bad it is and Rembrandtesque. Now Mrs. Paine came to say that after all it is off, Eastman having left for Europe. What do I care!"

Other oils of the period: *Coney Island Sideshow, Eighth Avenue, The Elevated, The Subway.*

Orozco's major handicap in "selling himself" was a lack of mural documentation. Friends attempted solutions to the dilemma, at times unusual ones:

"Mrs. Paine says that you and I should do mural decorations. She will propose to I know not what society of local architects that we decorate—on paper—one of their halls, 'to see if they take heart!?!?!?.' "

Good photographs of existing murals, together with preparatory drawings, seemed to Orozco a more dignified solution. I would bring the drawings with me. As to the photographs, spurred by Orozco's detailed letters and telegrams, Tina Modotti and I worked hard on the project. The task was not easy, sloping ceilings, stairwells, and barrel vaults, forcing camera and photographers alike into difficult positions:

"In a letter sent to Cuernavaca—I do not know if it reached you—I asked as a favor from you to see which ones of my drawings remain in Coyoacan [where Orozco's home and studio were located]. Choose among them those that are best to bring me if it is not too much bother. So take a little walk towards Coyoacan, and delight in the green foliage along the path.

"See if it is possible to take one or two photos of the beautiful portal of 'El Generalito,' with the arches. On one side, 'The Strike,' and on the other the so-called 'Trinity'. . . .

"Also try the door that gives on San Ildefonso Street, the main door, with the decorations overhead.

"See what other ways there may be of including the arches of the patio with the frescoes behind them. Main interest should be the architecture. One should realize that it is a *decorated building*. The pictures as such are of *no importance*.

"I sent you a telegram asking for photos with architecture. Ninety per cent architecture and no more than ten per cent painting. That is because no architect can get interested in the monkeys unless it be as a detail of the building."

Slowly the tide turned. Orozco wrote in April:

"By now, I have a small circle of friends and American admirers, all of them artists. Three nights ago, they gave me a supper party at 'El Charro,' the restaurant of the brothers De la Selva. Toasts were drunk in excellent whisky to the health of *the great painter* Orozco. A Rumanian gentleman, Iliescu, told me without my asking him anything that here everybody rated me higher than 'that other one.' "

In August he writes, "For us *an epoch comes to an end and another begins*, initiated in this monstrous New York. I hope it will prove more propitious."

In September, Orozco found trusted friends among members of the Delphic Movement. His first mention of their antics may lack seriousness, but he soon realized how sincere they were, and how well-meaning towards him:

September 10, "Indians from Greece shall be introduced to civilization. Same as in Mexico, the same worn-out cliche. Greek folk art shall be fostered—Their sarapes are just like ours—Dancing there shall be at the tune of Greek bagpipes. All of that will happen in Delphi, plus Olympic Games, and for a finale, a play, 'Prometheus.'

"Thus plans an aged lady, an American millionairess, wed to the poet Sikelianos. . . . A beautiful woman, Miss Alma Reed, is active in the goings-on. She admires me and bought one of the tragic drawings.

"The other evening, there was a get-together at her house. Mrs. Sikelianos, gowned in a Greek robe and shod with Greek sandals, danced one of the parts from Prometheus, singing in Greek meanwhile. Admirable! Claude Bragdon, of the Fourth Dimension and the Tertium Organum, was present. . . . He has the face of a de luxe pill-barker. Also present, two dozen dowagers, theosophical and Greekophile."

September 25, "Yesterday I received the photos and they pleased me much. They came at the right time as, minutes after, I left my apartment for that of Alma Reed, for a private showing of Orozco's works. Propaganda galore, notables present from the New York art world, writers, Greek poets, delegates to a congress of archeology. Most amusing, a Greek poet felt so deeply for the corpses in my pictures that he hugged me tearfully. I managed to avoid a kiss: the pig!

"Greek wine and lots of fun."

October 2, "Jean, to give you the news of great triumphs. There is no time for details but in short: October 10, my first show in one of the best galleries, in a group with Matisse, de Segonzac, Forain, and three other Frenchmen. Next year, in April, an exhibition sponsored by the New York Architectural League, with the set of drawings that you will bring with you, and the photographs. *Ample photographic documentation.* . . . I told my beautiful and gracious manager, Alma Reed, that I had a companion in this affair, Jean Charlot"

October 8, "There was no time to tell you in detail what I did of late, but here it is in short. The exhibition at the house of Alma Reed, though informal, brought great and magnificent results. Many of the best people came to see it. Such were the compliments that a Greek poet even composed verses for me and recited them before an elegant gathering. That was the comical angle.

"What was serious is that an exhibition of the now famous 'horrors,' the set of drawings of the Revolution, is assured in one of the most exclusive of 57th Street galleries, that of Marie Sterner, in a group with six Frenchmen, Matisse included. A good introduction to the innermost circles of painting.

"I already mentioned that in April we will be able to show photographs of murals and fresco cartoons in the annual show of the Architectural League.

"I am painting a portrait of Mrs. Sikelianos, with whom

Page of a letter from Orozco to Jean Charlot

Oct 2.

Juan, para anunciarte grandes éxitos. No tengo tiempo de entrar en detalles pero te diré lo principal: El 10 de Oct. primera exposición en una de las _mejores_ galerías, en grupo con Matisse, de Segonzac, Forain y otros tres franceses.

En Abril del Año próximo exhibición arreglada en la Liga de Arquitectos de Nueva York, esto con dibujos que traerás y fotos. _Amplia documentación fotográfica_. Le dije a Alma Reed, una bella y gentil "manager" que tengo compañeros en ese business, Jean Charlot. No divulgues la noticia. Aquí anda Frances Toor viéndolo todo y probablemente lo vaya a contar a México. Sería bueno desmentirlo.

Escríbeme noticias fotografías

Clemente.

Alma Reed lives. It is something novel, a complex color range and a mural treatment. The model is a most interesting woman of fifty-five, with golden hair and Greek vestment. A person most cultured."

Only sour note in this relative happiness:

"Frances Toor came to see me three days ago. The first thing she did was to inventory the corners of the studio. Now, for gossip, a little story. You know that I gave a small show of my work at Alma Reed, with such success as I shall tell you. Toor went there and seeing how well I was with them offered Alma Reed to give a talk on Diego Rivera! Not even three thousand miles away is one allowed to relax."

The Marie Sterner show opened in October. *Art News* reviewed it: "Orozco shows at Sterner Gallery . . . conveying bitterness by the fewest lines. Such works as 'Los Sepulcros,' should move even those adverse to propaganda in any form"

October 15, "By my *success* I just mean that I am working *hard* at paintings to my liking, and that I meet people who *truly count*. In my last letter I told you that I am painting a portrait. Up to now it goes well, pleasing both myself and my model.

"I sold one of the paintings that came from Mexico, the one with a white house; cheap indeed but a step to cement new friendships.

"The exhibition at Marie Sterner has been an artistic success. The same gallery owner suggests that the set of

drawings be sent to Paris, and it was agreed upon. Mrs. Sikelianos will take them with her. . . .

"Mrs. Sterner likes the drawings immensely. She states that she is not interested in the subject matter, but in the rendering. Forain had to be hung in another room, and others too. Such is the explosiveness of things Mexican! . . .

"Best is for you to come and join in the fray. When will it be?"

This letter was the last to reach me in Mexico. Mother and I received our passports October 18, arriving in New York the 27th. In our trunks were more photographs of Orozco's murals, the remainder of the drawings of the Revolution, and charcoal studies for the Preparatoria frescoes.

January, 1929, I left New York for Washington, there to correct the proofs of my report on the Yucatan diggings. It was in Washington that I received the last letter of the series. Enclosed was a full page clipping from the *Philadelphia Ledger* of February 17, "Emotional Attitude versus Pictorial Aptitude," with impressive reproductions:

February 19, ". . . Some Philadelphia ladies invited me to send an exhibition of Mexican paintings. Great success! A nice gallery that does not charge commissions. This past Wednesday we went there, Alma and I. There was a great reception with the best of Philadelphia society. George Biddle gave a talk on Mexican painting, fresco, and my biography. He had been on a drunk for days and you can imagine the things he said. I was introduced, gave

thanks, received applause. That evening, an elaborate supper at the home of George Biddle's brother, more drinking, and return to New York. I am showing everything there, including drawings and photos. . . .

"Exhibition at the Downtown Gallery March 26, with paintings of New York *that are not yet painted*. In April, a show at the Art Students League with everything, and at the Architectural League with a mural *that is not yet painted*. The drawings will be shown in Paris, the show to open February 24, at the gallery 'Fermé la Nuit,' have you heard of it?

"The lithograph 'Requiem' was chosen one of the 'fifty best prints of the year.' . . .

"Included are a number of little pictures newly painted in the worst of folkloric vein, done at the last minute in all haste

"I send you the only lithograph left. Only two were sold. The rest I used as handsome Christmas gifts, and for the New Year with a calendar pasted on.

"George Biddle did a great portrait of me that makes me look like Lincoln."

The following year, 1930, Orozco received his first great mural commissions in the United States, the Pomona "Prometheus" and in New York, the decorations for the New School for Social Research.

This article first appeared in slightly different form in *College Art Journal*, Fall 1959.

A Review of Alma Reed's
J. C. Orozco

This book contains indispensable source material towards
a definitive biography of José Clemente Orozco. There is
no one more qualified than Alma Reed to cover Orozco's
long sojourn (1928–1934) in the United States. Besides, it
is good reading and the story rings true from the author's
first meeting with the artist in his tiny New York studio,
to their adieu at the Chicago Terminal as he returned to
Mexico.

Orozco emerges clearly out of such unassuming and
expert reportage, but as a man constrained and caged by
the unfamiliar, and on the whole inimical, milieu. At
first, poor and puzzled, the artist could bear rather well,
due to similar past brushes with loneliness, the incompre-
hension of his art, and occasional hunger. Later on, when
he was accepted as a master, other distractions came his
way that were the irksome price he had to pay for his
American fame: there were dealers keen at horse-trading,
potential patrons to be humored, occasional speeches, and
worst of all in his estimation, the taming and tipping of
uniformed doormen. As he rose to acclaim, Orozco stored
enough fuel of resentment to power throughout the rest
of his life many a bitter masterpiece.

Within this already strange milieu, passing strange must have seemed to him his well-wishers. "Little angel"—his nickname for the author—was one of a chapel of dedicated ladies, shod in open sandals and clad in hand-woven linens of Grecian cut. Delphi, famed home of antique mysteries, remained for them the *omphalos*, or navel, of the world. The members' pantheon was a crowded one, what with Jesus and Buddha, Mithra and Walt Whitman, Gandhi and Zoroaster. To put Orozco at ease, the Mexican Quetzalcoatl was courteously assimilated. The painter was "baptized" a Greek—with a new name, *Panselenos*—and fitted with a crown of live laurels. When I visited him in his tiny Chelsea apartment I noticed the dried-up wreath, but the artist was not loquacious about it.

Delphic ideals notwithstanding, Alma Reed proved a determined and tireless executive in behalf of the master, who was both too retiring and too explosive for sustained and sound human contacts. The goal she set forth for him was success as a New Yorker envisions it. This success would be measured in terms of newspaper clippings—two, three, or four columns wide—of strategic hangings in group shows, of successful lobbying for museum representation. Substantial private collectors would be hunted and captured, and, of course, a Hearst paper sued for defamation. Indeed, moves as tough as these were needed to crash art circles practically synonymous with the art market.

The frank and detailed retelling of this tactical campaign paradoxically makes a story free of meanness or selfishness.

It proved to be a heroic effort against odds, that blends well with the heroism of Orozco's themes and style. What hallowed this practical endeavour, besides the generous motive, is that its story is not one of unalloyed success. Some of the deep drama of Mexico, with Orozco as the catalyzer, infused, despite the hopes of his benefactress, this otherwise typically American adventure.

Orozco was a muralist. In Mexico, he had freely spread of his heart and his gall on eighteenth century patio walls framed in noble arcades, tiered high, and scaled generously, as if awaiting since they were built the heroic lime-skin of the future frescoes. Orozco conceived his work on a scale, and of an orchestral complexity, that could hardly fit the Procrustean bed: dealers' velvet-lined walls, collectors' paneled rooms, museums' storage racks. Alma Reed could not quite turn the tide of Northern indifference. The best informed among the men she approached conceived of murals as watered versions of the pale renderings of Puvis de Chavannes. Orozco's noisy frescoes would not do.

As with Gauguin and Van Gogh, the villains of this play were art connoisseurs. Astonishingly, its heroes were college presidents and professors who proffered walls, braving incensed trustees, aroused local societies, and the resulting adverse publicity. It seems that Orozco was left quite free to paint what he pleased. That no money was forthcoming as a fee for these gigantic chores was hardly worth a second thought. Again seated on a scaffold, again in coveralls spattered with lime, at last out of reach of dealers and salons, the Mexican felt sane again.

This story of Orozco in the United States is the heart of the book. To live up to its inclusive title, its scope extends over the full biographical span, from birth to death, but these added chapters may be afterthoughts. They lack the authentic fire with which Alma Reed testifies about events in which she was an active participant. In Orozco's own view, his stay in the United States was perhaps little more than an awkward, if prolonged, interlude. In the book, the change of pace and interest queers the all-over balance. The reader is left with the idea that, neglected at home, the master found refuge and fame in a foreign land. Facts are otherwise: a first extensive appreciation and praise of Orozco was published by José Juan Tablada in 1913. In 1923, he successfully climaxed a campaign to give walls to Orozco, in itself a tale fully as exciting as the one Alma Reed tells so feelingly.

Who could blame the author for being confused with the marches and counter-marches, the frays between top dogs and underdogs that churned throughout the Revolution? When she mentions "the Zapata epoch, when the artists and other followers of Obregon abandoned Mexico City for Orizaba," only a well-informed reader will make out that Orozco left with the troops sent to fight Zapata. The painter of the famous picture, *Zapatistas*, now in the Museum of Modern Art and of the equally formidable *Zapata*—that Alma Reed extolls as the heroic portrait of a hero—contacted his models only as they were brought in daily as prisoners, and shot. The author states that these pictures are "an eloquent reaffirmation of Orozco's revolutionary convictions." What is meant as straightforward

praise remains probably true, in the sense that strain, and stress, and turmoil, were the main motors of Orozco's inspiration, and thus a justification *per se* of the Revolution.

Similar simplifications are attempted on the religious plane. Even in his lustiest anti-clerical days, filled with the sport of priest-baiting and church-sacking, Orozco never pretended to moral or philosophical originality. When the free-thinking plebs he had fought for came on top and launched a religious persecution, the painter, in a typically bold turn-about, frescoed pious incidents from the life of Saint Francis. Alma Reed extolls the pagan martyrdom of Prometheus as a supreme achievement, but the Christian martyrdoms that Orozco painted towards the last, and his noble Crucifixions, are silently bypassed.

Thus it comes as a total surprise to the reader that Don Luis Maria Martinez, famed archbishop of Mexico, would choose Orozco as his official portraitist. The stairs of the studio were many and high, and for seven sittings the aged ecclesiastic climbed them, well knowing that the painter was neither an apple-polisher nor a brush-licker. The last commission, that death left unfinished, was for a monumental church crucifix. Either these clerical patrons —as did Father Couturier in France—prized genius over faith, or else and more probably, being themselves Mexican, they allowed for tantrums between a child and his mother, be it his Mother the Church.

A review of Alma Reed, *Orozco* (Oxford University Press, 1956), this article first appeared in slightly different form in *College Art Journal*, Fall 1956.

Siqueiros at the Academy of San Carlos

Alfaro Siqueiros wistfully states that he was scarcely big enough to take part in the great strike of 1911 at the Academy of San Carlos. He admits in conversation that, ". . . all I did then was to throw a few stones at things or at people, and little else." Somewhat at odds with this self-effacing admission is the fact that Siqueiros—then thirteen years old—landed in jail with some of the ring leaders, there to be consoled by a gift of chocolates from an anonymous well-wisher.

The next year, 1912, he weathered successfully his examination in a branch of painting in which he was indeed to become a master, "Class of chiaroscuro: Alfaro, José David. Passing grade."[1]

The artist dates his first mature remembrances as a student from the year 1913, in the days of President Huerta. In an election freely held by both teachers and students, Ramos Martinez—who was the candidate of the anti-academic element within the Academy—won the directorship of the school. At that time and in that milieu

Charlot: Portrait of Siqueiros. 1924

his style of painting, courting, as it did, Whistler and Impressionism, carried the impact of a revolutionary manifesto.

Irrelevant of a style that Martinez himself would outgrow, it proved of crucial importance for the generation of Siqueiros that the new Director already thought in terms of a Mexican art, and strived to put his students in daily contact with Mexican subject matter. Though arrived at with all the gentleness that characterized his actions, this was a true revolution against the modish attitude of local connoisseurs who advocated an increasing dependency on recognized European masters, men of the caliber of Gérôme, Roybet and Meissonier.

Martinez stated his aims in a letter to the Secretary of Public Education, September 29, 1913, "It is the wish of the Direction of the Academy that its students of painting work from the model, and in direct contact with nature, in locations where the foliage and perspective effects be true to the character of our *patria*.

"The aim is to awake the enthusiasm of the students for the beauty of our own land, thus giving birth to an art worthy of being called genuinely national. . . ." Following this premise, Martinez asked permission to take students away from the twilight of the classroom into the sunlight of the countryside.[2]

Permission was obtained and a lease signed, October 17, for a house and garden on the outskirts of Mexico City, "The Direction of the National Academy of Fine Arts is renting the house situated on Hidalgo Street, No. 25 . . . in the village of Santa Anita Ixtapalapa, that includes

dining-room, bedroom, front room, corridor and garden. A class of painting will be installed there, making possible the direct study from nature. . . .

"The monthly rental to be 30.00 pesos."[3]

Thus was started the now famous school of Santa Anita, forerunner of the many open-air schools that flourished in Mexico during the nineteen-twenties. Flushed with the memories of a stay in Paris and a Salon Medal, Martinez stressed the French flavor in his teaching, though not in the choice of subject matter. He encouraged his students by addressing each after the name of a famous master, Renoir, Manet, Monet, even Cézanne. The school itself he dubbed "Barbizon," to underline the rustic character of the surroundings wherein this zealous group of landscapists labored. Photographs show easels set around the chipped *azulejos* fountain in the center of the open patio. Plaster casts transferred there from the store-rooms of the Academy vied in attractiveness with live Indian models, and all were set against a natural backdrop of upright poplars, mirrored in the shimmering waters of the Santa Anita canal.

Dating from that period, a mimeographed form with manuscript additions constitutes Siqueiros' earliest auto-biography:

"Birthplace: Chihuahua City, State of Chihuahua.
Age: 17.
Residence: Fifth Street of Altamirano, No. 101.
Father: Cipriano Alfaro.
Residence: Same address.

Occupation: Student.
Diplomas: High School.
When first registered in this school: 1912.
Curriculum: The undersigned is currently a student at Barbizon, in the classes of painting.

Mexico, March 4, 1914.
Petitioner: José D. Alfaro." [4]

Twofold were the reordered activities of Siqueiros at Barbizon. His schoolmates still speak of his extravagant adolescent appetite that led him to Machiavellian plots: he exalted loudly the aesthetic virtues of still-life painting, and especially the rendering of fruits and other edibles; then, often without waiting for a friend to finish a picture, Siqueiros borrowed and stealthily devoured the models. Not denying this, the artist prefers to tell how, under the cloak of protection spread by the gentle unworldliness of Martinez, there were underground political meetings at Barbizon, where plots were hatched against the dictatorial Huerta regime.

Between eating, conspiring, and presumably painting, Siqueiros passed at the school most of the day and much of the night, and his sedate father wondered at this excess of zeal:

"December 17, 1913.
Señor Don Alfredo Ramos Martinez, Director of the National Academy of Fine Arts.
Most esteemed Sir,
 "It is as the father of student José David Alfaro that I make bold to intrude on your busy time. Could you let

me know until what hours of the night do the students stay in this Academy or house of Santa Anita. Indeed, this son of mine returns home haphazardly, more often than not after 10 P.M., and at other times I do not even know when; always swearing that only his studies keep him there.

"Your answer will doubtless contribute to the order that should reign in the home. My questions are born of the imperious duty that is mine to watch over the conduct of my son as well as care for his health, bound to be adversely affected by the irregularity of sleep and meal times. I trust that you will not refuse me the data asked for.

"Receive my anticipated thanks . . .

"Cipriano Alfaro."[5]

Martinez answered:

"Your son, the young José David Alfaro, assists indeed at the classes of painting from nature given in Santa Anita under my supervision, but only in the useful hours of the day, that is before nightfall.

"A few students have received from the Ministry of Education and Fine Arts small allowances that help them further their studies, and they have permission to live on the premises where the classes are given. They remain there as in an internate, but your son is not among them. . . ."[6]

When, on the shifting political scene, First Chief Carranza ousted President Huerta, Martinez was replaced at the school by Dr. Atl. Unlike Martinez, who wished to bring his students in closer contact with nature and local

color, Atl meant to strengthen their imagination along cosmic lines. Hence, "Operative from this date, and valid until countermanded, there will be in this school no more live models. Mexico, September 12, 1914 . . . Dr. Atl."[7]

In the revolutionary free-for-all, Pancho Villa got the upper hand soon after that. Siqueiros, siding with the beaten Carranza, was one of the group of San Carlos students who fled from the Capital to provincial Orizaba. Feeling as yet not close enough to the battlefield, Siqueiros left the group for forthright military pursuits, the youngest officer on the staff of General Dieguez, steady foe of Villa. The painter proved a good soldier, and his companions-at-arms considered his art his only weakness. Once, when Siqueiros offered to sketch General Dieguez, the crusty old man exploded, "I will not have my photograph taken by a boy still wet behind the ears!"

Carranza once more ascended to power, and this time he felt seated securely enough in the Presidential chair to reward the faithfuls of leaner days. When the turn of Siqueiros came, his dual aptitude was duly acknowledged: as a young officer of the Revolution, he received a small diplomatic plum for his expected share; as a promising young artist and ex-student of the Academy, he was given, as also was customary, a fellowship to further his studies of painting in Europe.

In practice, this double award proved cumbersome. Later on, in a letter to José Vasconcelos, President of the National University, sent from Paris and dated September 29, 1921, Siqueiros reminisced on these quandaries,

"... The Government of Señor Carranza ... sent me to Barcelona in the quality of First Chancellor of the Mexican Consulate, and with the added character of art-fellow. The turn given to the affair did put me in a difficult position. I was required to make act of presence at the offices of the Consulate from 9 A.M. to 7 P.M., and thus found myself unable, during the year and a half that this situation lasted, to fulfill the object of my trip.

"As the agreement now stands, the University over which you so ably preside grants me a monthly pension of 300 pesos. To accept this new arrangement, I had to discard a salary much superior. ..."[8]

Siqueiros was writing under the apprehension that the pension was to be cancelled soon:

"... I received this help for only five months; that is a barely sufficient time to orient my efforts in the artistic milieu of Paris, and it is a totally insufficient one to do the same in the artistic milieu of Europe. Nevertheless, I have worked zealously to prepare an exhibition of my pictures that is to open at the Galleries Bernheim Jeune this forthcoming May."[9]

Meanwhile, Vasconcelos was rounding up the best of Mexican artists—musicians, painters and poets—to launch the cultural renaissance that was his favored topic; and he sensed that restless Siqueiros might prove a worthy factor. Vasconcelos wrote to the young artist a soothing letter, October 22, 1921:

". . . José Vasconcelos salutes his esteemed friend, Señor Alfaro Siqueiros . . . and states that it is with pleasure that the pension will be continued for the whole of the coming year, thus enabling him to further his pictorial studies in Europe.

"He [Vasconcelos] also asserts that if at any time Siqueiros wishes to return, he may rest assured of making headway here also and of creating for himself a position superior even to what he could hope for in those [other] tired countries."

Siqueiros, failing to realize from distant Europe the magnitude of the Mexican project, overlooked the artful bait by which the risen politician sought to speed his return. The painter clung instead to the idea of a pension and of a Paris show, and enlisted to the purpose the help of his trusted friend, Juan de Dios Bojorquez, who contacted Vasconcelos:

"Legation of the United States of Mexico in Honduras. Tegucigalpa, November 9, 1921.
". . . Alfaro states that, if he could be assured of his pension for one or two more years the Government could bank on his gratitude; that he would doubtless add luster to the name of Mexico in foreign parts. His confidence in his own talent is unshakable and there is also the fact that he is a born worker.

"I earnestly beg you not to forsake Alfaro Siqueiros, ex-captain in the Revolution, great dreamer, and future national glory . . .

Juan de Dios Bojorquez"

December 19, it was the turn of Señor Gonzalez, Mexican Consul in Paris, to lobby for art's sake. He wired Vasconcelos that, if money was not urgently sent, the situation of the Mexican art-fellows stranded in Europe, including that of Siqueiros, would become truly critical.

January 5, 1922, Vasconcelos, now Secretary of Education, wrote in earnest of his plans to Siqueiros and this time made an imprint on the young artist's mind. Though the original letter is now lost, we may surmise its importance from the answer of the painter, dated February 2:

"To Licenciado Don José Vasconcelos, Secretary of Public Education, Mexico.

". . . Answering yours of January 5, wherein you state that you do not think timely my plans for an exhibition.

"Before anything else, I must sincerely confess that the enthusiasm that your letter breathes intensifies my great desire to return to the *patria*, there to collaborate with all my resources to the common task.

"I am in total agreement with your basic idea, 'To create a new civilization extracted from the very bowels of Mexico,' and firmly believe that our youths will rally to this banner When I asked for a furtherance of my pension, I meant to study part of that year in Italy and part in Spain before returning to Mexico; but your intelligent initiative in matters esthetic has given me A LONGING TO RETURN SOONER THAN THAT TO THE FATHERLAND AND TO START WORK THERE. . . ."

Though agreeing in principle with the blueprint of a

Mexican cultural renaissance so suddenly displayed before his eyes, Siqueiros hesitated to throw overboard the memory of the treasures so recently contacted in France and Spain, and he gave voice to these reservations:

". . . As concerns us, Mexicans and Latin-Americans in general, a knowledge of the artistic tradition of Europe—that is also in part our tradition—and of its contemporary trends remains pertinent, inasmuch as it illustrates the workings of an unavoidable universal process according to which the Europeans are today the masters. Yesterday, it was the turn of the Orient; tomorrow will be our turn. To witness Europe's actual achievement is to touch the very wound of its decadence and to acquire faith in our future. . . . We are at the meeting ground between Orient and Occident, between rationalism and sensuousness, and this fact should mold the character of our own civilization."

In the balance of the letter, Siqueiros delineated his new plans, including a show to be held, this time, in Mexico City; also,

". . . could you advance me here 700 pesos to be discounted at the rate of 100 pesos per month from the 300 monthly that I receive. This amount is approximately what I intend to spend on art materials.

"May I remind you that, two and a half years ago, I was sent to the Consulate of Barcelona with the character of art-fellow, and with travel expenses paid for. Given this precedent, I ask the necessary allowance for my return. . . ."

Vasconcelos to Siqueiros, February 27, 1922:

". . . Your plans seem very good and I have advised the Department of Pensions to take them into account. In case you decide to come back in May or at mid-year, we will forward your travel expenses as soon as you wire us concerning your return. . . . We will send a sum of 1200 pesos, and you may apart some of it towards material expenses. . . ."

Siqueiros wired Vasconcelos, April 16, "SUM NEEDED RETURN MEXICO NEXT BOAT SITUATION PARIS CONSULATE MOST URGENT."

The next day, Vasconcelos sent Siqueiros one thousand pesos, specifying that they be used "to return to Mexico."

July 6, Siqueiros, from Rome, wrote to Vasconcelos a lengthy plea: the artist had spent so much money on art materials that he had not enough left to buy his return ticket, ". . . You will see that I am faced with a grave defalcation I am in danger of having to stay in Madrid, where I will arrive in a few days, and in very sharp money difficulties. . . ."

Patient Vasconcelos advanced the needed sum, cautiously stating however that, if Siqueiros failed to return this time, his pension was to cease automatically. Siqueiros arrived in Mexico City in August.

At that date, the mural renaissance was already under way, with a handful of muralists at work on the walls of the Preparatoria School. Joining them, Siqueiros chose for himself one of its stairwells, that of the *Collegio Chico*,

a cluster of walls and vaults, curved or slanted, that lends itself to further optical elaborations. His first realized panel, *The Spirit of Occident Alighting on the Americas*, shows, in its chiaroscuro both soft and strong, the impact made on the artist's mind and eye by the frescoes of Masaccio.

The opportunity to paint this first mural, heading as it did Siqueiros towards the carrier that best suited his monumental gifts, already fulfilled potentially the promise made by the Secretary of "... a position superior even to what he [Siqueiros] could hope for in those [other] tired countries."

Financial plenty, that had at least been hinted at, proved more elusive. Official demands for money to be spent on the painting of murals were camouflaged artfully to pass, when possible, the scrutiny of a Congress whose heart was lost to the military, and that remained quite immune to aesthetics. At the time that Siqueiros worked on his first set of murals, he was paid 3.00 per day as "Teacher No. 59 of Drawing and Manual Crafts"; he also was "Assistant to the Director of the Department of Plastic Workshops," a directorship that, in turn, had been specifically created by Vasconcelos to provide a living for Diego Rivera; a little later, Siqueiros also turned up as, "Assistant smith in the bronze foundry attached to the Department of Fine Arts," a job that paid him 6.00 per day.

When documents are the only source of knowledge, one must, at times, be led to false conclusions, or at least to irrelevant ones. In this case, however, it is still possible to cross-check existing texts against live memories. I was a witness to the fever of creation that seized Siqueiros on

his return, and that was to eventually stamp many of his personal traits on the Mexican school. In this light, the only Academy document to touch on that period is perhaps disappointing. It is a report addressed to Director Ramos Martinez, dated January 9, 1923.

". . . Last night, the Señores Gabriel Alfaro Siqueiras [sic] and Fermin Revueltas showed up at the main entrance of this Institution at 18.30 p.m. Being in an inconvenient state [i.e.: drunk], they broke a glass pane in the skylight of the studio of Señor Dominguez Bello. The student Pedro Sanchez, hearing from inside the crash of the falling glass, rushed out of the studio. There they were at the foot of the window, those responsible for the damage.

The Janitor, Enrique Suarez"

[1]Archives of San Carlos, 1912–19: "Concursos."
[2]*Ibid.*, 1913–21: "Clase en Santa Anita."
[3]*Ibid.*
[4]*Ibid.*, 1914: "Inscripciones de alumnos numerarios."
[5]*Ibid.*, 1914–10: "Correspondencia del Director."
[6]*Ibid.*
[7]*Ibid.*, 1914–1: "Asuntos varios."
[8]Archives of the Ministry of Education: "Siqueiros, 1–21–6–10," for this letter and the following nine documents.
[9]Archives of San Carlos, 1923–114: "Partes del Conserje."

This article first appeared in slightly different form in *College Art Journal*, Vol. X (4), Summer 1951.

Xavier Guerrero,
Indian Artist

Xavier Guerrero was born in northern San Pedro de las Colonias, whose native name is Cachuila. His ancestry makes him the one undiluted Indian of the original group of Mexican muralists who recreated Amerindia on modern terms.

To describe the warm ochre of the Chilean soil, poet Pablo Neruda wrote that it was of Xavier Guerrero color. This elliptical image holds true both ways. The painter melts into a landscape as readily as its rocks or flora. He resembles the boulder-textured Aztec sculpture, squatting men apparently as immobile as the volcanic stone they are carved from. Compared with the *Discobolus*, these figures seem idle; feelingless, matched against the writhings of a Laocoon. The white man's eye must get accustomed to their vegetative twilight, made to measure with the dense green of an underbrush. Once in focus, he realizes that Aztec sculpture is as alive as the Greek, only less blatantly. Belying the impassive features, the symmetrical fists of a figurine will press amorously to its flanks two half-hidden ears of corn, as a miser counts his gold.

Guerrero: Indian Courtesy. Ink drawing

Quiet Xavier Guerrero is the uncommon common denominator of the individual trends that weave into a Mexican Renaissance. He helped shape the medular marrow of its works by evolving most of the unusual techniques that did as much towards defining national forms as the painters' personalities.

In the 1910s, Paris cubists talked of signpainters and housepainters as being truer masters than many an academician, for they alone kept alive wise traditions long forgotten by fine art schools. Picasso and Braque proceeded to experiment with the recipes of the trade, and to handle its specialized tools. In Mexico, Xavier Guerrero tapped the same vein by birthright, as the son of a skilled master house painter who rated crews of his own.

Xavier learned to toddle his winding way between paint pots and ladders; the fat or flat brushes of the trade were his toys. The future muralist watched his father at his job of painting walls, learned of a plastic alphabet before he was introduced to A B C. Soon, he tried his hand at it, challenging with juvenile exercises in make-believe woods and *trompe l'oeil* marbles the paternal *chef d'oeuvres*. The training of hand and eye was rounded out by practical experience as an architectural draftsman, and the fourteen-year-old branched south, trekking from Chihuahua to Jalisco.

In Guadalajara, a rich milkman, Don Segundo, was building to his fancy a house that came to be known, from the source of his fortune, as the House of the Cows. Said loitering little Xavier to the master house painter, "I am a painter too."

Said the master house painter, without slackening the swish of his brush, "Well, put a river here."

Said Xavier, "I will, and with a sky too," and he did.

Said master painter, "Good, now put rocks here," which he did.

That done, "Put a child by the river."

That done, "Make him cry."

Once proved, little Xavier rated a scaffold of his own. He milked the milkman for his worth, selling him on the idea of a renaissance frieze, hand-stenciled at so much per yard, full of people that ended in fishtails, a feature that greatly surprised Don Segundo.

By 1912, a decade before the best-known Mexican muralists thought of painting walls, Guerrero was a seasoned mural painter. He did among others a ceiling in the chapel of the hospital of San Camillo, its theme a Resurrection. That was in mid-year, and there was a string of earthquakes that shook the high scaffold where he worked, while the nuns huddled and knelt underneath.

His participation in the military revolution began with a *quid pro quo* that caught him quietly at his job. "I was asked to paint a mural in a hacienda, that is to paint a new map of the grounds to replace one become obsolete. Such good meals they served there, large pitchers of creamy milk, and two desserts to choose from. But it did not last long. Came a troop of armed men and they invited us outside, to witness the shooting of hacienda hands. Said the chief when he saw me, 'You will be my secretary. Get us some medicine.' Naturally I agreed, 'You can get some at Chapala.'

"They gave me a huge white horse, and I galloped at the head of the troop, and because I knew most people in town, I took my cavalcade all through the main street to the outskirts and back again. And people gasped and said, 'We did not know that you had been promoted to general!'"

Come 1920, the revolution was top-dog, mural painting was in the air, but not yet on the walls. Roberto Montenegro was first to receive a mural commission from the Federal Government, the decoration of the former church of San Pedro y Pablo, now become a hall of free discussions. He was wise enough to give Xavier Guerrero the post of technical adviser. The advice given by the young veteran muralist was eminently practical: let Montenegro do the back wall in oils as his fancy dictates, and Xavier would see to the rest.

The beautifully preserved decoration, painted in distemper on a white plaster ground, strews garlands of stylized pomegranates, blue birds, black birds, cornflowers and camellias over walls, pilasters, and cupolas. Guerrero also painted the dome of a lateral chapel with the signs of the zodiac.

When Diego Rivera returned in 1920 after a twelve-year stay in Europe, he received for his mural assignment the auditorium of the Preparatoria School. Montenegro presented Guerrero to the cubist master, who also asked him to be his assistant. The new mural would be painted in encaustic, a wax method that Rivera had practiced in Spain on a small scale. His European trials included rare and expensive materials, *resine elemi* extracted from lemon

trees, and *essence d'aspic*, a wild lavender base used in perfume making. These ingredients could not be bought in Mexico and their importation in the quantities needed for making a mural was prohibitive. Xavier sensibly adapted the overseas technique to local purse and conditions by suggesting plain wax, turpentine, and the copal rosin still used by Yucatan natives as incense to propitiate jungle gods.

The job started from scratch, that is from the wetting and grinding of the dry pigment; but even the tools of this disused craft had to be made. A marble slab was chosen for a first grind; a glass slab for the final one. Xavier drew a plan and profile of a marble pestle and had it carved to specifications. Carlos Merida, Xavier, and I were a willing team of color grinders, and came to commune with pestle and slabs intimately, widely in excess of union hours.

Other mural chores were the incising of the line in the cement ground, the pricking and pouncing of detail drawings, the priming of the wall with hot rosin at the instant of painting, and the synchronizing of a blowtorch lick with each stroke of the brush, to vitrify its load of pigment.

Rivera's conversion to mural painting occurred in front of Byzantine mosaics in Ravenna, and his first mural retained the hierarchic flavor of its source. Gold backgrounds and gold halos presented another technical hurdle. Only Xavier could use the gold leaf with success on the roughly chiseled cement. We watched in awe as he rubbed the brush on his wrist to charge it with electricity, and how the incredibly thin leaf would leap to it and

flatten itself on the wall as if by Indian magic. When I attempted the same, the leaf just crumbled into uselessness.

Rivera moved to the Ministry of Public Education in March 1923, to begin there a job that was to continue for years. This time he would paint in fresco. I offered what help I could from the experience amassed in making my first fresco, but the switch of techniques proved too much of an ordeal for Diego. Late one of the first evenings that we were on the job, as I walked through the dark court, I noticed that his scaffold shivered as at the start of an earthquake. Climbing up to investigate, I found the master crying, and viciously picking off his day's job with a trowel, as a child will kick a sand castle in a tantrum. Guerrero came upon similar tableaux in these first hectic days.

The whole work threatened to wither at birth. It was imperative to find release from this mental and technical emergency. Happily, Xavier remembered how his father would trowel a coat of mortar, lay on top a coat of plaster mixed with marble dust, then paint, then press the surface smooth as glass with a hot iron. He started from there, changing the plaster for lime, experimenting cautiously on portable fresco samples with mortars of distinct contents. Meanwhile, Rivera was sent on a farflung trip to sketch and rest.

Siqueiros wrote of Guerrero, as he remembers him at the time, "More than the fine art artist, he was a worker in practical painting, a studious searcher for autochthonous technical material, a good finder of traditional landmarks. A good walker, he ambled through the most remote of

our regions, unearthing past plastic secrets. He was both the worker and the scientist of our group."

Says Xavier, "I made trips to Teotihuacan to compare my results with pre-Hispanic murals, then matched mural samples in the Ministry. At last I made a successful sample and showed it to Diego, who said, 'We will save this sample, imbed it in the finished work and paint by it your portrait, with the date of the discovery.' I suggested that Diego let me take the sample out myself as he is somewhat clumsy with his hands, but he insisted on doing it himself. He hammered the sample to bits, and the last, rather large fragment to fall, he crushed absent-mindedly underfoot and spoke no more of painting my portrait."

As he already had done with encaustic, Guerrero thus streamlined fresco to fit the Mexican milieu. One of the minor features of the modified technique was the use of nopal sap as an agglutinant. This picturesque touch stirred the newspapers into eloquence, and they dubbed Guerrero's method "The Secret of the Mexica."

In June 1923, *El Universal* said: "The artist painter Diego Rivera has rediscovered, in the opinion of certain technicians of painting, the process used by ancient Mexicans to produce their splendid frescoes, such as those that we admire today in the monuments of San Juan Teotihuacan.... It consists in mixing nopal juice with the preparation, completing the work with a special polish, adopted after numerous trials by the assistant of Diego Rivera, Señor Xavier Guerrero."

And in July Rivera praises, in an interview, " 'Xavier Guerrero, well versed in the craft of painting, who

discovered in his noble approach to it as a laborer a procedure that resuscitates the manner of painting of the ancient Mexicans. I use this technique,' adds Diego modestly."

By then the danger of failure had waned. Bucked up by his esoteric share in "the Secret of the Mexica," Rivera gathered courage, and in a few weeks fresco had no terrors left for him.

In the chapel of Chapingo, Guerrero also worked with Rivera and painted panels of his own, among them monochrome floral decorations that prove the care with which the Indian observes nature. Not content to look at a flower, he memorizes its anatomy, sampling inner shapes with lateral and longitudinal slices from tip to roots, after the manner of his Aztec ancestors, the *tlacuiles* who left us exquisite botanical albums.

The decoration of the house of the director of the Chapingo agricultural school is entirely his work, important as an isolated example of private decoration from that early period. Here, but *a sotto voce*, are the usual symbols customarily flaunted on public walls on a colossal scale.

When the "Syndicate of Revolutionary Painters, Sculptors, and Engravers of Mexico" was created, Guerrero was the only one of the painters to take the move for granted. His father had been a devout union man, and would take him by the hand as a child, to walk in street demonstrations of the painters' union. Unlike his artist friends, Xavier had thought of painting as a communal affair since the days he trotted on short legs behind the unfurled, hand-painted banner of his father's guild.

As a member of the new syndicate, he shouldered the responsibility for its organ, a newspaper that carried more woodcuts than news, the wrathful *Machete*, its name borrowed from the curved blade, half hunting knife and half scythe, that the Mexican peasant knows how to use in war and peace. Its slogan read:

> The machete is used to reap cane,
> To clear a path through an underbrush,
> To kill snakes, end strife,
> And humble the pride of the impious rich.

Left of the left, its contents were such that neither right nor center nor left could find any solace in it; and it was butted in turn by enraged politicians. Guerrero, Orozco, Siqueiros, contributed to it some of their most mordant works, got fired from their mural jobs in retaliation.

The paper was paginated in reverse, the contents of the first page being printed on the verso of the last sheet, an apparent artistic oversight that allowed the paper to be read straight as a poster. Siqueiros and Guerrero, loaded with a pail of glue and a roll of *Machetes*, used to sally forth at four A.M.—after the street lamps were extinguished and before the first stirrings of day. They stealthily pasted the paper at strategic street corners, where its illustrations, cut in wood on a mural scale, at last settled on an architecture.

More than a decade of travels interrupted Guerrero's technical researches and art realizations, taking him to

eastern Europe and western Asia, to live among Caucasians and Kirghiz, Cossacks and Tartars.

Most important of the murals executed after his return are those he did in Chile, as a cultural ambassador of the Mexican Republic. The town of Chillan had been destroyed by a lethal earthquake in 1939, and help came from the sister republic. Mexico donated a school and its decorations. While Xavier painted the hall in fresco (two floors, a staircase, and ceilings, an area close to four hundred square meters), Siqueiros decorated the library in Duco.

No sharper contrast could exist between two stylistic temperaments. Siqueiros recreated the bloody dynamism of the catastrophe under guise of the maimed, shrieking figure of a semi-mythical Indian hero. Guerrero, with selfless respect for a people sated with tragedy, painted symbols of reconstruction and hope. Wrote Chilean Pablo Neruda, "An outer harsh grandeur, an inner clear core of medular freshness. The peasants of my country will detain their horses alongside the decorated school, and look long at Guerrero's figures, obscurely conscious of the secret roots, the hidden waters that link our nations under a vast continent."

Before painting on it, Xavier observes an architecture with the same oriental minuteness with which he dissects a flower. The standing building is, unlike its blueprint, a fragment of a larger habitat, ruled remotely by sea, sun, and stars. The painter encourages natural phenomena to intrude upon his geometrical schemes and to propose optical accidents that he will make his norms. Outside the

Chillan school, a pool of water strews shivering slivers of sunlight through the windows and on a ceiling at certain hours of the day. Guerrero slanted figures in movement after their diagonal play, in contrapunto to the ceiling square. This obeisance paid to the immaterial is repaid when, every late afternoon, the figures swim in reflected light.

His other Chilean mural is inside a modern hall, used as a recreational club for workers. A man and woman, each over thirty feet long, fill walls whose strong inner slants join at the top in a V barrel vault, where a child levitates in zenithal position. Of a sustained, fruity *goyava* pink, the fresco is painted on a mortar rich in cement, modeled in part with thin airbrushed films. The mood is one of lassitude after an exertion that may be work or war.

Guerrero usually does not paint on a scale that fits exhibition walls, nor subjects flattering to a period drawing room, and yet he has experimented in small scale, subdued, non-didactic, surprisingly intimate easel pictures that contrast with his public style. These he paints in Duco over *costal de ixtle*, a local gunny sack that comes in graded textures, from the tough, hairy fiber of the common *magueye pulquero* to the medium roughness of the Yucatan *hennequen*. He coats the coarse stuff with a mixture of fine plaster, sulphur, zinc white, glue and varnish, that hardens with the paint to wall hardness.

We learn from Guerrero how an Indian visualizes Indians, and that is not as plumed, chanting, dancing natives, caught by the tourists (be they foreigners or Mexican citizens) disgorged by motorcades on a given

village, on the one day of the year when it does not look or act like itself.

Xavier succeeds in painting silence and repose, eminent characteristics of his race, so forgotten by artists who specialize in painting Indians. To open a vast store of Amerindian knowledge, he needs but to close his eyes to disturbing exterior spectacles, of which he has so often and so forcefully been an actor, and let an ancestral voice speak. That his easel pictures are so surprisingly quiet proves that they are the unadulterated echo of such a wordless meditation; they do not attempt to "put anything over." They are simply the essence of a nature more finely attuned than most to that which is of wide human worth in a given heritage and locale. The deep root nurtures a calm blossom, like the black spears that stretch against a white moon in one of his finer flower-pieces. Far from modeling itself after a Fenimore Cooper yarn, the Indian art of Xavier Guerrero treads on padded feline paws.

This article first appeared in slightly different form in *Magazine of Art,* January 1947. Reprinted by permission of The American Federation of Arts.

Carlos Merida

1928

Driven by the iron hand of a discreet and implacable taste, Carlos Merida has discarded, as the balloonist drops ballast, not only elements pictorially doubtful, but those legitimate tricks and recipes with which even good painters stuff and prop their work. The aesthetic creed of Merida is defined better by the ponderous list of means that the painter purposely renounced. He avoids linear perspective, that paradoxical convergency of parallels, of which Raphael wrote with scorn as "those measurements that seem to be, but are not." He repudiates also the suggestion through values of a film of atmosphere whose elasticity defines the volumes. His pictures do not use a light with localized source. They are imbued with a diffused glow which affirms local colors as flat areas. This painter of tropics has thus to do without the facile duplication of sunlight, the easy way of describing objects by exalting the contrast of values. To a mind so strong with scruples, modeling appears perhaps as a means more akin to sculpture than to painting. He avoids also tactile qualities, the rough and juicy strokes suggestive of mastery:

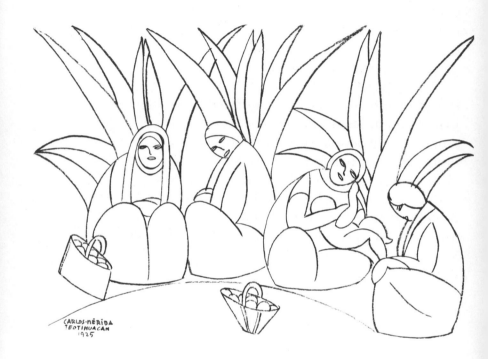

he applies his pigments without visible brush marks, with a mechanical monotony which however respects and reveals better than other ways the physical plane which is the picture. The line that Merida prefers owes little to the twist of the wrist or the spur of inspiration; ruler and compass define for him the circle, the oval, straight verticals and horizontals. He shies from dynamic composition, using a vertical median axis with symmetrical wings, or simple variations on this theme.

This pictorial world in which Carlos Merida rejoices should then be without space, without volume, without light, without linear swing; something of a world in two dimensions, where bulk and movement would exist no more than in a carpet or, to soften the blow, in a stained glass window.

But this good strategist guardedly escapes defeat; in his tactical retreat into a world of purity, he preserves intact a factor which gives him victory. The role that the artist refuses to drawing and modeling falls to the single means of color: color alone re-creates space, volume, weight; in the end his painting is enriched by this extraordinary refinement of means.

Merida is a conscious master of this geometry of color which reaches deeper than the geometry of line. Because of this, the scaffolding that his drawing raises is not intended to solve problems, is no more than the geographic boundaries of his color. From tone to tone, an optical magic multiplies vibrations, living intercourse binds the

Merida: Teotihuacan. 1925

parts into one picture, gives it more life than any handi-work could. This optical life of the picture is after all its reason to be, and to it the physical picture must bow.

The artist has lately applied this knowledge to drawing; in his earlier work the line is of such orthodox geometry as to clash with nuances. In his last water colors the geom-etry becomes on purpose deficient, as if reflected by an unruly mirror; such lines of more human lineage pass through the eye without wounding it, to reform in the brain, though not on paper, a puritan architecture. Both line and color, by weakening their physical impact, mature into spiritual reality.

The artist even indulges now in what must seem to him immoral cavorting, certain modulations within a flat tone, a sly modeling of volume under the guise of technical accident discreet tactile qualities, a few visible brush strokes.

By digging a little wider than before in the treasure chest of pictorial resources, Merida varies his art without deviating its course. This oeuvre, all intimacy and restric-tions, is yet not a drawing room display or the relaxation of a dilettante. His works speak "sotto voce" but with deep conviction of his Mayan birth and breed. To bellowing politicians whose platform is to civilize the native, the artist offers an alternative of equally instant necessity, a redemption of the white man by the Indian, who can well teach him physical and moral nobility, and over all con-templative peace.

<div style="text-align: right">Merida: Figures. Circa 1930</div>

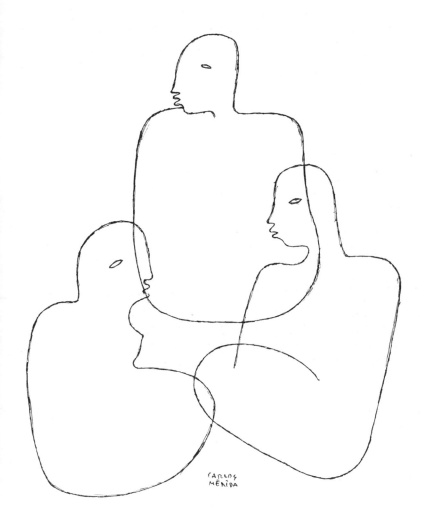

1936

Be it for shame or glory, Carlos Merida is the pioneer of the so-called "renaissance" to which his show of 1920 in Mexico City gave both birth and a healthy jog. He was also the first of this group to cleanse his work of the picturesqueness of folk-lore, even though he well knew how to translate it into sound plastic terms.

Following a rigid process of introspection, Merida came to question even this impressionist painter's paradise that is the world as seen through the human eye. At last he has come to rest his art upon this rock bottom level labeled "abstract," where color and line do not masquerade any more as outer things, where the painter's aim is not any more to tell a lie.

He brings to this recondite work the same racial grace used in depicting his own tropical land. The silent geometries, the reticent sensuousness of textures, the earthly dampness of color, speak still of a land and a race, but sublimated unto a plane where neither tourists nor travel agencies have access.

We, who were not brave enough or rash enough to do the same, still clinging to picturesque themes and realistic vision, gaze with longing upon Merida as he opens his path through those rarefied regions where appearance gives way to substance.

The first part of this article was originally published in Spanish in *Contemporaneos*, 1926; the second part was the Foreword to a show, 1936.

Rufino Tamayo

Twenty years ago a small group of Mexican artists, eschewing the international style centering in Paris, brought forth an essentially local aesthetic. The travail entailed shows in the results, especially the murals frescoed in the twenties. The magnitude of the areas covered, the scope of the heroic subject matter, bespeak a gigantism that jarred certain sensibilities. A Mexican witness writes in 1924, "This itch to paint decalogues, transcendental symbols, philosophical concepts, revolutions and revelations, is either a joke or childish delusion."

Though a youthful prize-winner at the San Carlos Academy in 1918, Rufino Tamayo came of age as a painter about 1926, when the first energy of the mural movement was already spent, when some ears, sated with the routine of pipe organs going full blast, sighed for chamber music. He, and others of similar mind, witnessed with amused awareness the sport of fellow painters pushing Sisyphean rocks uphill. Surrounded by red banners, closed fists, open mouths, clanging chains, and eviscerated money bags, it was a most natural thing for the dissidents to rediscover for themselves with delight *l'art pour l'art* with

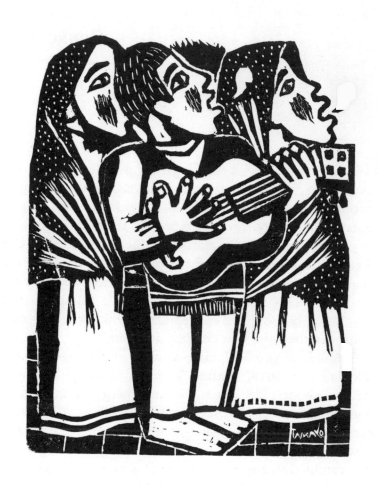

354

its exquisite soul searching, and the aristocratic monologue of a subconscious talking aloud to itself.

Indianism was a major note of the renaissance. Whatever his inclination, Tamayo could hardly discard a racial heritage that was not for him a cerebral option but a biological fact. His colleagues had picked the most gigantic of antiquities as touchstones against which to assess their muscles—the monolithic moon-goddess from Teotihuacan, the geometric serpent heads dug up in the Zocalo, the colossus *Coatlicue* girded with snake rattles, displaying baubles made of human hands and hearts. But a whole valid vein of Mexican art remained closed to the muralist intent on size and scope—the archaic terra cottas of people making music, holding hands, giving birth, delousing each other's manes, yet remaining minute pellets of clay stamped with the functional thumbmark of the potter. Tamayo adopted them as stylistic ancestors, and also the Tarascan fat men sculptured in baseball attire, raising their bats at equally fat dogs with shamrock-shaped ears and wagging stubby tails. Instead of the grinning mask of the death god, he warmed to smiling Totonac heads, halfway between the Mona Lisa and kewpies.

The dualism of mood of pre-Hispanic times holds true of our day as well. While the self-appointed painters to the Indians frescoed brown giants with thunder on their brow and lightning in their fist, the Indians themselves produced their own art as usual: they embroidered or lacquered arabesques bearing a crop of buds and birds,

Tamayo: Folksingers. Woodcut, 1931

patted black clay into the shapes of monkeys and owls, dressed fleas, wove straw horsemen astride petate horses, painted pigs, and ex-votos where people suffer, pray, are cured, all happening in silence within cloistered hearts, with not a fist, not a flag, not a streamer in evidence.

All this was in accord with Tamayo's own life. Born in tropical Oaxaca, he lived in Mexico City in the quarter of La Merced, the district of markets and wholesale fruit dealers. His adolescent eye took in mountains of bananas—of green gold, yellow gold and copper—heaps of mangoes—the whole gamut of cadmiums from lemon to purple, their bloom enhanced with leopard spots of black—of still more lush papayas, *chirimoyas*, and round brown *zapotes*. At home, genteel baskets smothered with ribbons displayed paper flowers and fruits again—wax fruits this time.

The muralists had solved the relationship between local and international art by turning their backs on the School of Paris, on which most had been nurtured. Their hearts set on plastic oratory in the grand manner, they felt an affinity with such old masters as Giotto and David, masters of propaganda in paint, and could seek no compromise with the Parisian attitude that tabooed substantial themes as subject matter. For Tamayo no such harsh choice arises. There is a kinship between those he loves, gentle Indian "old masters" and folk artists, and the brittle masterpieces of Dufy and Laurencin. In his early work, traditional Indian and modern Parisian styles coexist in peace, with an easy grace and an unassuming relaxation that contrast sharply with what is usually understood by Mexican style.

While his fellow painters favored heroic themes, Tamayo chose humbler models. His early still lifes heap childish wonders—mangoes, ice cream cones, electric bulbs—juggle with them for the sake of color in a palette not intended to be soaked through the eye, but gustatory as it were, not in the esoteric sense suggested by Rimbaud, but as if the motor reflexes of childhood experience remained miraculously alive. André Salmon holds that painters' climates should be common human currency, suggests the weather report: "Today Tiepolo skies, tomorrow Rembrandt clouds." In turn, Tamayo greens and Tamayo pinks equate celestial pistachios and raspberries.

Born to it, Tamayo is one of the few who can validly claim as his the picturesque subject matter of tropical Mexico. With postcard splendor, native Oaxacanian markets display, besides their colorful wares, bronzed Tehuana types with naked feet hugging the ground, full-pleated skirts, embroidered blouses, natural flowers braided into their hair. Add palms and parrots, varicolored houses, and mangy dogs. All this subject matter is to be found in the artist's work, but used with a tremulous sense of responsibility to the rules of good taste and good painting. This race of women that started many an ethnologist babbling of a lost Atlantis roams through his canvases as bell-shaped pyramids, with a flaring starched ruffle at ground level weighing more heavily in the painter's hierarchy than the featureless heads. His curiosity clarifies the nameless shapes that peeling coats of paint produce on an otherwise plain wall. The hot sun is culled

and sieved into color patterns that studiously avoid the rendering of sculptural bulk. The tropical scene is "recreated" if you wish, "abstracted" if you want.

Artists are often tempted to play the Peter Pan, inertia suggesting caroling and carousing in collegiate fashion as an easy way to grow up. Endowed with a personal style, shown and sold by New York dealers who appreciate the affinity between his vision and that of the School of Paris, Tamayo could have hardened his early success into the mold of a well balanced formula: enough sophistication to intrigue the layman, with enough naiveté to delight sophisticates.

No such fate awaits this painter, whose evolution steers its able course equally far from the somersault turned stale and from the paunch grown at the Academy. A break in style, aesthetic *pedimento* or plastic *mea culpa*, is nowhere in evidence, and yet the difference between the early and present work is emphatic. A change of psychological approach signals a shift of seasons, as the slow summer fullness of maturity takes its hold. The long residence of Tamayo in New York results paradoxically in a depurated inner comprehension, a sifting of racial quintessence. The picturesque allusions in modern guise that his northern public had come to expect, the toy shapes, the candy hues, fall short of this new urge whose far-flung motors feed on more disquieting strains. Distortions of the human figure are no longer meant for purposes of wit—as plastic puns. They are bona-fide distortions of passion. While Greco's mark holiness, Tamayo's liberties with man's frame suggest a ripper's surgery, or the craft of the Mexican

village witch baking bits of hair and nail filings from the intended victim inside a clay doll, with deadly purpose. In these later pictures, certain dogs or dragons open jaws as barbed with teeth and as ravenous as the vampire-headed beings that sit, Buddahwise (but with none of Buddah's static acceptancy), on the Zapotecan funeral urns dug up in the painter's native Oaxaca.

In the twenties, taking no part in the mural movement, Tamayo pitted purification of means against sheer size and scope. Later, perhaps because he felt secure enough in his acquisition of pure plasticity, perhaps simply because he is a Mexican painter, Tamayo painted murals. That of the Academy of Music of Mexico City, frescoed in 1933, is close to his easel pictures in mood, if not in physical size. With the same relaxed subconsciousness, the same delight of the brush, and the same racial validity, it also shies from didactic purpose. Indian angels pluck stringed instruments and play at being but still lifes—if not Cézanne's apples, at least Tamayo's *zapotes*.

Tamayo: Two Guitars. Woodcut, 1931

His 1943 mural in the library of the art department of Smith College signalizes, however, a wish to tell a complex story in terms of giant size and in collaboration with the architecture. In this fresco the artist tackles unafraid a theme that some of his non-objective colleagues would irreverently call a hoary chestnut. In Tamayo's own words, "The first panel is entitled 'Nature and the Artist' . . . the figure of Nature is of heroic size. It has four breasts and lies in an attitude of surrender, to symbolize abundance and generosity. From the rocks . . . there springs a blue female figure from whose hands flows a stream of water. This figure symbolizes Water. . . . Above Water is a male figure in red, symbolizing Fire. . . . Another female figure, coffee colored, represents Earth. . . . At the right a blue male figure . . . represents Air. The whole group is capped by a rainbow which . . . symbolizes Color, the basic element of painting.

"Another male figure represents the Artist engaged in producing the Work of Art . . . between the Artist and the group representing Nature there are a lyre and a compass, to show that the Artist, when he looks at Nature in search of plastic elements, should do so through the medium of poetry and knowledge. . . ."

This description may conjure up for those who have not seen the actual wall, ladies in Greek veils toying with operatic accessories, such as a seventeenth-century *peintre d'histoire* bent on moralizing could have conceived. The chosen subject implies the representation of three different degrees of reality: the artist, his vision, the work of art, in decreasing order. Such a program would tax even a

realistic painter, though he could lavish on the figure of the artist all the tricks of his trade and taper toward lesser realism. Tamayo manages to carry his complex program to completion without once falling into photographic vernacular, as he doses with sagacity diverse degrees of abstraction.

In the microcosm that the artist orders to taste on those 400 square feet of wall, geometry rates over anatomy— shapes elbows, knees, and shoulders after the rigid fancy of ruler and compass. Bodies as we know them are done violence to, breasts are multiplied, fingernails swell to the size of heads, heads shrink to thumbnail size—while prismatic hues sally forth out of the rainbow, seize on any skin as their prey, or fight for possession in a piebald melee.

While Nature is given true weight and a sculptural mass, Fire and Air remain buoyant, their two-way traffic streaking diagonally the dense earth-colored sky. Patches of brown on blue mark Water's subterranean origin. Earth emerges between the mountainous hip of Nature and the prismatic fluorescence of the rainbow, like a star-nosed mole, claws clamped at the egress from its shaft, as it senses the unwanted sky. Observing this semi-abstract vision from the side, the painted painter abstracts it further. Style shifts by imponderable transitions from the massive Nature born out of the steaming Mexican loam, to the international style in which the artist is working.

In spite of its size, its brilliancy, its eloquence, this fresco affects the observer more through the handling of the brush than through its intellectual planning. One is prone

to overlook the didactic purpose and to relish instead modulations of color, especially those passages from red ochre through darker ochres to burnt cork, culminating in the figure of Earth.

This huge mural should put Tamayo's mind at rest as to his ability to produce the kind of full-throated pipe-organ music that he questioned twenty years ago. It should not make us forget his other, major claim, staked in more recondite grounds of Mexican aesthetics with those easel pictures that strike two contrasting chords, the white magic of his early toyland and the brown magic of his maturity.

This article first appeared in slightly different form in *Magazine of Art,* April 1945. Reprinted by permission of The American Federation of Arts.

Tamayo:
Man and Woman.
Woodcut, 1931

Rufino Tamayo,
a Review

This is a beautiful book about a worthwhile artist, concerning whom up-to-date published data was scarce, especially in the English language. Format, typography, brilliancy of the colorplates, and amply legible size of the halftones, deserve praise. Robert Goldwater communicates with unaffected sincerity in his text what knowledge he has of Tamayo's Mexican cultural background, and a first-hand connoisseur's reaction to Tamayo's paintings.

Unavoidably, a few quid-pro-quos arise from the difficulty of translating Amerindian concepts into Saxon ones. At the mention of the artist's aunt, who ran a wholesale fruit business, refrain from a mental image of ordered rows of apples individually wrapped in tissue paper, or of oranges, each branded with a rubber stamp and dipped from stem to navel in orange dye. Picture instead piles of naked tropical fruits cluttering corridors and sidewalks, and heady with gamey perfumes. The market of La Merced, where the young boy lived, is still today crowded with disorderly throngs that squat and barter, buy and sell, with a hue and cry and passion reminiscent of those of a medieval fair or pilgrimage. And over the conglomeration of wooden booths and canvas tents, as a

castle gathers to itself a village, rises the ex-convent of La Merced in its dilapidated colonial magnificence.

Excellent on the whole, the panoramic report of Mexican art at the beginning of the twentieth century can stand minor retouchings. The august Academy of San Carlos, founded in 1786, hardly deserves to be the villain of the piece when most of the great Mexican painters are indebted to the institution. A school that started on their way, in our day, men of the stature of Siqueiros, Orozco, Rivera—and Tamayo—must have its good points. The truth is that Mexico's academic art was a much more vital product than its European counterpart, due in part to the magic *décalage* in time that qualifies Mexican styles. At the opening of the twentieth century, painter Rebull, a belated Ingrist, was instructing Rivera along the lines recorded in mid-nineteenth century by Amaury Duval. And the other aging native academicians, Parra, Velasco, were much greater artists than the imported Catalan master, Fabres, even though the latter, in 1903, was more informed of international trends.

When the artist, as seems the case here, scruples to recount his past, means may be validly used to fill in, ever so slightly, biographical gaps. Scholars whose study is ancient art scan contemporaneous archives in an attempt to reconstruct the life of the Old Masters and to untap the source of their inspiration. The modern artist, too, is leaving factual clues in documents that await future art historians, who will entrust to these more impersonal witnesses the task of assessing the understandable enthusiasm of today's critic, who speaks of a master who is also a living man.

By the use of the historical method, premature as it were, Tamayo may be specifically linked to the local cultural background so ably described by the author. Though we cannot quite "tell of the first drawing done," we may come a few years closer to it than does Goldwater: in June, 1918, Ramos Martinez, though not yet director of the San Carlos school, offered cash prizes for the best student sketches, with emphasis laid on atmosphere and movement rather than on a rendering of static form. In this contest, nineteen-year-old Rufino Tamayo rated an Honorable Mention, this first printed appearance of his name being found in *Boletin de la Universidad*, 1, 2, November, 1918.

First published appraisals of Tamayo's painting style, of interest as no pictures of that period are known today, appeared in 1921, in conjunction with the annual student show of the San Carlos Academy. In *El Universal*, October 2, critic Vera de Cordova singles out his work: "Tamayo, a disciple of Montenegro, but more divisionist in his color and making use of a Cézanne-like structure." And Rivera, just returned from Europe, speaking of the same entry in *Azulejos* for October: "Quickness of notation, sensitiveness and good understanding of planes, quite a painter."

Vera de Cordova's quote suggests that the artistic first steps of the artist can hardly be evaluated fairly without at least a mention of Roberto Montenegro, whose name should end the search of the author for "the first great man met who saw the child's talent." More than Ramos Martinez, with whom Tamayo never had other than marginal contacts, Montenegro can be said to be his master. First muralist to receive a commission from

José Vasconcelos—in 1920, the refaction and decoration of the ex-church of San Pedro y Pablo—Montenegro, before Rivera's return, had gathered around himself a phalanx of young artists that included Tamayo. Bronze-skinned Rufino served as assistant and also as model, and one of Montenegro's engaging portraits of the twenty-four-year-old is reproduced in *La Falange*, September 1923.

That same year saw the large-scale adoption in primary schools of the drawing method of Adolfo Best Maugard, devised to conjure long-forgotten racial images out of the national subconscious. This method, mentioned in the text as part of the whole cultural tableau, deserves to be underlined as one of the stylistic ingredients that came to be digested and transformed by Tamayo, who was part of the small, hand-picked group of teachers groomed to launch the method. While he freed his small charges, mostly Indian, from the forced obeisance paid to Greek art—contacted in public schools in the form of plastercast models—the young teacher watched them splash color on paper, inspired as they were to careless rapture at the sight of the wobbly fruit-dishes, calligraphic watermelons, and tattooed pineapples that enlivened their new textbook. Students' drawings of the period artlessly prefigure some of the charm, pungent color and sensitive line of their master's forthcoming "ice-cream" period. Some of the childish "papers," invited and hung at the New York Independents of 1923, stole the show from the adult work sent from Mexico. In that same show, Tamayo himself made his United States debut with a *Young Man*, listed in the catalogue.

Does it add to Tamayo's respectable stature to belittle what had gone on before him? Legitimate is the use of quotations from the artist for the subjective light that they throw on his choice of aesthetic paths, but should some of the statements go unqualified they might be accepted by most readers as history. Surely the tagging of the Mexican muralists' achievements as provincial, the suggestion that their grasp of aesthetic problems was only half-hearted, and deficient their knowledge of the international scene, bears correction. Their provincialism was not one of ignorance but of choice.

Drastic had been the temptation of Rivera to forget his small *patria* and remain in Europe, a successful expatriate. He was not merely a traveler through the School of Paris, having added his own stone to the imposing construction. Even the innuendos of André Salmon suggest that the Mexican could not be by-passed in telling the story of analytical cubism; and for an unbiased report, read what Gino Severini says of Rivera, speaking of *"La Peinture d'avant-garde,"* in the *Mercure de France*, June 1, 1917.

Similarly, Siqueiros knew well the Parisian milieu, and Picasso had praised his painting. In Spain, he edited an art magazine a little ahead of up-to-date. In Italy, besides worshipping Masaccio, he worked awhile in the idiom of *pittura metafisica* just launched by Carlo Carra and de Chirico. An all-round itinerary of that sort was needed before this strong temperament could feel humble enough, and provincial enough, to fresco the archaic-looking brown giants of 1924.

Of more than usual interest in this monograph are the plates that relate to archeological sources. The masterly directness of the drawings that have pre-hispanic carvings or modelings for models constitutes in itself a justification of the use of a material that, in other hands, would acquire self-conscious overtones. The sequence of four plates related to *Dog and Serpent* is especially rewarding. To ease the change of mood from the gentle pre-hispanic clay dog to the fierce enigma of the modern picture, additional material from Tamayo's own ancestral Zapotec art would be helpful, especially a photograph of one of the stylized black clay vampire bats.

The references to Picasso as another stylistic influence explain the ready toe-hold, as it were, that men thoroughly conversant with idioms of the Parisian school can achieve in the art of Tamayo, even if they do not know before-hand of his other, Amerindian, models. That Tamayo himself is not spoiled by the welcome mats spread on 57th Street was proved to me by a single small fact on a visit to a gallery that handled his work. The admiration felt by the dealer for some of his best pictures, dark and very close in values, was tempered by the fact that they could hardly be photographed; thus throwing out of gear the complicated machinery needed to launch and to sell an artist; thus reassuring me as to an integrity unswayed by success.

A review of Robert Goldwater, *Tamayo* (Quadrangle Press, 1947), this article first appeared in slightly different form in *Magazine of Art*, October 1948. Reprinted by permission of The American Federation of Arts.

Lola Cueto

To appreciate the needlework panels of Lola Cueto, no other effort is needed than to open our eyes and let them be saturated with the flow of colors and nourished on the wisdom of designs. The patient, countless bee-pricks of her knowing needle imply in their minutiae no smallness of heart. What stroke of pigment-loaded brush could compete with the variety of this magic petit point in which the thread streams around form and space with liquid ease, or forcefully breaks its rhythms against their outlined boundaries? This technique is a natural one to match spiritual expression, wherein the thread is present, not so much in its physical concreteness, as in its function as a snare to hold and to hoard light, and to master its prism in the same impalpable way that a copper wire curbs and channels electricity.

The artist has pitted her unique technique against another, older one, whose principle is also that of ensnaring light, the technique of the stained glass in medieval windows. Her set of panels embroidered after Biblical histories from Chartres is far from being slavish reconstruction. What she brings to the fore may lack archaeo-

logical pulchritude, but stresses heroic inspiration. Rather than adhering to the letter of line and color, she evokes the spirit, that is, the sun rays that transform each chunk of colored glass into a chromatic universe. She tells how each blue, transfixed by sunlight, ranges from cerulean to an ultramarine so saturated that it bleeds with carmine overtones; how the play of each red is from the shade of a faded rose petal to a hue so deep as to become colorless, the same colorlessness that dyes the ocean's depths.

Truly a feast for the eye, these embroideries also reach further than the senses, even further than would a quest for objective beauty or for subjective exaltation. The concept of art for art remained unknown to the artisans that built the cathedrals. Glass and lead, the stones used in building, all were respected servants of theology. The stories that art told were meant to touch and to edify even the smallest or the roughest of pilgrims. When we refer today to art as propaganda, we think of closed fists and red banners, forgetting that other kind which, for centuries, disseminated the lessons of martyrdoms and miracles.

In the time we live in, many a Catholic, however heroic he may happen to be in his personal life, believes that there is a kind of virtue in preserving mediocrity in aesthetics. In the century when Chartres was conceived, the faithful clearly saw how it was his duty to forge an aesthetic language to fit his own devotional clime. Of course, the builders of cathedrals were familiar with the works of past cultures. Villard de Honnecourt—a great medieval architect—sketched antique marbles in his notebook. Goldsmiths enriched reliquaries with Roman cameos. Yet,

all felt how the arts of Greece and Rome, despite good drawing, anatomical correctness, and the stress put on physical beauty, lacked the power to express sentiments that pagans had never experienced. Discarding as obsolete a tradition that he knew to be capable of masterpieces, the medieval artist was brave enough to turn to modern art, than as now the only way of expressing new truths.

Lola Cueto has recaptured the intensity of emotion still latent in the distortions of twelfth-century drawings, when draftsmen discovered the emotional power released by twisting the line of a nostril, changing a convex cheek to concave, or half gouging out of place the circle of an eye-ball. There was a surge of drunkenness as the artist, using color for its symbolical intensity, pinned saints against skies impossibly purple, or painted flesh yellow or green, but never a flesh tone. Then as now, these experiments were no idle pastime, but represented an earnest search, at times stuttering, at times disoriented, as has always been the way with genuine discoveries.

For two milleniums, the Church has managed an understanding of art and of art-makers. Throughout, she has mothered the slow and continuous transformation of style that parallels cultural changes. God has been served by artists who worked in styles as dissimilar as those of Byzantium and Chartres, of Raphael, of Cabrera and Rouault. It is only in our day that a timorous critical approach attempts to deny this unity clothed in diversity, and would impose as the only Catholic art a synthesis of mediocre traits filched out of context from the arts of the past.

Blending a modern approach with a true understanding of ancient models, this show is proof that Catholic art is alive enough to make impossible the task of those who wish to force it into the narrow mold of naturalism. Anyhow, religious painting, whose role is to make the invisible visible, is the genre least suited to such a form.

Besides her tapestry versions of stained glass, Lola Cueto presents an original composition dedicated to Our Lady of Guadalupe. On this day—the Feast of the Indian Virgin—we artists should apprehend with devotion the lesson taught by the miraculous image. Its aesthetic, conceived in Heaven, in its linear purity so close to geometry, in its flat hues so delicate and yet so pure, has little in common with photographic realism, and even less with the lessons taught in art academies.

THE CUT-OUT PAPERS

Since Lao-Tse stated that the most active part of the wheel is its hub, needed to receive the axle, a philosophy of the vacuum has underlined the fact that it is not only by addition that things and people are bettered, but often by subtraction. The extra matter flung from the matrix block transforms the raw stone into a statue; Diogenes is enriched the moment he throws away his wooden drinking bowl. This notion is in harmony with the *mores* of the Mexican artist, in a land where the uses of art are as widespread as those of bread, where art-making is not the privilege of the few but the birthright of all.

Cueto: Skeleton on Horseback. Cut-out paper

While only a few can afford expensive materials, it is generally recognized that art value does not depend on the rarity of the original material. What humbler material than paper? And to subtract from it should make it still humbler—and yet what splendid results!

For the true artist, the pleasure of art resides in its making. Its permanency, its appreciation for generations, its enshrining in a museum—all these are very good; but have nothing to do with creativeness, with the one luxury that the artist knows: art-making, that is both a collaboration with and a mastering of his material. The brittleness of paper is not easier to master than the hardness of marble. It may be the Asiatic strain latent in the Indian race that made the native artist try his hand on paper, as the Persian warrior essayed his scimitar on a floating feather. Also Oriental and Amerindian is the resigned understanding that, time being short of eternity, a work of art made to last a day is not much more ephemeral than one created to last for centuries.

Codices have preserved the features of pre-Hispanic arts that were not made to last. To play its role in lay and religious feasts, a paper made of agave fiber was dyed and cut into fringes and rosettes, as splendid for a day as de luxe head-dresses and standards; its garlands beautified temple and palace.

Come Colonial days, paper vies with lace to ornament churches. Impoverished by the Conquest, Indian master hands turn forever from the shaping of gold and of quetzal feathers to that of the humble paper, with as great a creativeness.

Today paper has an important place in folk art. There are pre-Hispanic survivals. In villages paper is still made from the fibres of traditional local plants, its use limited now to sorcery and agrarian incantations. Cut-out silhouettes of gods are buried in the soil to insure its fertility. Other cut papers, on display, add beauty to the opening of a *pulqueria*, or, made into fringes and flowers, will be stretched from house to house, often filling the air over a whole village to celebrate the visit of a famed religious statue to the local shrine, or even the homecoming of a politician.

The cut-outs of Lola Cueto are a valid quintessence of the ancient art traditions which have merged into folkforms. Paradoxically, the mosaic of colored papers is made into the solid expression of Mexican modes. The grave religious images, the kneeling devout at the feet of a scourged Christ, remind one also of the Mayan reliefs, in which the pagan faithful perform blood rites. The hieratic Virgins, stiff in their brocaded robes, facilitated the religious transition long ago by their imitation of the shape of ancient *teocallis*.

Lola Cueto preserves a deep understanding of what constitutes the essence of each medium when she transfers to cut-out papers the stylized birds that nestle in the leaves of Michoacan lacquers, or the popular engravings of Posada, which range in mood from a comical tourist whose umbrella is no defense against a Mexican bull to sensational dramas in which teeth, hearts, and machetes are bared.

The last show of Lola Cueto was that of her needlework,

tapestries of rich and heavy material competing in splendor with stained-glass windows. The versatile artist turns to the humbler paper cut-out as one relishes a glass of water after too rich fare. Her pictures, as light in weight as they are heavy with tradition, preserve for a while childish enchantments, all the more exquisite for eschewing the permanency that marbles and bronzes rarely deserve.

THE ETCHINGS

It is often stated that art must confine itself to the aesthetic realm; that to make it serve other ends is to drag it down from its high pedestal. Do we forget that, once upon a time, art was an indispensable accessory of everyone's life, and especially the graphic arts? Woodcuts and metal engravings instructed, edified or amused. Art's main worth was its helpfulness to the people at large as it spread its visual delights to further practical or pious knowledge.

An exception to this commonsense attitude was the etching medium, whose physical blandness could hardly resist the pressure from the press needed to print trade editions. Making a virtue of necessity, etching came to play the aristocrat among other, tougher mediums. To this day, it is the darling of collectors and the prize of museums. Its weakness has become its pride, and what few good proofs can be pulled from a plate soon disappear in collectors' portfolios to be aired only on counted occasions.

Thus, it was fated that etchers in their turn, catering to the elegant and somewhat melancholy reputation of their

Cueto: Indian Dancer. Etching after a puppet

medium, would adopt for their subject–matter models of equal refinement, and display flourishes of technique much in demand from their over-specialized public. The theologians of old assigned a guardian angel to each nation. If we postulate in turn a guardian angel for each technique, we may well pity the one assigned to etching, closeted for ages with artists most conscious of being artists, familiarized to distraction with the schemes of dealers and the feuds of collectors who love rarity above beauty, its flight jailed within the confines of the aesthetic and the exquisite. Doubtless, after perusing this refreshing set of etchings, both wise and innocent, this angel will smack a hearty kiss on the cheek of their maker, as the Sleeping Beauty did when the hero awakened her!

These plates attain to art all the better in that they were conceived without thought of making art. Their aim is to translate faithfully and respectfully the appearance and essence of these tiny constructions of rag, clay, wire and cardboard; these statuettes whose worth in terms of material does not exceed a few cents; whose style was never described in art encyclopedias; whose destination, once their stage days are over, is not the showcase of a museum, but organic disintegration. Being alive like us, the puppet is no more built to resist time than we are, and its motley parts last no longer than our own flesh and bones.

The etched line is thin as a spider thread, and like it weaves webs paradoxically strong. Lola gives to her puppets the dignity of monuments. Through her eyes, we see them as of heroic size, worthy of being raised on

pedestals where they would, in truth, look better than many a one among their big brothers.

Lola's line captures so successfully both space and volume that the aquatint washes limit themselves to suggestions of local color; the kind of unabashed color that raises the puppet from the status of statue to that of a living being. The many grays of the aquatint function as the rungs of this Jacob's ladder that bridges black to white, and evoke besides prismatic contrasts that range from lime green to magenta dye.

To reach those eyes that miss the magical chromas latent in the range of grays, Lola adds to some of her prints hand-painted touches of water-color. In so doing she breaks the rule of purity of medium held dear by etching-lovers; she also intensifies the spirit of play and further cleanses these charming plates from the stigma of art for art.

As heretofore in her embroideries and cut-out papers, the personality of Lola Cueto proves, in these plates, that it is in good enough health to rejoice in its own creativeness without worries as to uniqueness. The typical amateur of etchings may feel somewhat cheated in the presence of so much simplicity. Others will communicate through these prints with something rarer even than exquisiteness or abnormality; and that is the very spirit that puppets breathe, compounded of contraries, cynical and tender, innocent and ironical, infantile and wise.

The three parts of this article first appeared as the catalog of the show held in Mexico City, October 1945; the catalog of the show held in Mexico City, 1947; and the Foreword to the album *Titeres Mexicanos*, published by the artist, Mexico City, 1947.

Martinez Pintao

There are in Mexico many artists who work in clay, some of great talent, but only one sculptor, Manuel Martinez Pintao. There is quite a difference between working with a soft material, with equal opportunities to add or subtract, a hit or miss technique, and pitting oneself against hard material, wood or stone, without the soothing guide of a maquette, the choice of pasting back the piece chipped off. This difference between sculptor and modeler goes deeper than methods and material, imbues the finished works with incompatible spiritual atmospheres.

Those who model, having polished to a finish the clay statue, transpose it into hard material; this stage of the work is that of a copyist, who duplicates the clay original with co-ordinate measurements. The artist, or a stone cutter, can tackle equally well this translation from one medium to another. It is folly that a marble should acquire the surface of pawed and kneaded clay. If the model is docile to the qualities of soft material, the resulting marble will be a lie. Or if the artist tries to suggest the marble with the clay, the statue will be in the end only the lying image of a lie.

Charlot: Portrait of Martinez Pintao. Woodcut, 1925

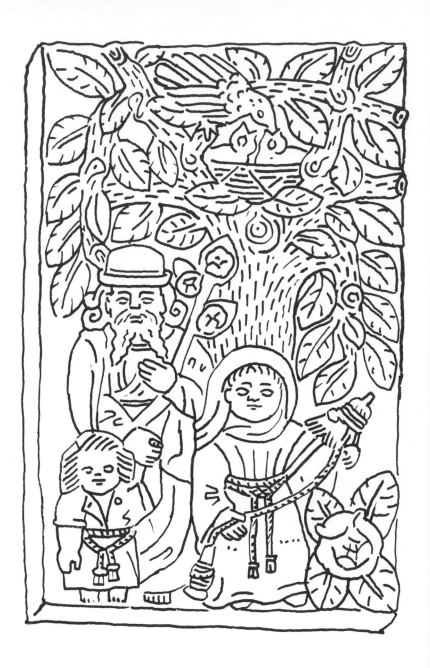

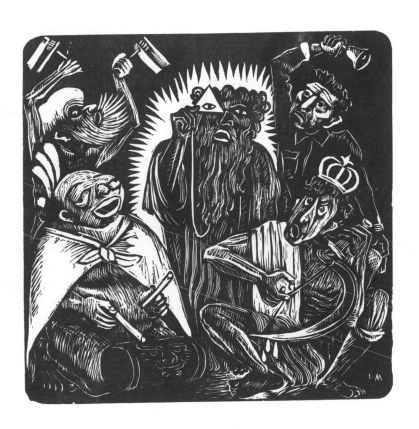

With an urge to brush time against the grain, I revisited the buildings where the movement started. To point the changes, this short survey describes the present state of the walls painted over twenty years ago, contrasting them with the latest crop of murals, mostly still in the making in the winter of 1945–46.

San Pedro y Pablo, dedicated by Vasconcelos as a public hall, has been transformed again, this time into a public library. This new function has blocked the decorative walls of the nave with tiers of bookcases and superimposed balconies of dark wood that slice the verticality of the polychrome columns, still rich with garlands of pomegranates, bluebirds, blackbirds, cornflowers, and camellias. The workshop of the mural group was the cubicle at the back of the auditorium of the Preparatoria. On the low thick round columns, patches of discoloration on the gray stone still mark the spots where our first fresco trials were made in 1922. In the auditorium proper Rivera's first mural, *Creation*, is scarcely any longer a truthful witness to the seething *élan* that saw it born. The distinguished geometric planning is still perceived, but the wax mixed with the pigment has opaqued, dulling the once intense chromas.

The Orozco patio is of course beautiful, only it seems that time has frozen to a stop what once had depth and movement. To recapture the thrill of the work in the making, one should be able to discern under a mortar become translucent the layers of superimposed subjects that succeeded each other on the same stretch of wall as the artist worked, wrecked the work, and tried again,

bent on an expedition to reach the *toison d'or* of style. Only *The Strike* obeys the rules of a plastic palimpsest, disclosing over the red banner held by two workers a fragment of the earlier theme, the giant head of the destroyed *Christ Burning His Cross*.

Going up the main stairs, I pass the fresco that I painted there twenty-four years ago; I can look at it objectively as it is not mine anymore, but rather the work of an adolescent who dreamt long and deep before the battle-piece of Uccello, hidden at the time in the small room in the Louvre, where Italian primitives were side-tracked by curators who far preferred Carlo Dolci.

The fresco is intact, except for the exertions of unkind students. The light washes and reserves of white mortar proved too much of a temptation to scribblers. A generous quota of mustaches and eyeglasses has been added to faces; the despair in the eyes of the massacred Indians is underlined by a Niagara of teardrops coarsely sketched in chalk.

On the top floor the Orozco frescoes on revolutionary themes are as maculate with *graffiti* and doodles as if they were not revered by critics, widely reproduced and admired. On this visit *Rearguard* and *Adieu to the Mother* were disfigured by blatant slogans to insure the election of a college queen, *"Pompeia para reina."* A zealous janitor rubs off such offending additions, but not always with the light hand of a mural devotee.

The staircase of the last court still testifies to the action directed against the first Siqueiros frescoes, when enraged students bent on championing "beauty" stoned the ugly giants. Today the more mutilated portions have been

neatly chiseled out. What remains of the mat frescoes, delicately modeled brown on brown, contrasts with the oily and varnished texture of the makeshift repairs.

In the Ministry of Education, the open archway that divided the inner court into patios is being torn down to make room for an opaque box-like partition that will hide elevator shafts. It is as awkward as it must be exceptional to see architecture shot from under the mural that rides it. Because sound mural painting obeys the optical rules that the architecture dictates, the change will negate originally correct formulations of scale and color.

The ground floor frescoes, painted "*à la mode Teotihuacana*," by Rivera—brushing pigment mixed with nopal juice on a thin film of pure lime—have suffered from this unusual technical departure. The sand packed underneath has burst through the film of painted lime, each grain leaving a microscopic patch of white. As a result, the early Tehuantepec and mining scenes fade as if seen through a thickness of tracing paper. The later *Corrido* series on the top floor, done in the sounder Italian medium, have suffered in turn from the weakness of the architecture. The walls are rent with cracks that also split apart the painted personages. To add confusion, each crack is scientifically recorded, bridged by dated paper stickers, some already burst as the cracks widen.

These walls have also met with doodlers, would-be wits, and plain defacers. A crop of scratched-in swastikas answers the painted crop of red stars; jokes of the privy type thrive on nude allegories.

The second patio, originally given to Amado de la

Cueva, Xavier Guerrero and myself for a first attempt at communal painting, is crammed with building material, just as it was when we were at work. Scaffolds sprout from eviscerated floors, planks, crates, and rolls of *petates* pile high against the frescoes. I rather liked the implication: people feel more concern for a near future than for an academic interest in the near past. And, at least the day I was there, not a sightseer besides myself.

Among the plentiful crop of new murals, those of Orozco, Rivera, and Siqueiros can be singled out, their names being best known in the United States.

In Boston the Lowells talk to the Cabots and they only to God. In Mexico, *"Los tres grandes"* scream at the top of their lungs in a contest to see which can outshout the others, in the three neighboring panels that fate, or a witty sponsor, commissioned for the Palacio de Bellas Artes. This execrable building put all three in bad humor. A polychrome artnouveau interior, with enameled orange cupolas and peacock blue skylights, it reeks of the blatant assertions of world fairs long ago sold to the wreckers. The building offers only cramped mural space, behind pilasters and balconies, finally visible only at arm's length.

Ciceroni lie in ambush before the murals, tempting the tourist with chairs strategically facing the wall and a memorized patter. Favorite is the Rivera, a shrunken replica of the destroyed Radio City fresco, in front of which the New York scandal is rehashed. The many careful portraits, pyramiding like apples on a tray, the skimpy bodies hiding behind loquacious streamers and slogans, remind one of nineteenth-century French political

cartooning. Despite the size, the craft remains exquisite. In a public lecture held on the premises this past August, Rivera disclosed to his baffled audience that the panel contains a detailed prophecy of atomic power. As to the frescoes of his colleagues, not denying their artistry, he dismissed that of Orozco as representing "men without shirts clubbing men with shirts," and that of Siqueiros, *Democracy Breaking the Chains of Fascism*, as "one giant commonplace."

The bulk of Orozco's mural work is to be seen in Guadalajara, capital of his native state. The major ensemble is that of the ancient Hospicio Cabañas; the robust architecture cringes from his brush as from an earthquake. From the cupola falls a flaming cadaver, Prometheus or Icarus. On the vault, a colossal Cortez embodies mechanical war and conquest, on the walls savage redskins and mechanized robots pound the ground, gray monochromes more blatant than flags. In twin half-lunettes, caravels glide over a turquoise ocean, blown by an unearthly wind towards the black void ahead.

This terrifying sermon addresses itself paradoxically to the only lodgers on the giant premises, state-endowed orphan children who pay no heed to the loud Cassandra, but instead lazily people the old patio, pile pebbles, chew fingers, scratch their heads, or merely lie in the bountiful sunlight.

In Mexico City Orozco has, for lack of an inclusive contract, left unfinished the decoration of the Church of Jesus, annex of the ancient hospital that Cortez himself endowed. On its vaults the scarlet Prostitute rides the

apocalyptic Beast, the monstrous grasshoppers with manes like women's hair chew the world naked. Desiccated limbs, headless torsos, shrouded and desperate forms crawl under a sky become heavier than the earth, pregnant with a hail of twisted steel girders scattered by the hoofs of the four horses, their riders hidden by the animal bellies distorted as storm clouds.

Rivera has staked for himself the whole of the National Palace, and, with a caution born of previous mishaps with buildings that split apart and patrons in revolt, chosen to do true fresco on false walls. The mortar is trowelled into shallow metal troughs, half sunk into the wall, but movable if the need arises. As they fail to fit the scalloped outline of the door frames, the panels, despite the compositional care of the painter, suggest a show of easel pictures, beautiful ones, huge and heavy ones certainly. The main drawback is that this precaution opens the way for the future removal of the frescoes from the walls, and their eventual disposition, shorn of their natural habitat, in a mere museum.

In the staircase of the same palace, painted over a decade ago, the artist modeled in black before applying the local color; now the film of gray comes through to disturb the polychrome balance. Today Diego Rivera paints with pure color, the transparent washes made more intense as the mortar hardens to marble white. For contrast, the high dado of the new work is of cement of a normal putty value, painted with monochrome false bas-reliefs.

What Rivera is painting in the National Palace keeps the archeologists breathless. The first two panels relate

to archaic cultures, of whose remains the painter has a copious collection, preferring them to the sophisticated Mayan culture, and to the later socially stiffened theocracies of the Mexican plateau.

Just finished, the third panel, breath-taking in its scope, effects the resurrection of the merchants and buyers who thronged the market of Tlatelolco, after data furnished by recent excavations of the site. The background is a panorama of the pre-Hispanic capital, based on aerial photographs of the modern city, so close is the identity of plans from a height where a church cannot be told from the pagan temple it supplanted, nor a main artery from the antique waterway.

A motley crowd mills in front of the risen Tenochtitlan, herb merchants, dog butchers, witch doctors, tattooed prostitutes and cannibal priests. Lower still, at our eye-level and most exquisite of all in treatment, are tiny objects and shreds of refuse that litter the foreground, bitten, spat out and trampled fruit pulp, a toy clay dog on wheels, the only use known for this device in an otherwise wheel-less civilization.

Rivera is so bent on completing his record of Mexican history, that storytelling has no more plastic terrors in store for him. Paris may frown on his present work, sophisticates sniff at its matter-of-fact craft, fans of abstraction sneer that photography is just around the corner. Rivera doggedly pursues his way to a conclusion that may mean a truly American style.

Siqueiros has published much of late; his opinions may be summed up in the statement that murals are closer to

moving pictures than to easel painting. While the latter presumes a single point of view, films move in front of an immobile onlooker, and murals, though immobile, attract a spectator in motion. Thus, the idea that the mural is serf to architecture is replaced by that of the mural as a dynamic unit that forcefully provides itself with room in its otherwise inert habitat.

Siqueiros is practising his theories in the Treasury Building. In spite of its moneyed title, it is an old colonial palace, of a stylistic simplicity that borders on the primitive with marks of a soothing laissez-faire everywhere. The painter has fallen heir to a vaulted ceiling between two open courtyards, curved both in width and in length, that promises perspective deformations aplenty, to be countered by drawing deformations. The two end walls are V-shaped to fit a floor plan that is a maze of diagonals, a staircase with ninety-degree turns and bifurcating slopes that blur both plumb and level. The plan lends itself ideally to further twisting and the optical illusions that are the means of Siqueiros' modern baroque.

At this stage, the walls are upholstered with celotex, rough side outwards, none too rough for the rough treatment still to come. A small model that duplicates in scale the complexities of the architecture is painted concurrently with the mural—added to, subtracted from, complete one day and whitewashed the next, in accord with a pioneering optical research that recognizes no precedent. A rickety ladder takes one to just under the high ceiling, to a false floor of planks so widely spaced that a body might easily fall between them to certain

maiming on the stone staircase, way below. A device with two advantages, it allows the daylight to filter in from underneath and keeps out chicken-hearted admirers after their first visit.

Siqueiros does not use the much-advertised Duco anymore. A need for authentically mat surfaces, essential to the great size and double curvature of the wall, leads him to prepare his own paint, blended with sugar cane fiber to intensify the roughness of the texture. This search for tactile strength removes Siqueiros from his early heroes; Masaccio and the uniform smoothness of *fresco buono* he deems archaic, and tags Ingres as too exclusively an intellectual planner.

The rape of the architecture is begun; the ceiling is split in two by compositional lines and, hinged at the end walls, opens skywise to prolong their vertical towards an infinite. From this illusive stratosphere down one side falls a hail of crystal shapes and cylindrical forms outlined in white on the red background. Bold color strokes begin their metamorphosis into a maze of men entwined with horses, the roll call of Mexico's traitors and collaborationists doomed by the painter to an unspecified hell. On the opposite wall another mess of manes and torsos speeding upwards will symbolize the national heroes that the artist ushers to some Marxist paradise. The completed subject thus will function when the two contrasting currents are joined, like a gigantic wheel of fortune, to carry vertically, in water-wheel fashion, the *personae* of Mexican history, horses, swords, epaulettes, loves and hatreds and all, to a

zenith of glory, and dump a corresponding load to an underworld.

For Mexicans, news of the art season is not the frescoes being painted, a routine long since taken for granted, unless they be by foreigners, as in the case of George Biddle, whose new fresco in the Supreme Court Building has raised an animated controversy. The rediscovery of the mid-nineteenth century muralist Juan Cordero also has aroused much comment. A show of his easel work at the Palacio de Bellas Artes led to a reappraisal of his tempera murals in the churches of the capital, painted with zest on walls and cupolas as large as those painted today. Like all important work, that of Cordero divided the critics. Rivera championed it in a public lecture, while Siqueiros attacked it in magazine articles. The fact remains that his work bridges with honor one of the weakest moments of Mexican tradition, when the magnificent crop of colonial murals had long been gathered in, and the modern renaissance was not foreseen.

Thus, adding a new stratum of murals to an already substantial sum of works, this year adds also to the woes of critics who think it is high time for the renaissance to stay put, so as to give them a chance to utter definitive estimates.

This article first appeared in slightly different form in *Magazine of Art,* February 1946. Reprinted by permission of The American Federation of Arts.